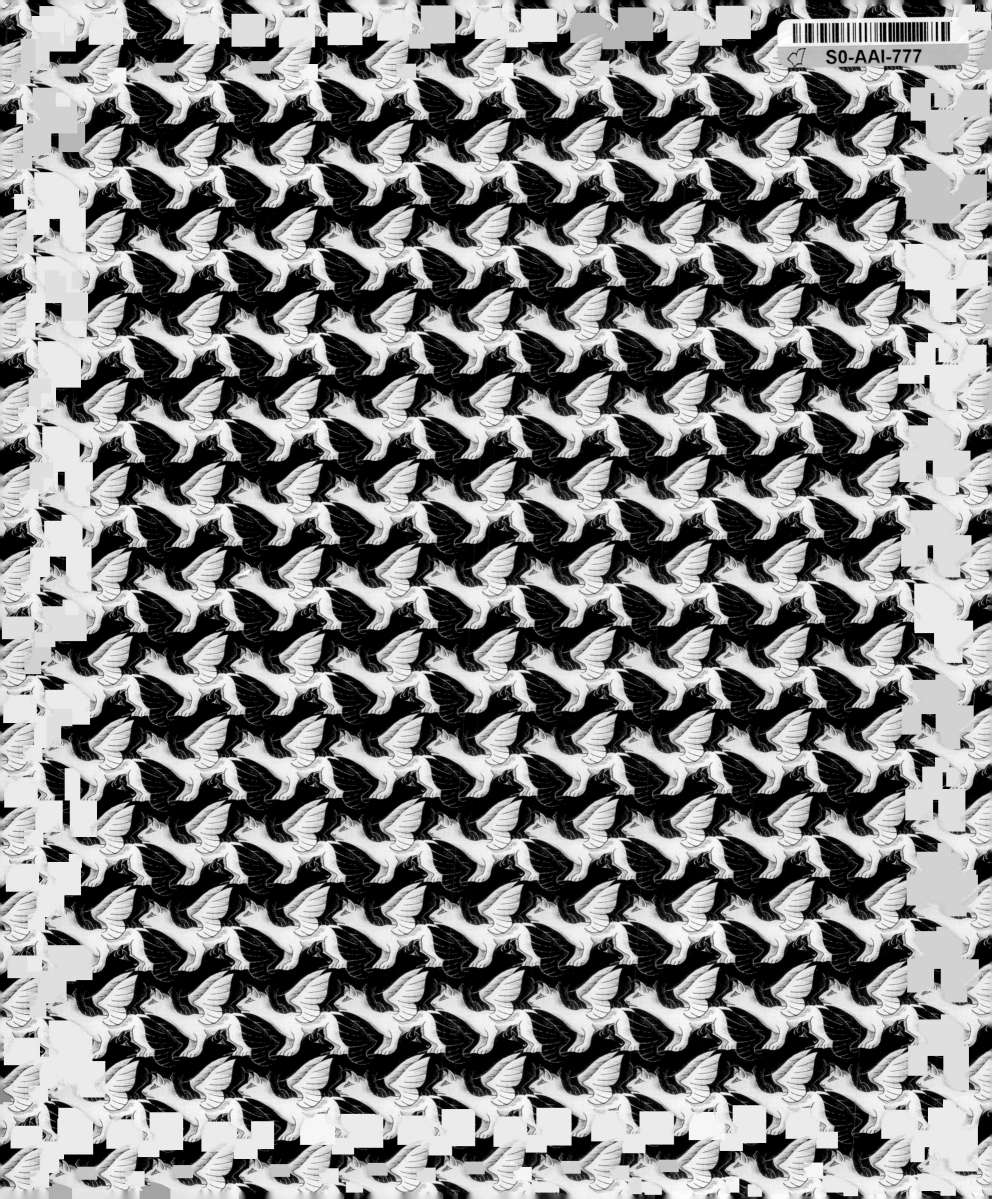

S0-AAI-777

THE MAGIC OF

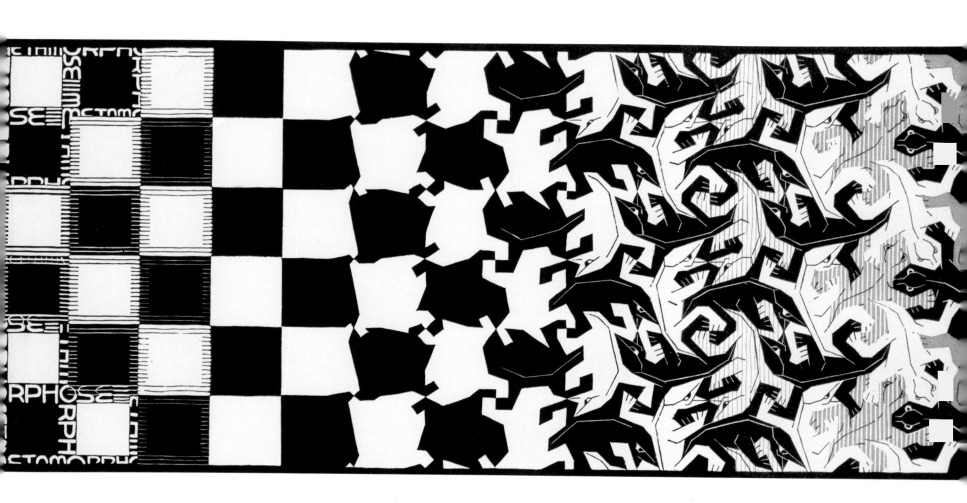

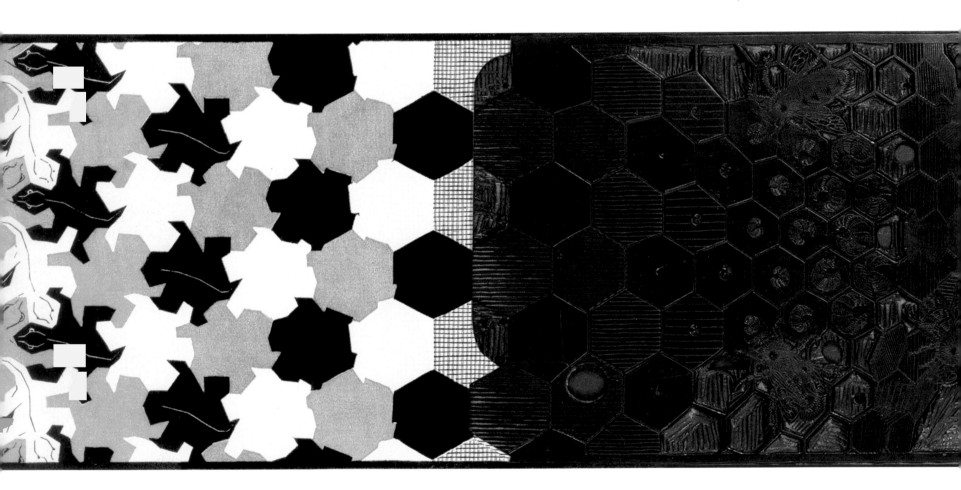

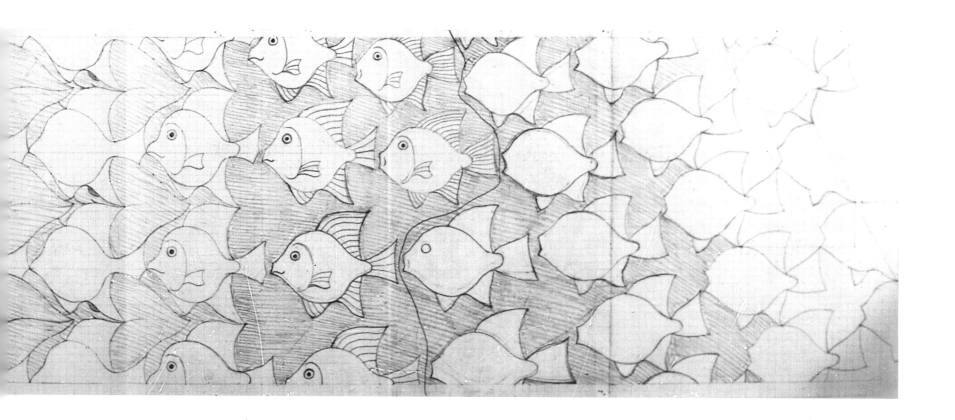

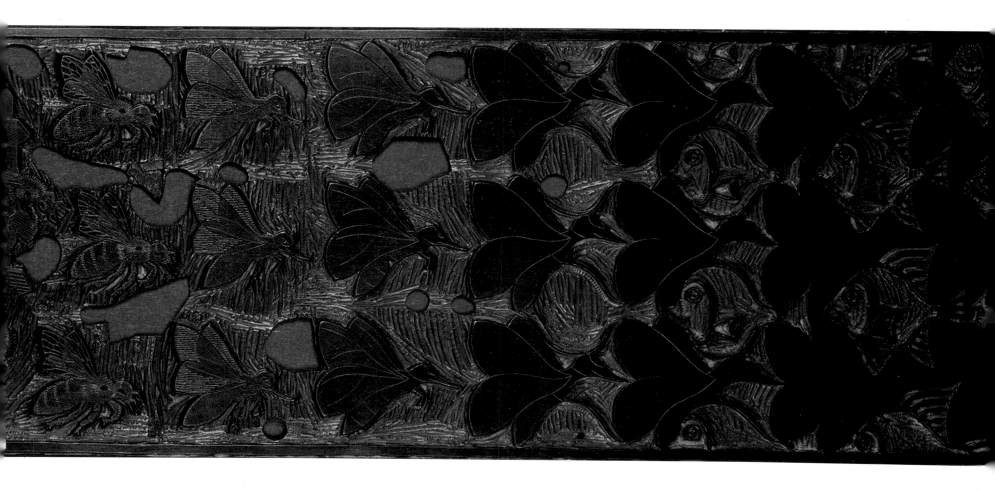

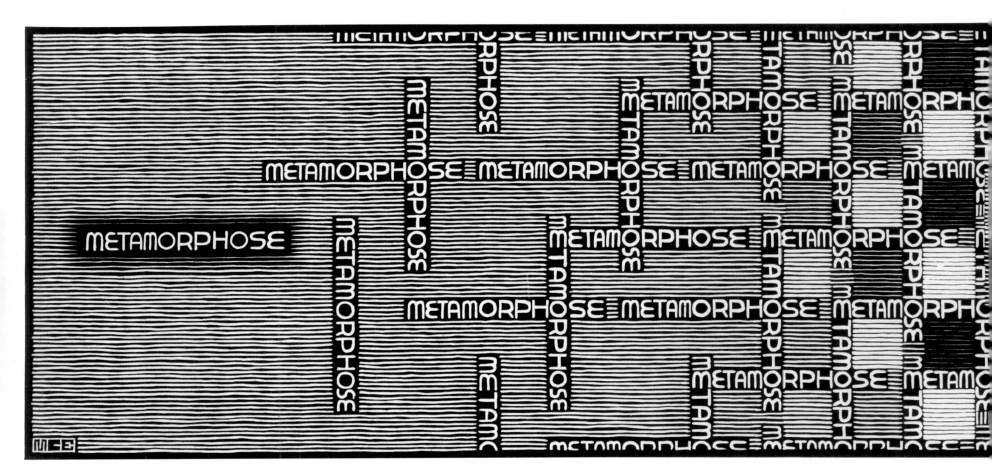

1
2

1 Study for **Metamorphosis** II
 Pencil, 8 x 52 3/8" (203 x 1330 mm)
2 **Metamorphosis** II
 1939-40. Woodcut, 7 1/2 x 153 3/8" (192 x 3895 mm)

M.C. ESCHER

With an introduction by J.L. Locher

Designed by Erik Thé

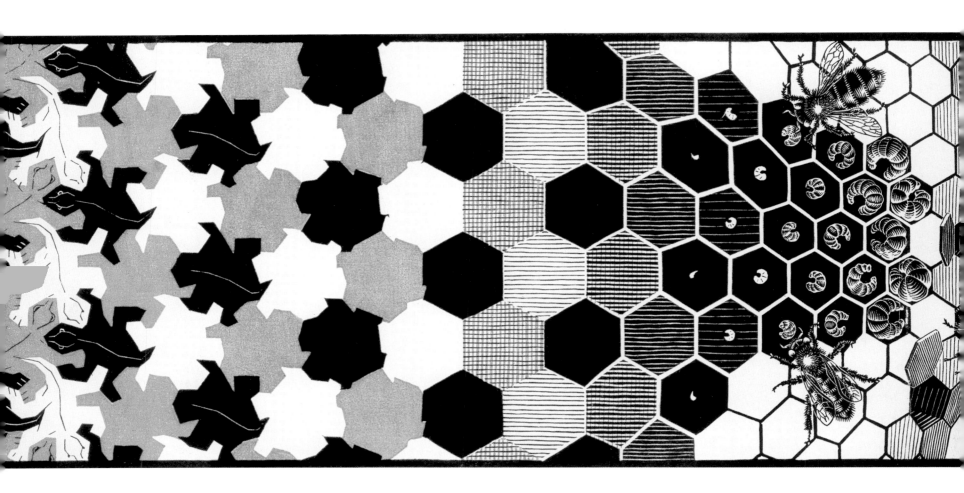

Joost Elffers Books

Harry N. Abrams, Inc., Publishers

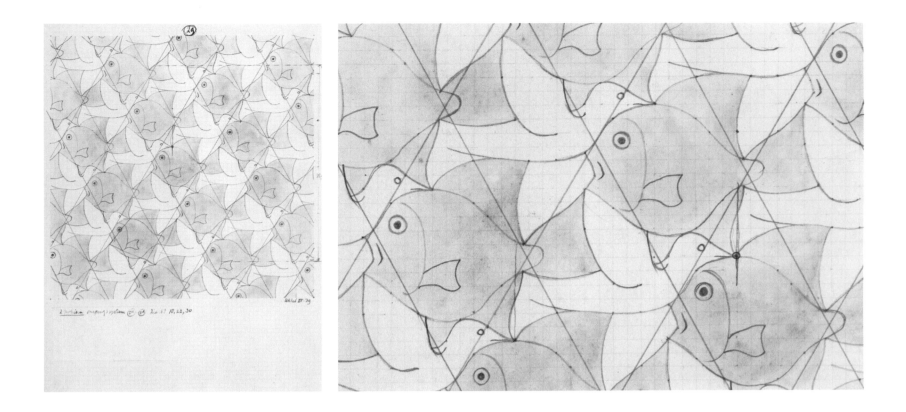

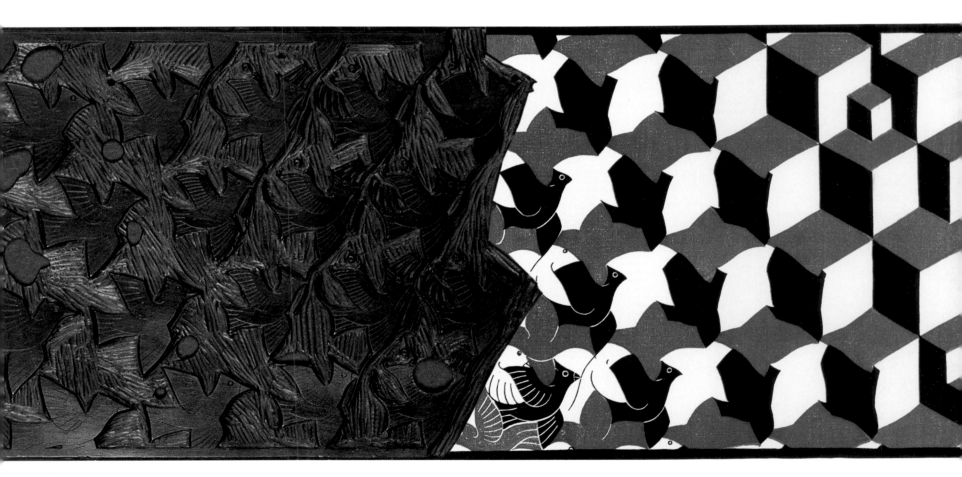

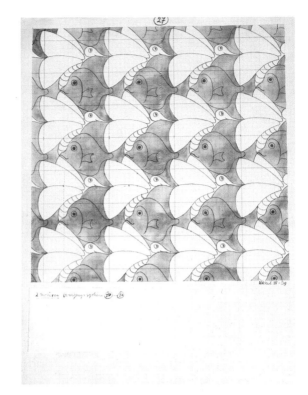

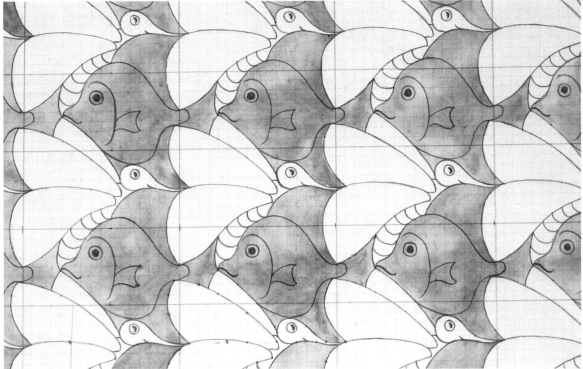

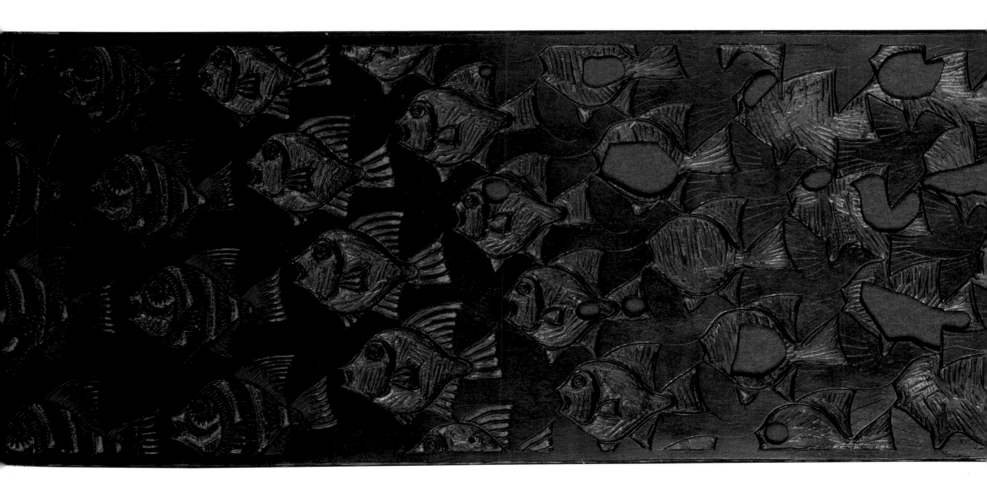

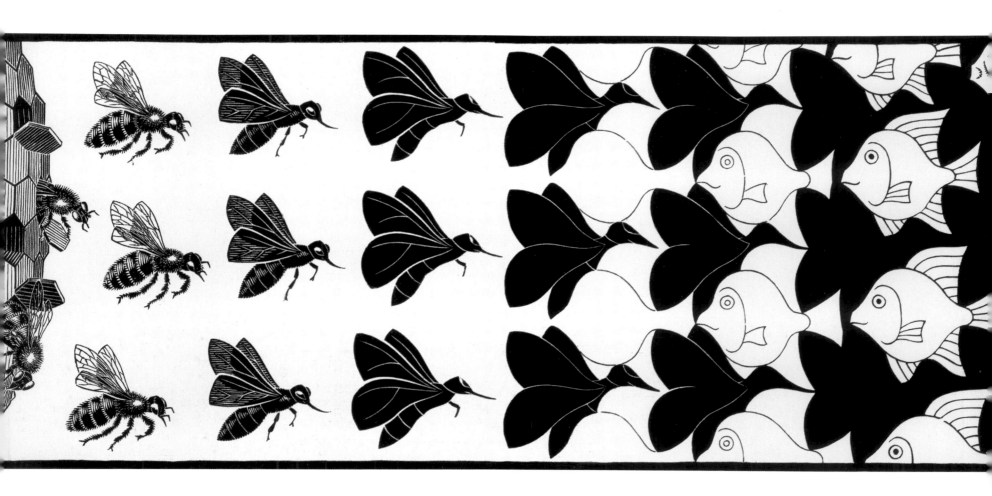

In the meantime, I haven't yet said all there is to say about **Metamorphosis** I [p. 51].
I see it, other than as a childlike association-impulse, also as a surrogate for a film.
Most of all, I'd like to express my metamorphosis and association-mania in an
animated film, and strongly believe that the animated film will become an artistic
expression of great value for the future, in which thoughts of greater importance will
be shown than Snow White or Micky (however, I have absolutely no disdain for
those products, on the contrary: admiration for Disney's talent!) Still, I often dream
of the film I would like to make. What an astonishing metamorphosis you would
then behold. Unfortunately, though, you wouldn't be able to find an audience for it;
I would certainly bore people to death with it.

Letter to Hein 's Gravesande, 1940

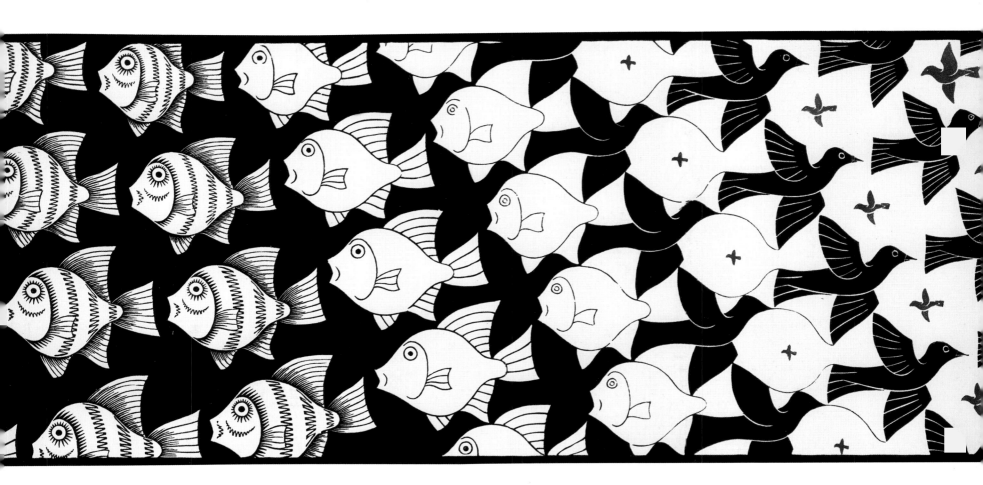

2 **Metamorphosis** II *(continued)*
1939-40. Woodcut, 7 ½ x 153 ⅜" (192 x 3895 mm)

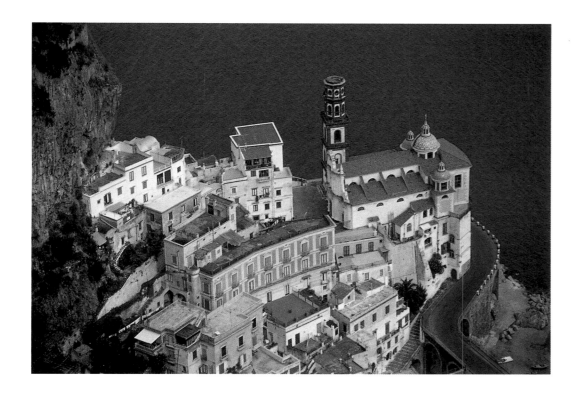

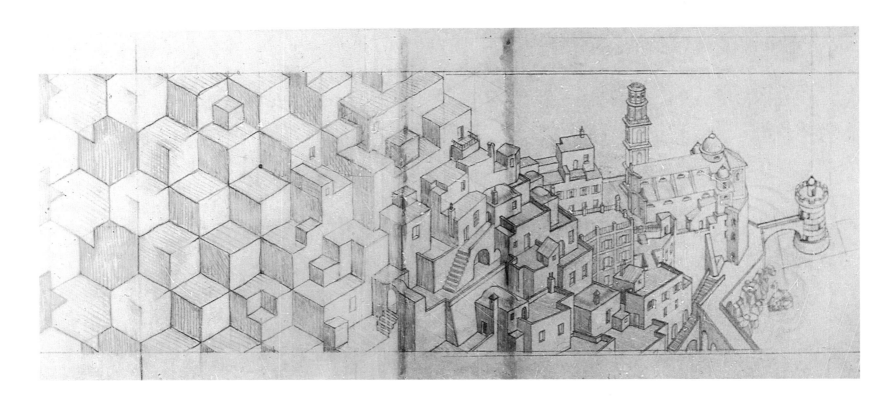

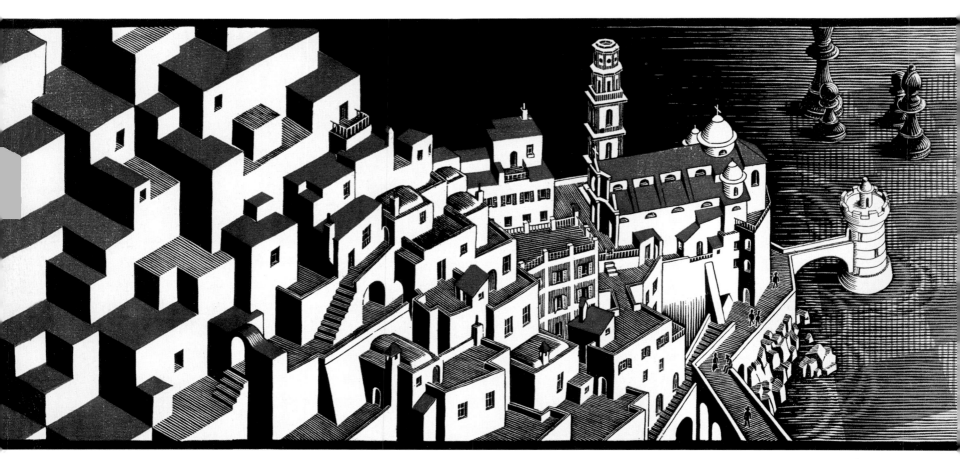

Lengthening a four meters long "closed" contraption like this by three meters is not as easy as it might seem. It is also an odd feeling to glue a second part onto it, twenty-eight years after the first one. Around 1940 my inventiveness must have been greater than it is now. Will I succeed in reaching the same level (if one can even speak of a level)?

*On **Metamorphosis** III (reproduced on the inside of the jacket of this book), from a letter to Gerd Arntz, 25 September 1967*

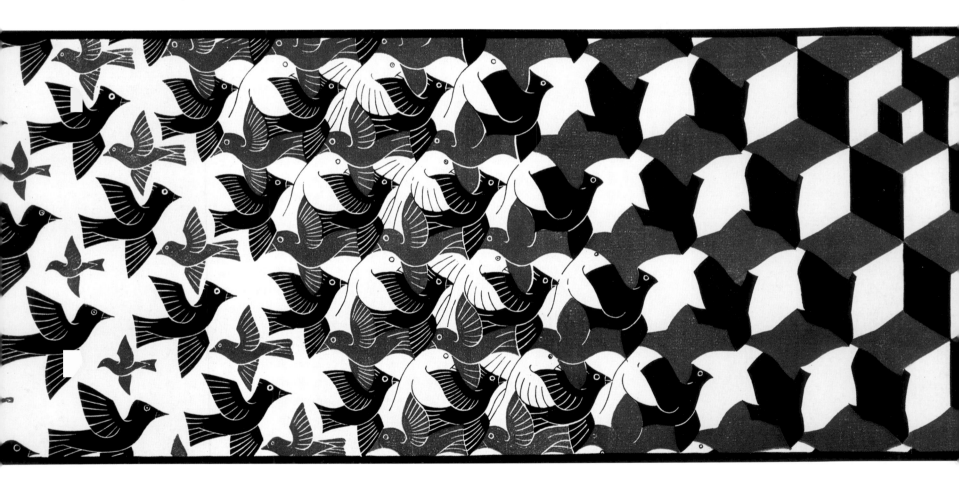

Translator's note:
All texts come from letters, notebooks, journals, and lectures by M.C. Escher,
with the exception of those bearing the initials J.L.L., which are by J.L. Locher.

Library of Congress Cataloging-in-Publication Data

Escher, M. C. (Maurits Cornelis), 1898-1972.
 The Magic of M. C. Escher / with an introduction by J. L. Locher ; designed by Erik Thé ;
[translated from the Dutch by Marjolijn de Jager].
 p. cm.
 "Joost Elffers Books"
 ISBN 0–8109–6720–0
 1. Escher, M. C. (Maurits Cornelis), 1898–1972—Catalogs. I. Title

 N6953.E82 A4 2000
 769.92—dc21

Copyright © 2000 M.C. Escher Foundation

All M.C. Escher works and texts © M.C. Escher Foundation, Baarn, The Netherlands.
All rights reserved. M.C. Escher ® is a registered Trademark of Cordon Art B.V.
Photography Italy © Mark Veldhuysen

Published in 2000 by Harry N. Abrams, Incorporated, New York
All rights reserved. No part of the contents of this book may be reproduced without
the written permission of the publisher

Printed and bound in Germany

Harry N. Abrams, Inc.
100 Fifth Avenue
New York, N.Y. 10011
www.abramsbooks.com

14 Detail for **Hand with Reflecting Sphere**
(**Self-Portrait in Spherical Mirror**) (see 275)

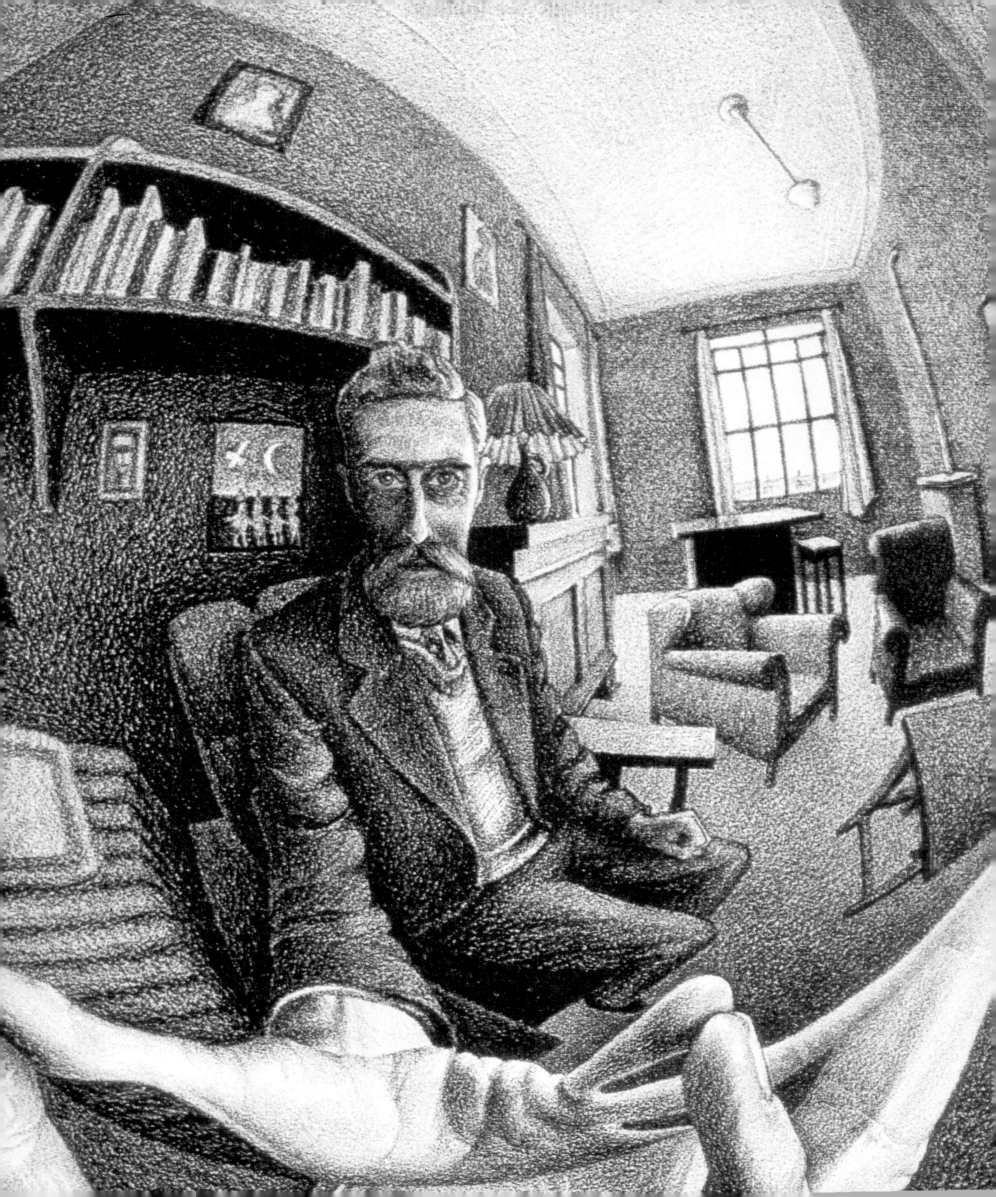

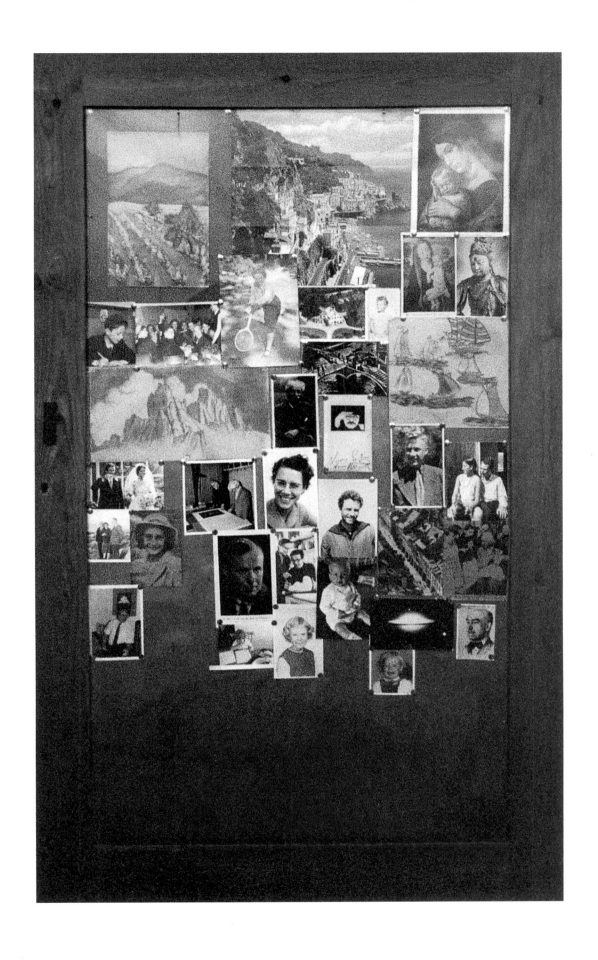

15 Door of Escher's tool cabinet

Foreword

"It could become a most curious edition, in any event something (in all modesty) that no other graphic artist on earth could deliver to you. It doesn't sound very modest, but what can I do? That is the way it is."

This phrase from a letter to one of M.C. Escher's friends came to mind when the publishers Andreas Landshoff and Joost Elffers suggested they publish a book with a wholly different approach to the work of the world-renowned graphic artist M.C. Escher. More contemporary. Not a reading book, but one that tells a story in pictures with complementary text.

Or had they themselves perhaps read the letter as well, since they had already made a maquette to support their arguments and, indeed, it had a look that was different from all other Escher books. Well, that is what it has become. And not only because of the format but certainly because of the contents.

Designer Erik Thé must be an inquisitive man: he poses questions visually and provides the answers at the same time. A captivating form of dialogue, which not only provides a surprising and personal view of the work, but at the same time emphasizes Escher's intention.

The whole is strengthened, too, by the numerous Escher quotations that have so carefully been selected by Mark Veldhuysen, who also provides two contemporary photographs taken from the same point of view that Escher used decades ago. It looks as if time had taken a break there.

Last but not least, there are the introduction and complementary texts by Dr. J.L. Locher, director of the Gemeentemuseum in The Hague, but above all an outstanding expert on Escher. His explanation of and insight into the work of his friend Escher have contributed greatly to this book.

The publishers did not overstate their case. Theirs is a fresh approach, that is certain. Many readers will be surprised by the new light their book casts on the work of the artist, whose international following was reaffirmed during the celebration of the centenary of his birth in 1998. With anniversary exhibitions in Washington, San Diego, Rotterdam, and Baarn, as many as 800,000 visitors came to see the work of Escher.

The M.C. Escher Foundation is extremely happy with this new volume, because in a very clear and contemporary manner it underlines the objective of the Foundation, which is to make the highly unique and unparalleled work of Escher known across the world again and again.

Baarn, the year 2000
M. C. Escher Foundation

W.F. Veldhuysen
Chairman

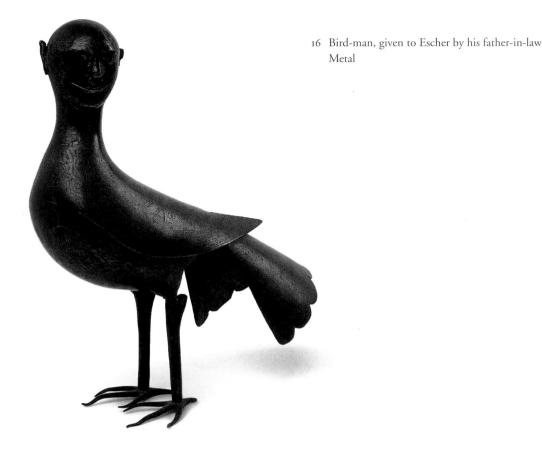

16 Bird-man, given to Escher by his father-in-law
Metal

Introduction

I encountered Escher's graphic art for the first time at the home of a beloved uncle who had been collecting this work since 1953. It was with him, also, in the second half of the fifties and in the early sixties that I saw various group exhibitions of Dutch graphic artists, which included Escher. Then, too, in 1954 there was the presentation of Escher's work at the Stedelijk Museum in Amsterdam, an exhibit that came into being on the initiative of an international congress of mathematicians, as the artist had become well known in the world of the sciences.

The uniqueness of these images was clear to me from the very start. However, as a student of art history and later curator of the Gemeentemuseum in The Hague, I discovered that in the Dutch art world Escher's extraordinary work was not much appreciated. It was judged to be too old-fashioned in its aesthetics, more craft than art, and too mathematical. Nevertheless, I decided to increase the small group of images by which this artist was represented in the Gemeentemuseum's collection as much as possible and to organize a large special exhibition in honor of his seventieth birthday. This took place in the Gemeentemuseum in June and July of 1968. It most certainly was not his first exhibit, but it was the first time that an important art museum on its own initiative showed an overview of the entire oeuvre. The approach was a chronological one but, with the aid of a number of copies of the most important images, an insight was provided into Escher's own systematics. In addition, attention was paid to the already innumerable scientific and popular-scientific treatments of his work.

Because of the great success of the 1968 exhibition, the catalogue was followed in 1971 by a book entitled *The World of M.C. Escher*. In the meantime, the Escher Foundation had been established and the Gemeentemuseum managed to add a virtually complete overview of Escher's graphic art to its collection. This made possible a comprehensive description of Escher's graphic work, subsequently published in 1981 in *M.C. Escher: His Life and Complete Graphic Work*, an exhaustively illustrated catalogue of all his images, accompanied by a biography of the artist.

Still other publications appeared, such as *The Magic Mirror of M.C. Escher* by Bruno Ernst in 1976; *Visions of Symmetry: Notebooks, Periodic Drawings, and Related Work of M.C. Escher* by Doris Schattschneider in 1990; *Maurits C. Escher: A Stubborn Talent* by Jan Willem Vermeulen in 1995; and *M.C. Escher: A Biography* by Wim Hazeu in 1998.

And now there is this splendid book. For the first time, Escher's most important pictures and drawings are presented as a true spectacle. This is done in unusual sequences of images with, at relevant points, enlarged details that strengthen the visual sensations evoked by Escher's particular imagery.

Side by side with a mathematical logic, an element of diversion plays a large role in arousing these sensations. In his famous images Escher often presents a picture-puzzle. How can a level field evoke depth or height, as well as surface? How can something be both inside and outside or both convex and concave? By looking carefully and by penetrating into the logic of the image every viewer is able to find the solution, and this looking and finding by seeking is fascinating. What is striking is that the solution is always purely a virtual one: both the question and the solution hold us captive in the image.

In Escher a feeling for the conventional foundations of visual reality went hand in hand with a profound awareness of the subjective dimension of every perception, an absurdist sense of humor, and an eager gazing at nature and architecture, especially the landscape of southern Italy and the old cities and villages nestled therein. His picture-thoughts or picture-puzzles often play games with these elements, which are present even in his early prints that became for him cherished picture-memories in the second half of his life, when he was no longer living in Italy.

Escher's picture-thoughts exhibit systematic principles of construction that appear to have very little to do with aesthetic laws. Still, they are always realized with craftsman-like passion. And they are filled with special emotion that colors the visual ideas that they express.

His best images express a unique single-mindedness, a drive to uncover something of the true reality of space and time, but which in the end confronts us with the limitations of our senses and particularly with the limitations of our eyes.

This unique interplay between insight and limitation, between possible and impossible worlds, has given Escher's body of work a wholly personal presence in the panorama of the visual arts. In a spectacular fashion this book justifies that once again.

J.L. Locher
Director, Gemeentemuseum, The Hague

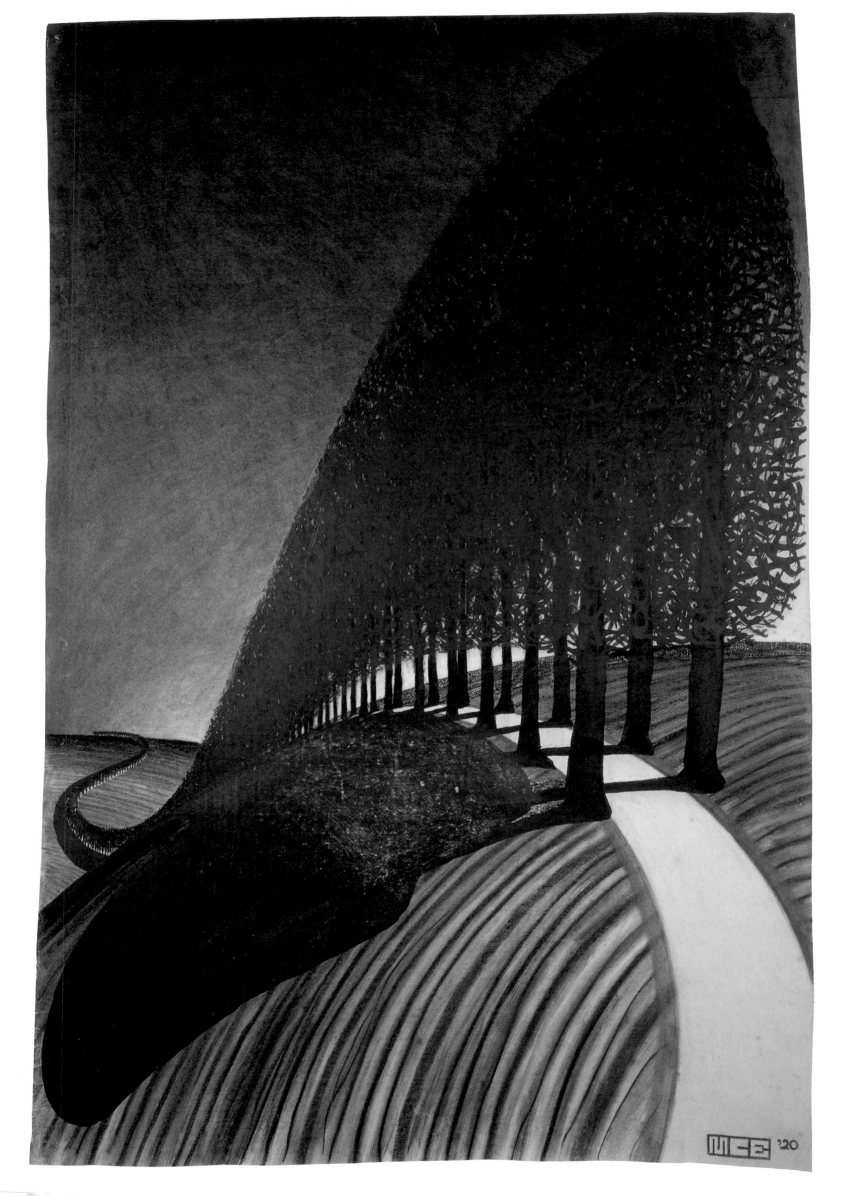

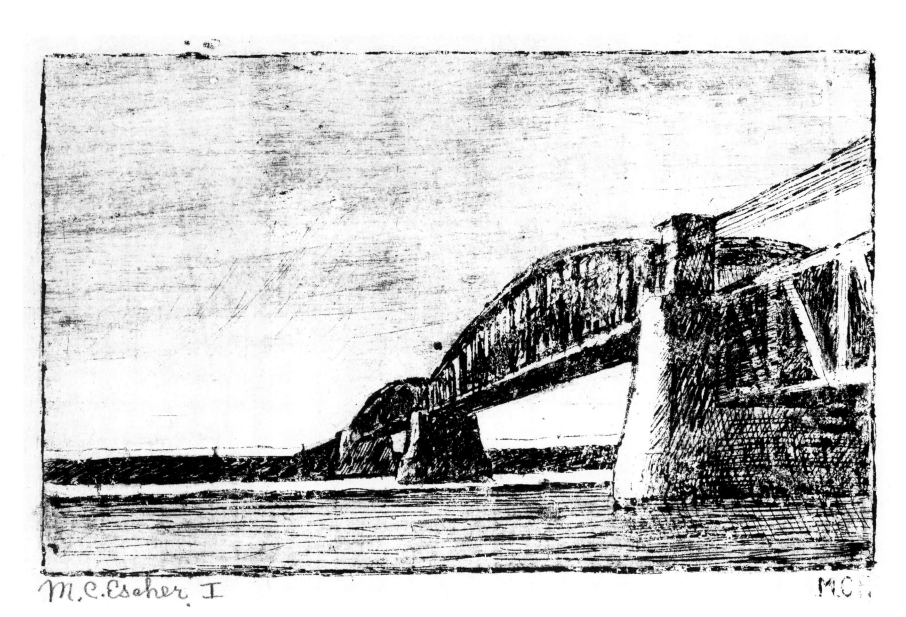

M.C.Escher, I M.C.E

I made a drawing of the tree, of which I spoke to you on Sunday;
it does please me somewhat but not enough. I am grateful, though,
to have obtained this result. Recently, it has been very difficult for me
to keep my mind, so easily distracted, on the "idea," but I do believe
I actually succeeded.

Fortunately, I strongly sense the "thought process" in the result;
the stately line of trees that comes sauntering across the hills from
a very great distance and, when the last hill has been climbed,
suddenly stands before us, huge and menacing.

Letter to Jan van der Does de Willebois, 11 February 1920

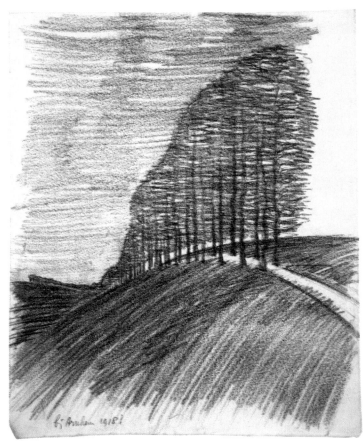

17 | 18
 19

17 **Trees**
 1920. Ink, 45 ½ x 29 ⅝" (1156 x 752 mm)
18 Railway Bridge across the Rhine at Oosterbeek
 1917. Etching, 3 ⅜ x 4 ⅞" (86 x 123 mm)
19 Study for **Trees**
 [Near Arnhem 1918?] Crayon, 11 ⅜ x 9 ⅜" (290 x 239 mm)

My intentions are, as you well know, more readily
arguable and, in many cases, more conscious, more
mathematical, more cerebral if you will than those of
most of my colleagues, whose more directly-aesthetic
and unconsciously-sensitive impulses can sometimes
be more easily felt than put into words.

Letter to B. Merema, 10 May 1952

20 **Eight Heads**
1922. Woodcut, 12 ¾ x 13 ⅜" (325 x 340 mm)

21 **Blocks of Basalt along the Sea**
1921. Woodcut, 5 ½ x 7 ⅛" (139 x 180 mm)

22 **Bookplate B.G. Escher**
1922. Woodcut, 2 x 2" (50 x 50 mm)

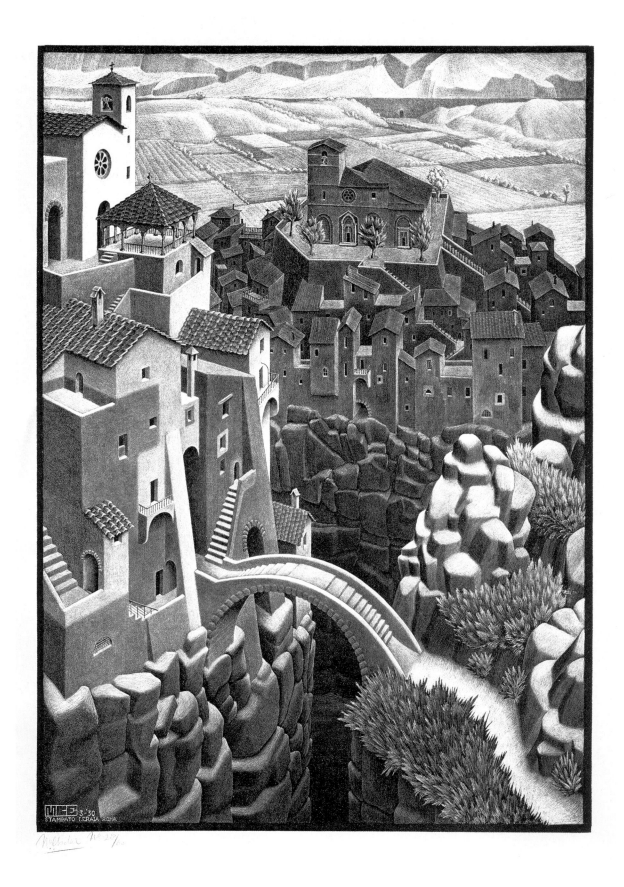

A person who is lucidly aware of the miracles that surround him, who has
learned to bear up under loneliness, has made quite a bit of progress on
the road to wisdom, or am I off target?
Letter to his son Arthur, 5 November 1955

23 | 24

23 **The Bridge**
 1930. Lithograph, 21⅛ x 14⅞" (536 x 377 mm)
24 Detail of **Castrovalva** (see 25)

24

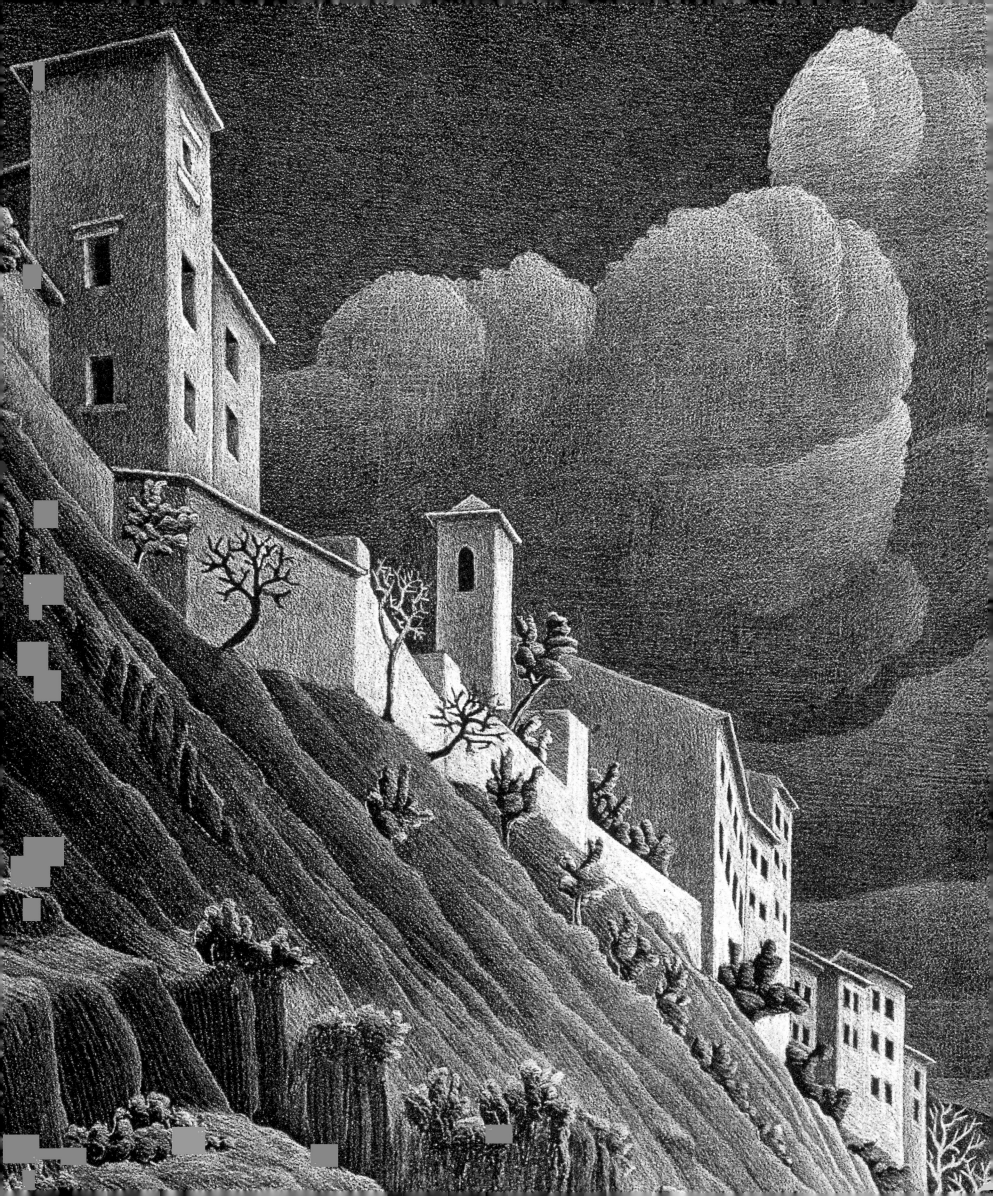

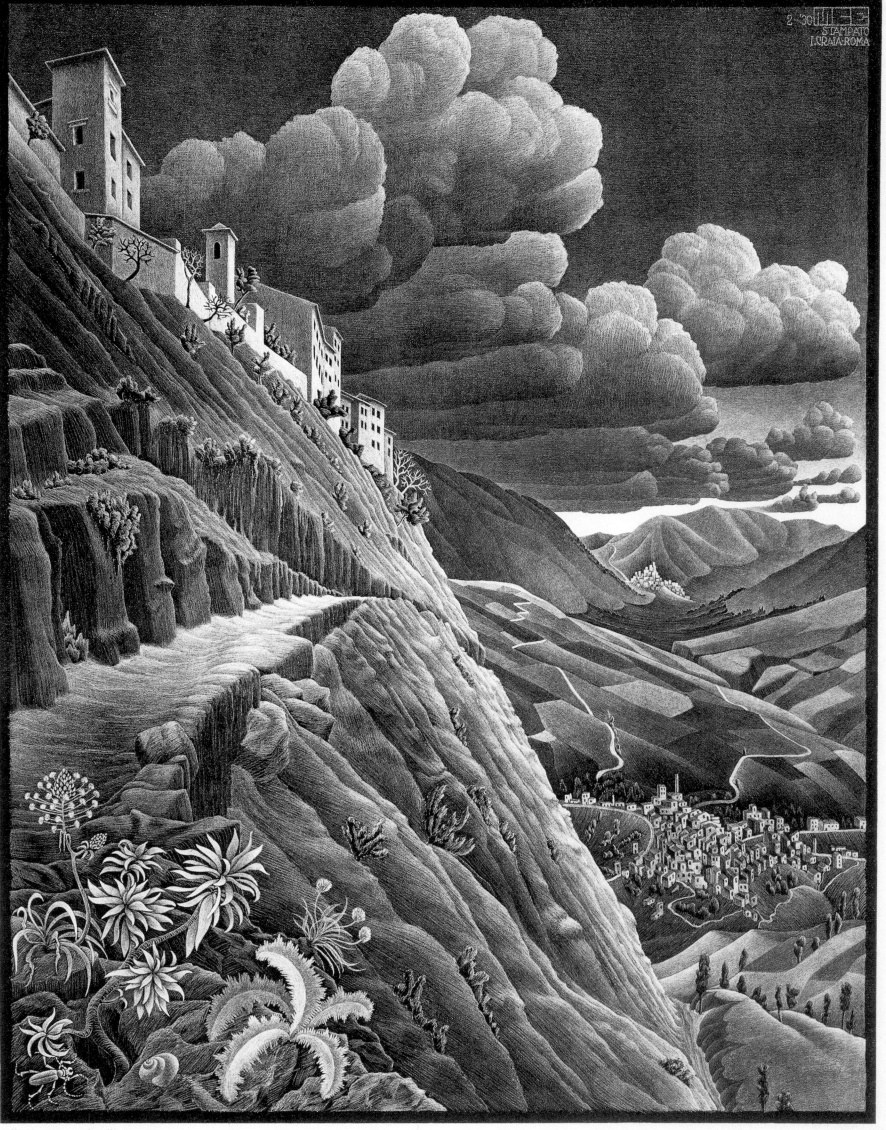

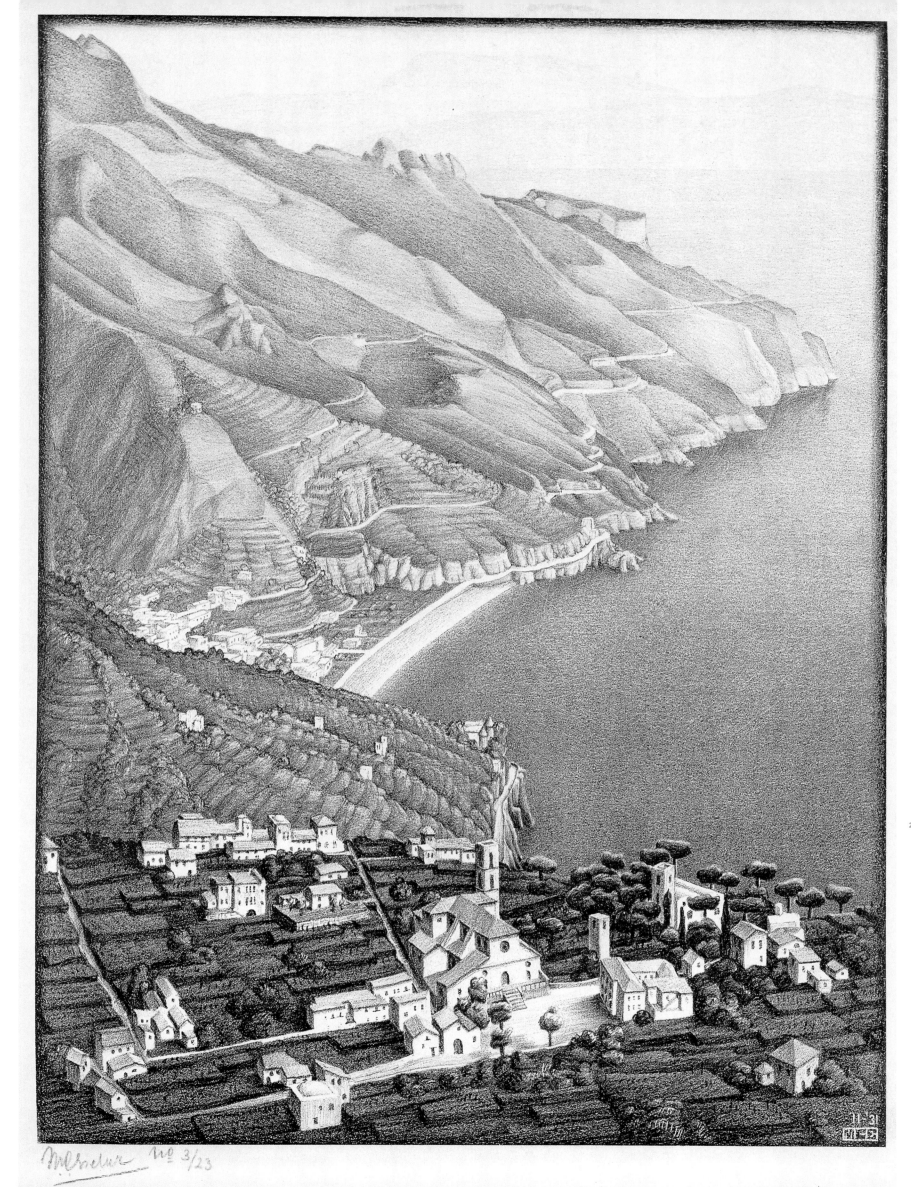

M.C.Escher No 3/23

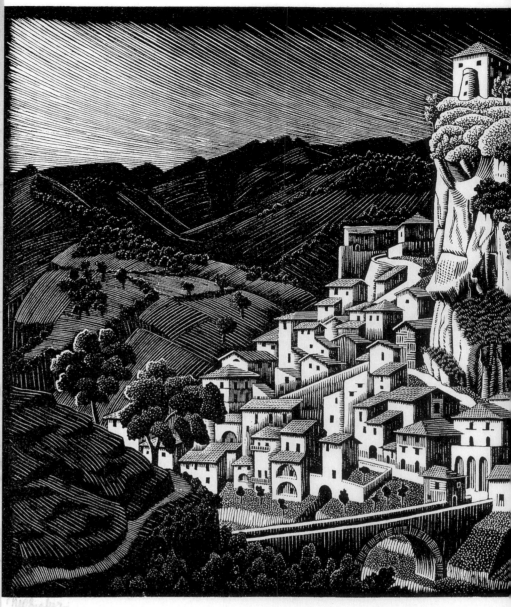

Every spring from 1923 until 1935, Escher took long trips through Southern Italy and made drawings of what fascinated him.
In the winter, he would develop the best drawings into prints. In developing what had struck him in landscape and architecture,
we also see him experimenting avidly with graphic techniques, especially with the possibilities of woodcut and lithography.
 J.L.L.

28

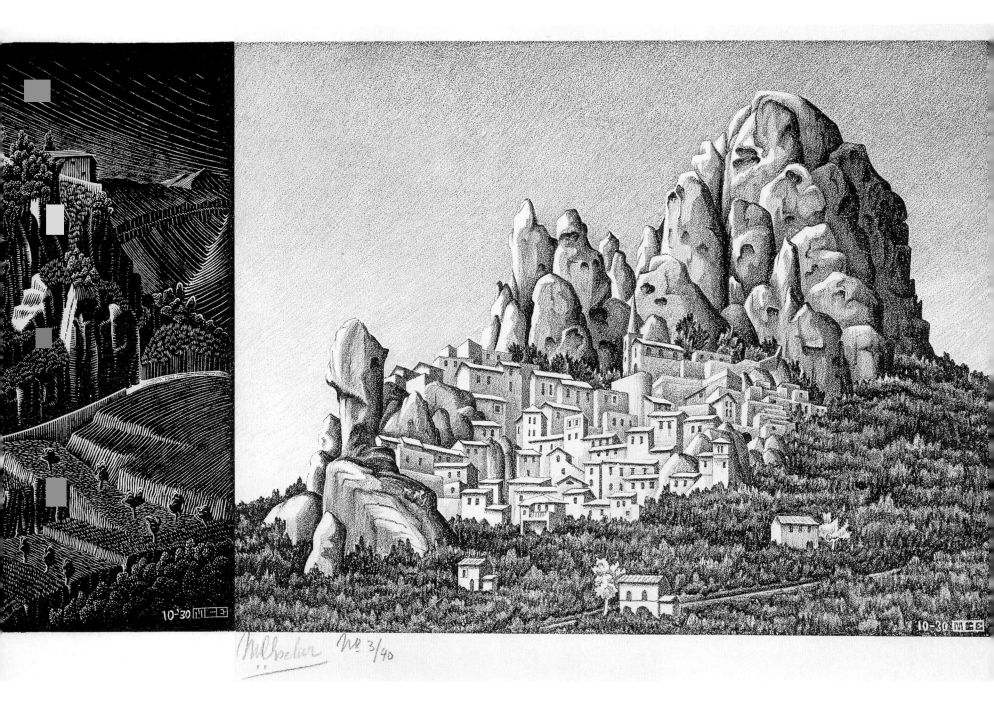

Is it possible that a mortal, no I mean: a human being, can reach such almost endless and timelessly great thoughts? I can't quite imagine that. All right: but how in the name of God is he capable of giving form to them, to express them so that another person can sense them. I can't imagine something like that at all anymore.

Letter to Jan van der Does de Willebois, 20 March 1920

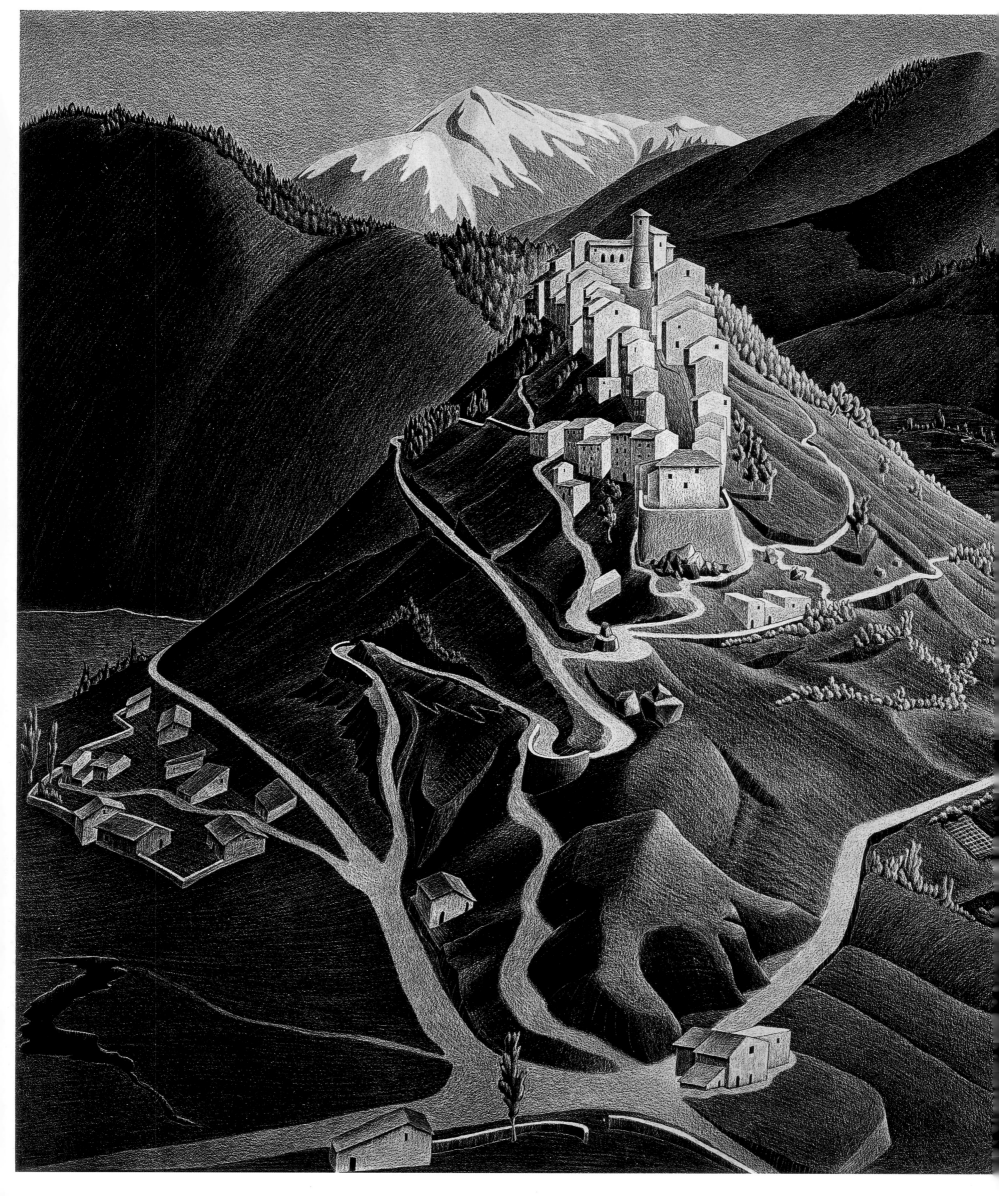

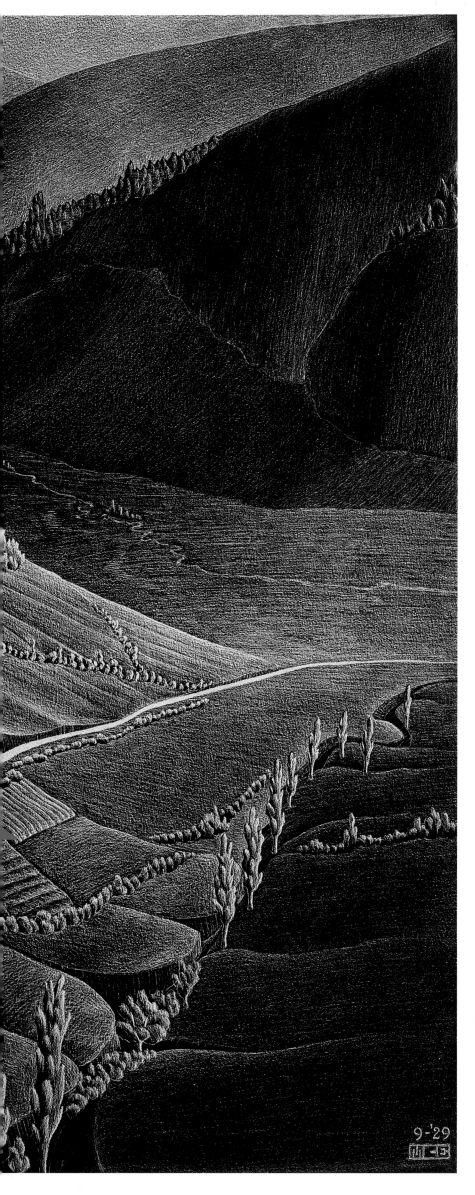

My meandering ways lead me across the crests of the hills. I can see far across the Tuscan landscape, far, as far as the waving horizon of the Apenines.

Letter to Jan van der Does de Willebois, 25 December 1922

30 **Landscape at Abruzzi**
 1929. Scratch drawing, blue ink and white chalk,
 19 ¼ x 24 ⅜" (487 x 620 mm)

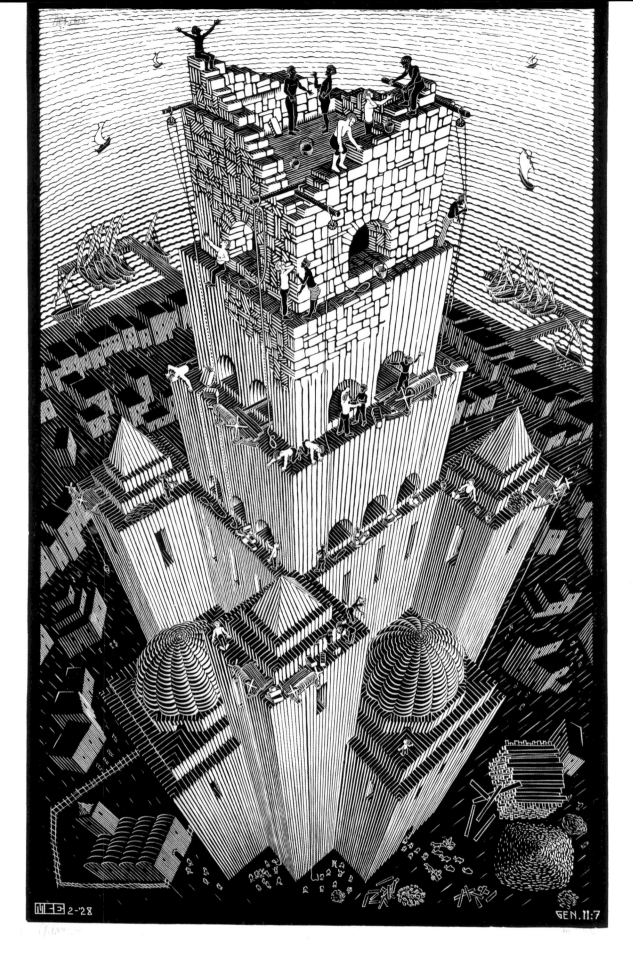

I was thirty years old then and now find it to be a typical example of youthful clumsiness and a lack of understanding of perspective. That picture never did meet with much approval, until recently, that is to say forty years later, when it was recreated on a brightly colored poster. Riddle me this and why do such things happen?

Lecture on **Tower of Babel**, *15 January 1970*

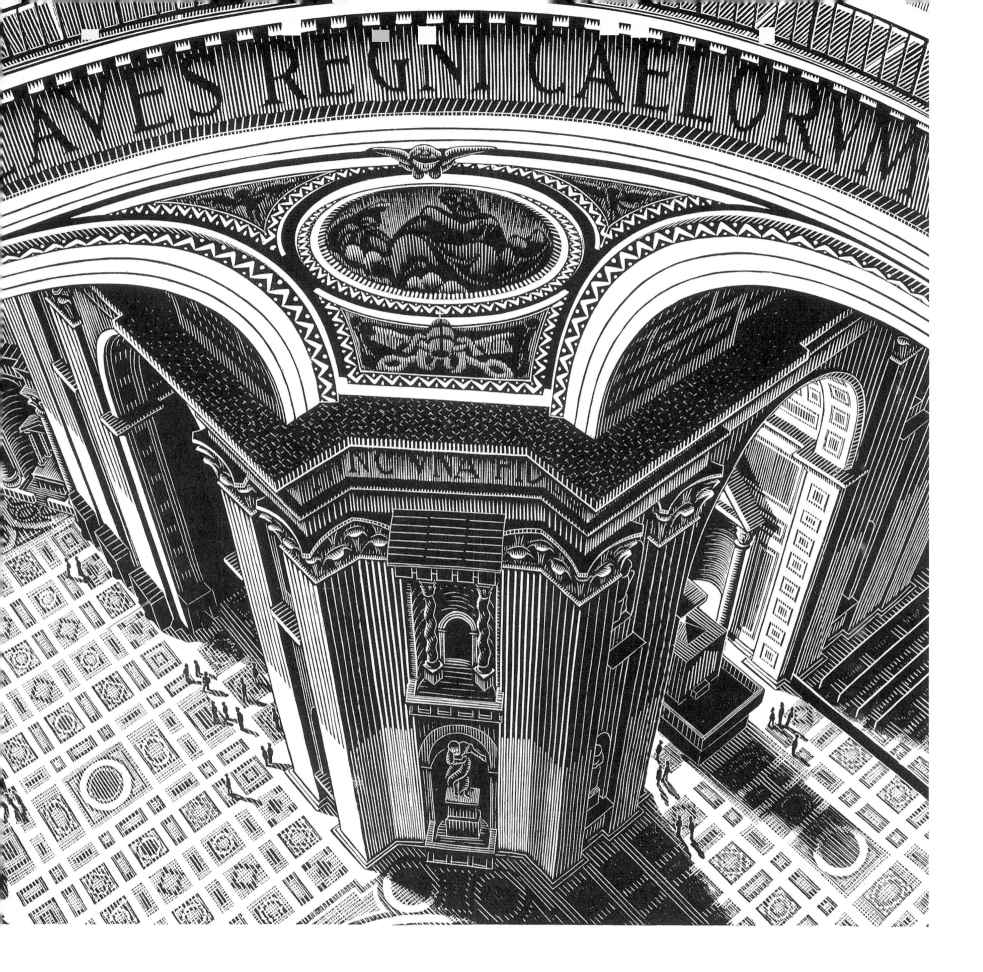

When I was living in Rome for twelve years I hardly ever looked at it. I only did the precipice in Saint Peter's because of the precipice, not because of the architectural style.... When I made that picture I didn't know that where verticals converge you're looking into the nadir.

Letter to Gerd Arnzt, 25 September 1967

31 **Tower of Babel**
1928. Woodcut, 24½ x 15¼" (621 x 386 mm)

32 **Inside St. Peter's**
1935. Wood engraving, 9 ⅜ x 12 ½" (237 x 316 mm)

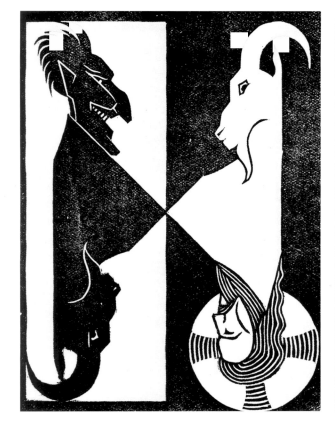
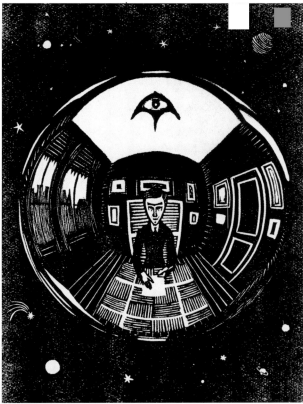

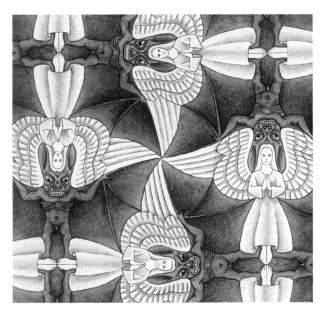
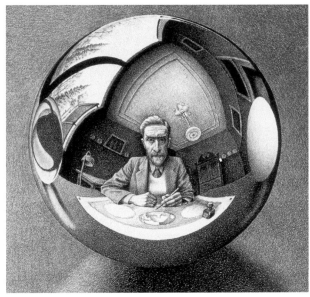

If someone has expressed himself in graphics from his youth; if he has created visual images for many years, always using such graphic means as woodblocks, copper plates and lithographic stones, as well as press, ink and all sorts of paper for printing on, this technique finally becomes second nature to him. Obviously, the technique itself must have been the most important thing for him, at least at the beginning of his career as a graphic artist, or he would not have taken that direction. In addition, he must continue to use the specific medium he has chosen with unflagging enthusiasm throughout the years, and he will undoubtedly strive all his life for a technical expertise that he will never completely acquire.

Meanwhile, all this technique is merely a means, not an end in itself. The end he strives for is something other than a perfectly executed print. His aim is to depict dreams, ideas or problems in such a way that other people can observe and consider them. The illusion that an artist wishes to create is much more subjective and far more important than the objective, physical means with which he tries to create it.

Lecture, Stedelijk Museum, 16 November 1953

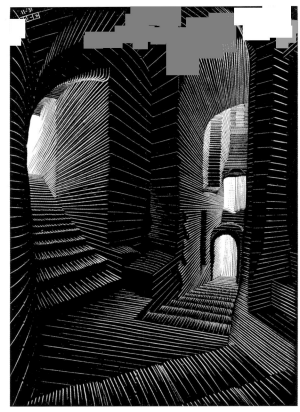

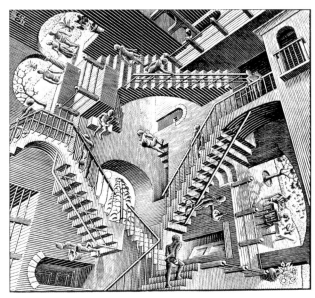

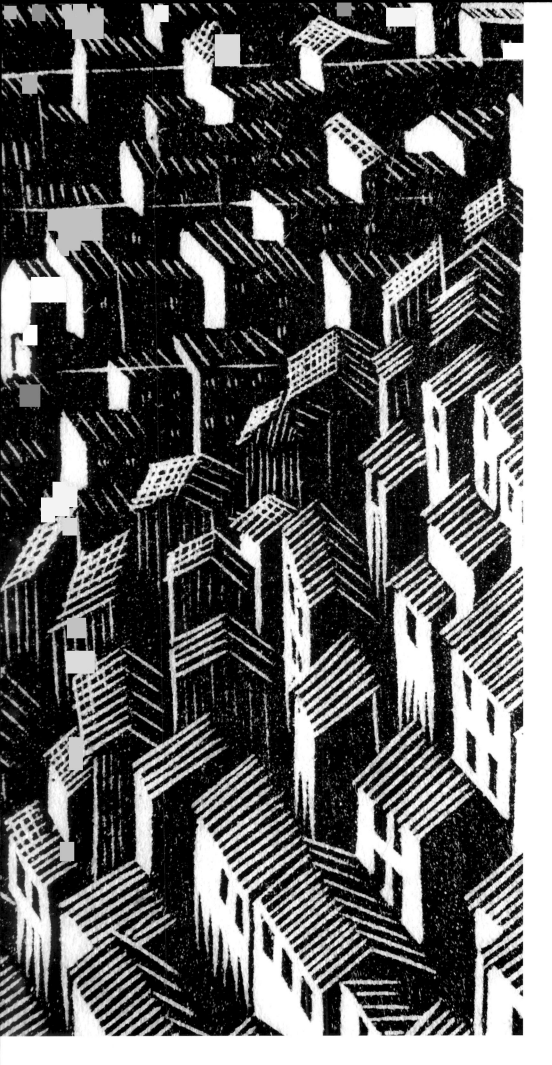

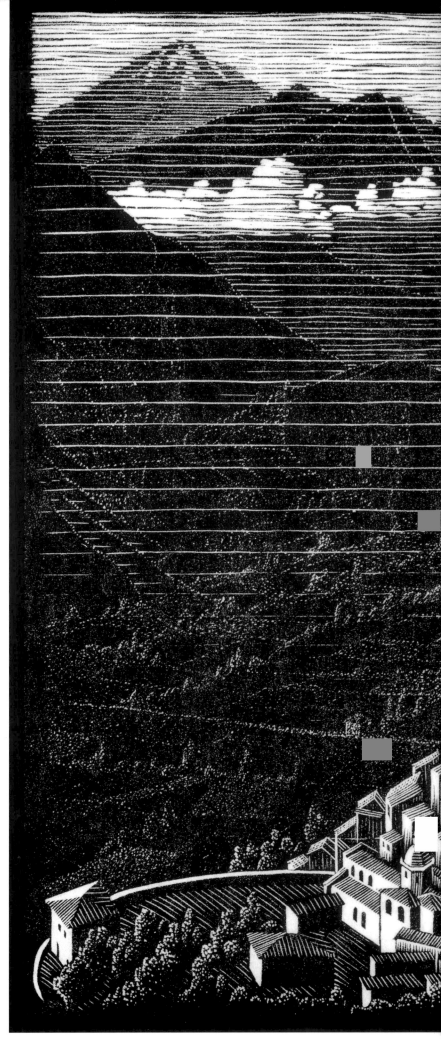

Height, depth and distance, the almost mathematical arrangement of the town's houses in the foreground, and the light filtered through the clouds, are expressed with lines and dots. The manner in which the long, horizontal, white lines go up and change over into black lines against the sky is very subtle.

36 *J.L.L.*

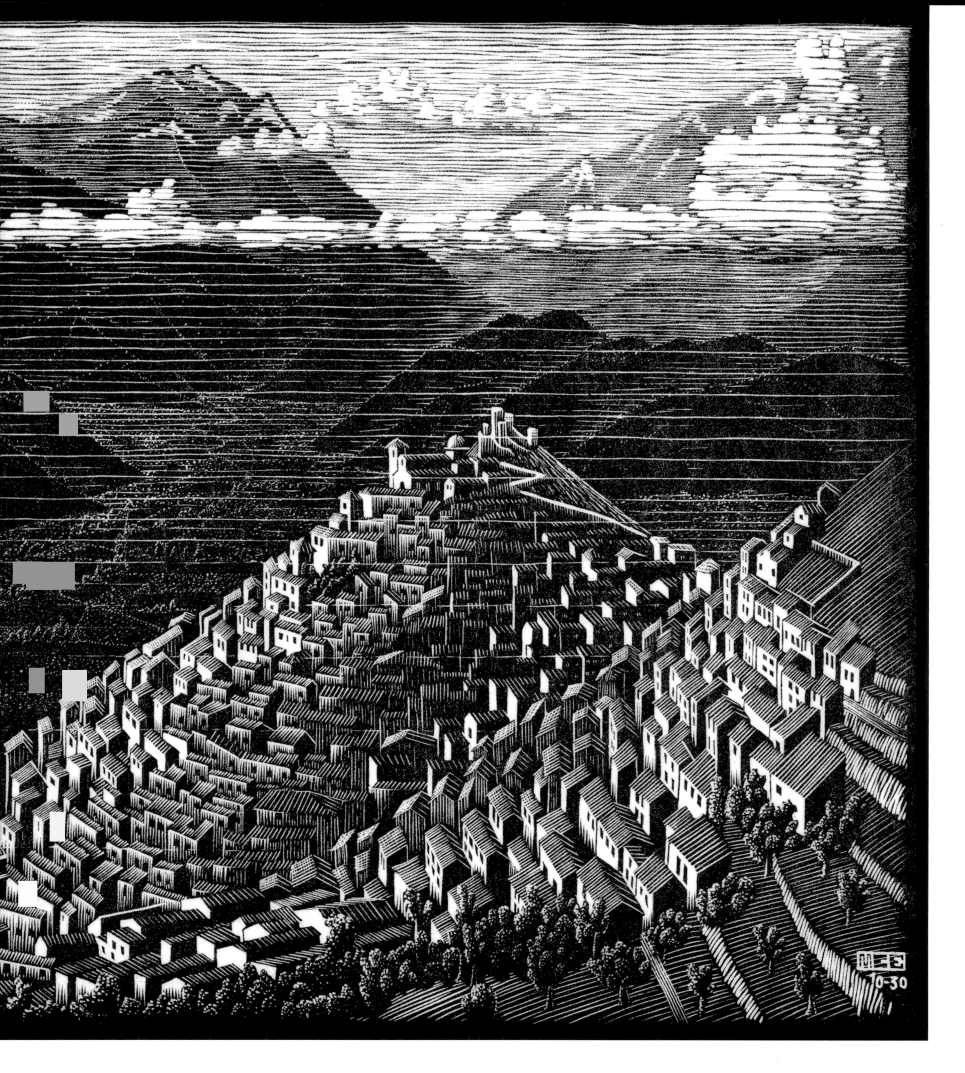

I believe that producing pictures, as I do, is almost solely
a question of wanting so very very much to do it well.
Letter to his son Arthur, 12 February 1955

45 | 46

45 Detail of **Morano, Calabria**

46 **Morano, Calabria**
1930. Woodcut, 9 ½ x 12 ⅝" (240 x 321 mm)

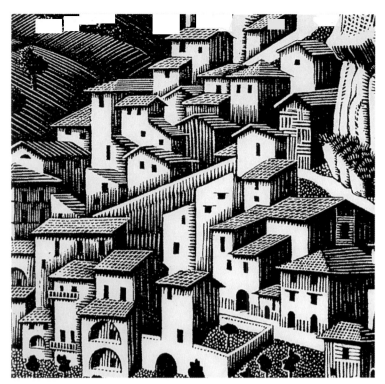

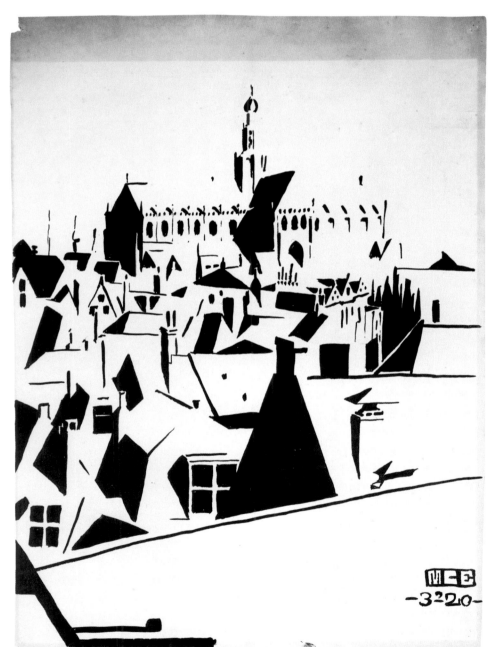

Especially when looking close-up we come into direct contact with Escher's graphic inventions: the planes, lines and lattices of the woodcuts and the grainy tones of the lithographs.
 J.L.L.

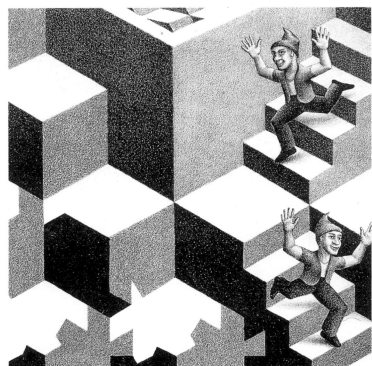

But serving up an action, suggesting the dynamic in the static,
has become a hobby of mine, which I cannot keep my hands off
(just as I can't keep them off suggesting the spatial in the flat).
I am telling a story, for example, even if it is never literary, as far
as I know. The "flowing" on that motionless plane holds my
attention to such a degree that my preference is to try and make
it into a cycle.

Letter to his nephew Rudolf Escher, 22 February 1957

47 48 49 | 51 52
50

47 Detail of **Palizzi, Calabria** (see 28)
48 Detail of **Morano, Calabria** (see 46)
49 Detail of City
50 City
 1920. Ink, 24 ⅜ x 18 ¼" (620 x 465 mm)
51 Detail of **Development I** (see 87)
52 Detail of **Cycle** (see 69)

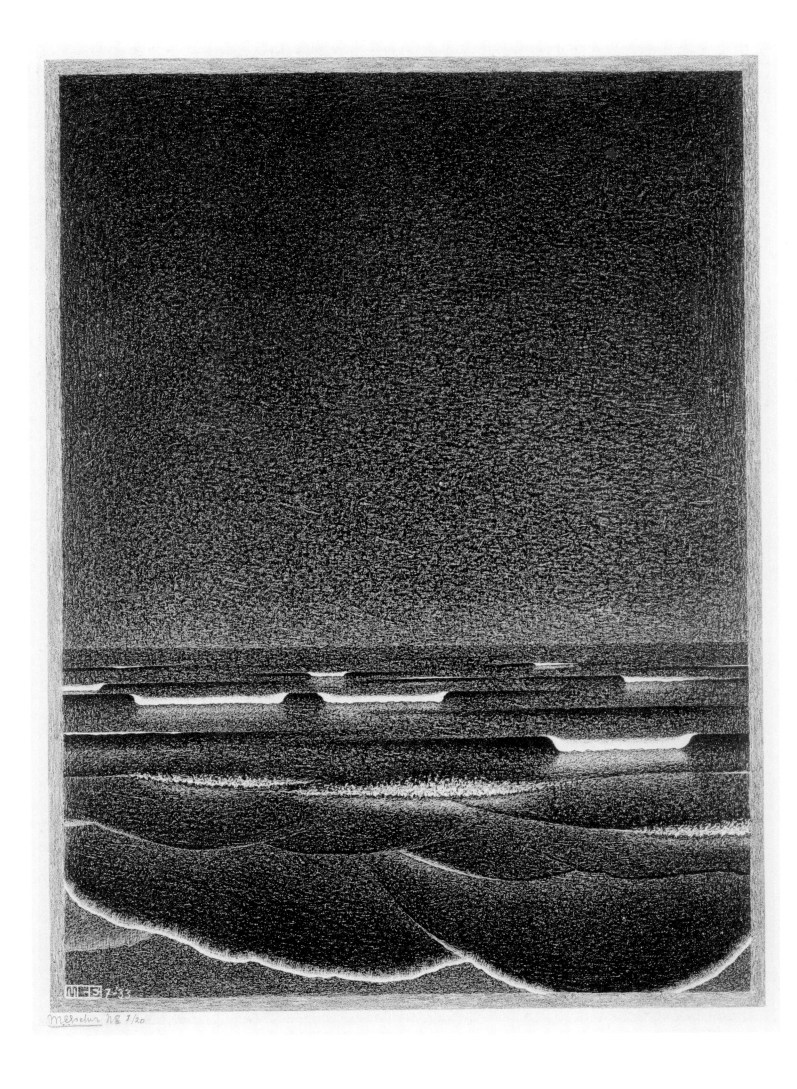

Phosphorescent Sea 7/20

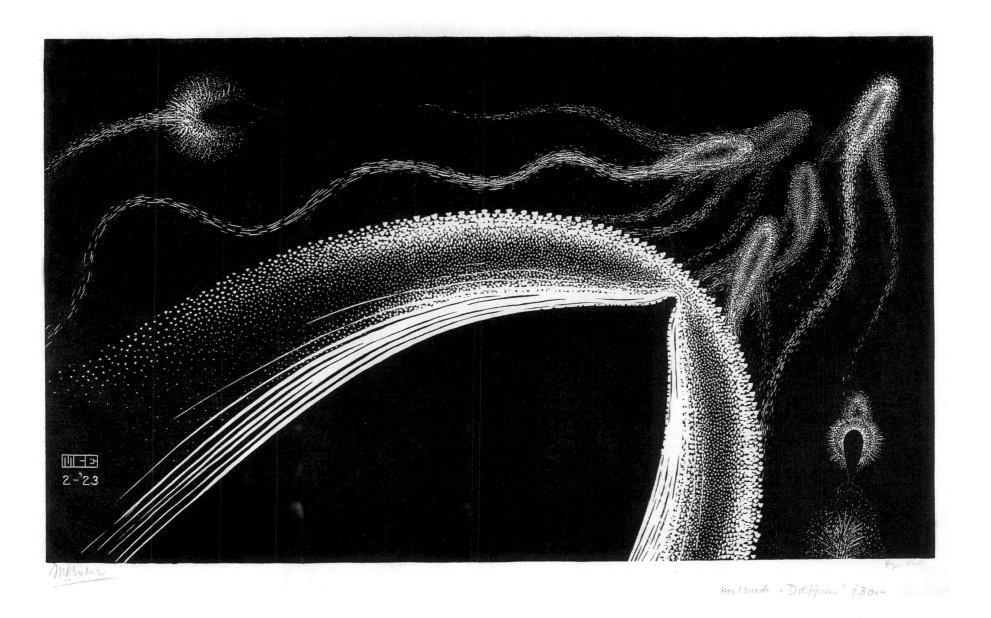

Escher always had a keen interest in unusual natural phenomena, such as the phosphorescence of the sea in the breakers beneath a starry sky or the traces that a ship's bow and a group of dolphins create in the water. For one print he chose the balanced black and white of lithography, for another the stronger opposition between black and white of the woodcut.
 J.L.L.

Those waves! Soon I'm going to try once more to draw something wavelike. But how can you suggest movement on a static plane? And how can you simplify something as complicated as a wave in the open sea to something comprehensible?
 Letter to his son George and daughter-in-law Corrie, 22 August 1959

53 | 54

53 **Phosphorescent Sea**
 1933. Lithograph, 12 7/8 x 9 5/8" (327 x 245 mm)
54 **Dolphins (Dolphins in Phosphorescent Sea)**
 1923. Woodcut, 11 1/2 x 19 3/8" (291 x 492 mm)

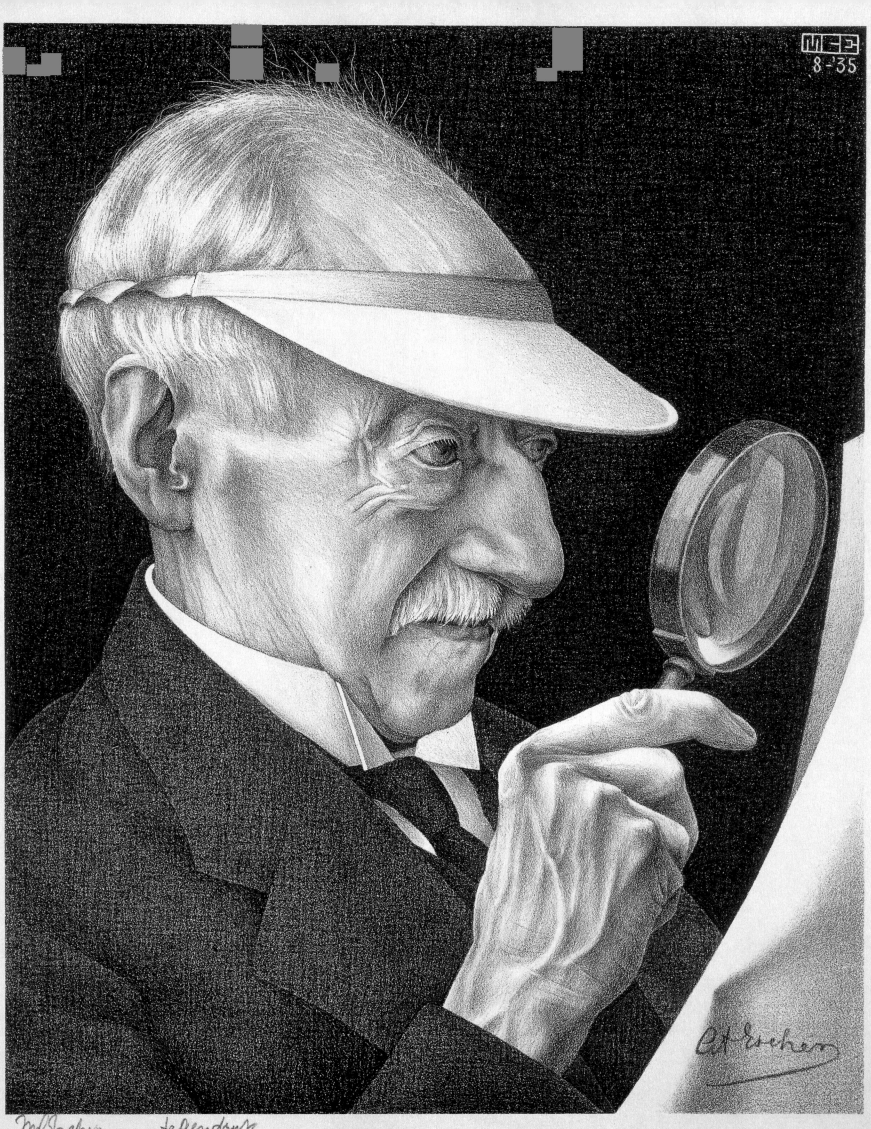

MCE
8-'35

When making an engraved portrait of someone with strongly
asymmetrical features, to a great extent the likeness gets lost in
the print, which is, after all, the mirror image of the original piece.
That is why in this case a "counter-print" was made, that is to say:
while the ink on the paper of the first print was still wet, it was
printed onto a second sheet of paper, with the result that the mirror
image was negated. The "proof" is in the signature of the person
portrayed, which was placed on the stone with lithographer's chalk
and which is visible here, mirror-imaged twice, the same as the
original.

*On Portrait of G.A. Escher, in The Graphic Work of M.C. Escher,
1957. Escher had his father write his signature on the lithographic stone*

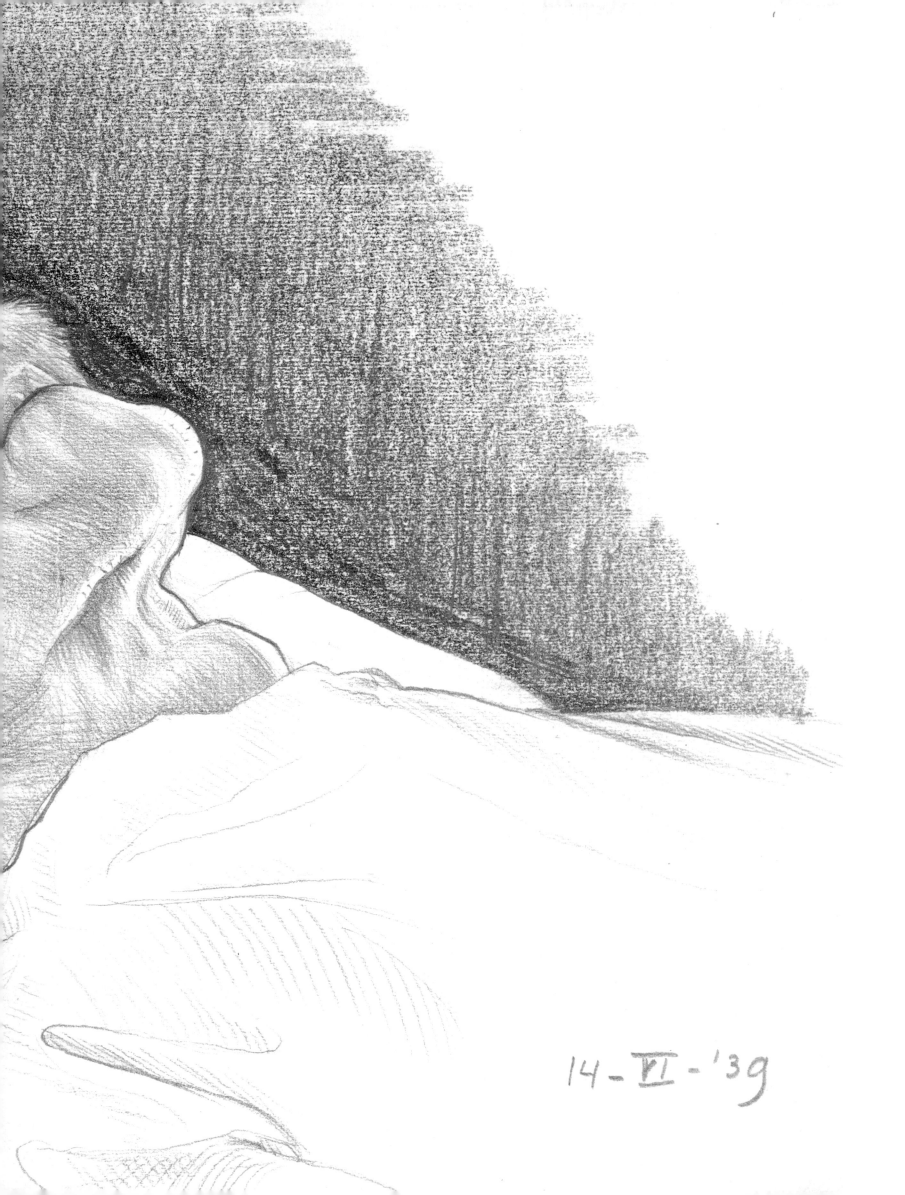

14-VI-'39

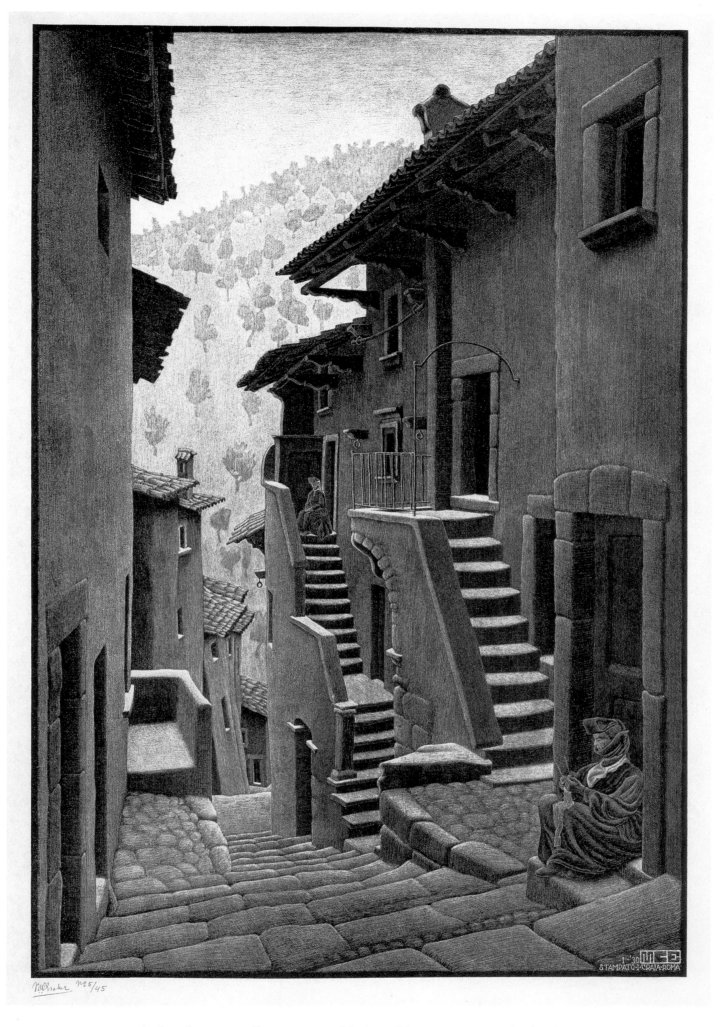

Which reality is actually more powerful: that of the present, instantly absorbed
by our senses and discernible, or the memory of what we experienced previously?
Is the present truly more real than the past? I really do not feel capable of
answering this.

Journal, 19 January 1945

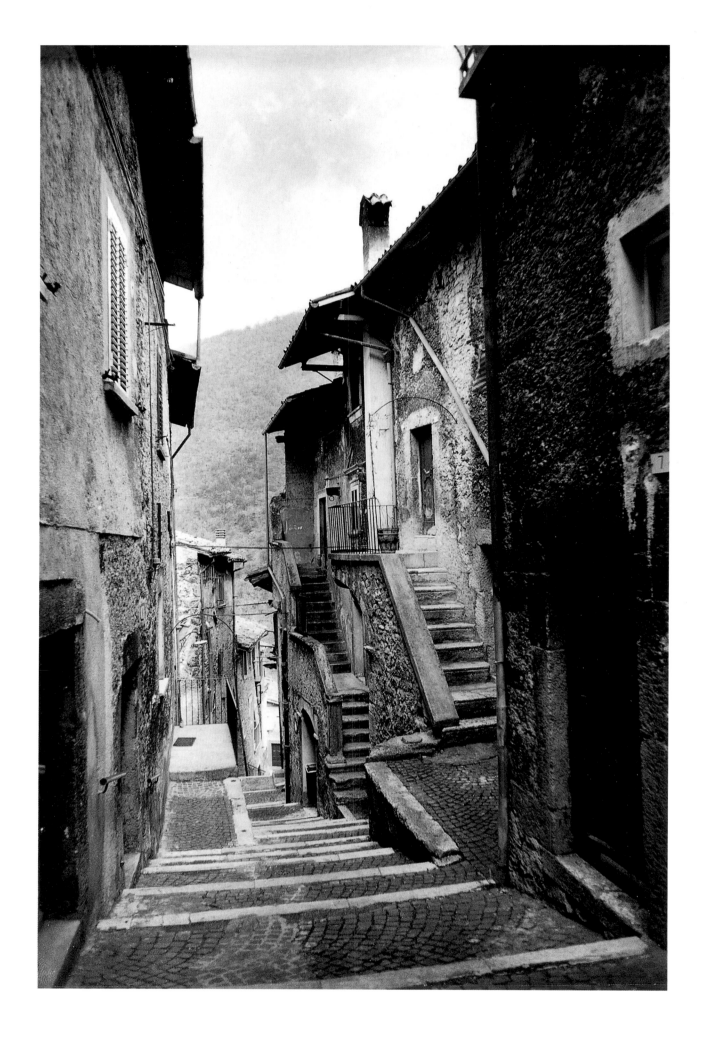

60 | 61 60 **Street in Scanno, Abruzzi**
1930. Lithograph, 24 ⅝ x 17" (627 x 431 mm)
61 Photo of street in Scanno, Abruzzi (Mark Veldhuysen)

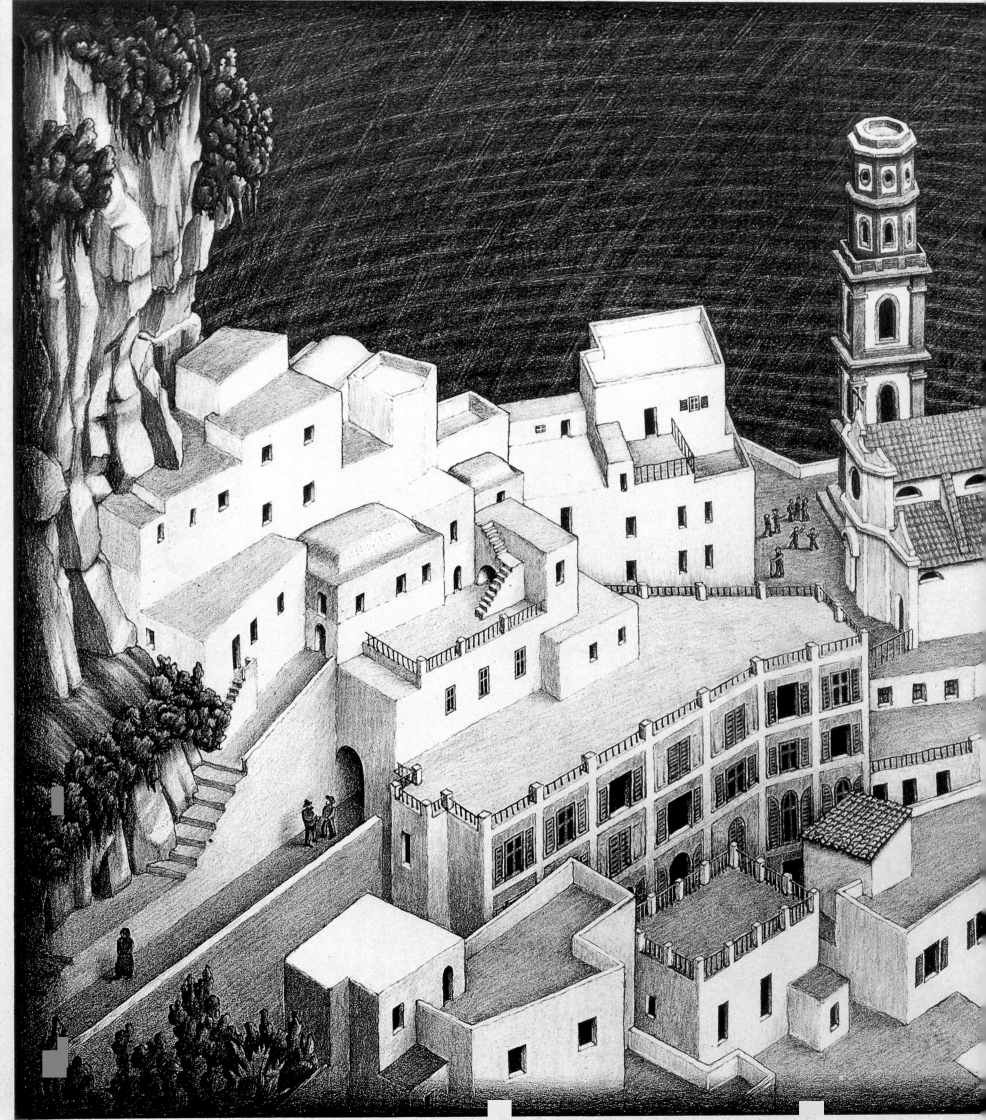

MCEscher Nº 10/30

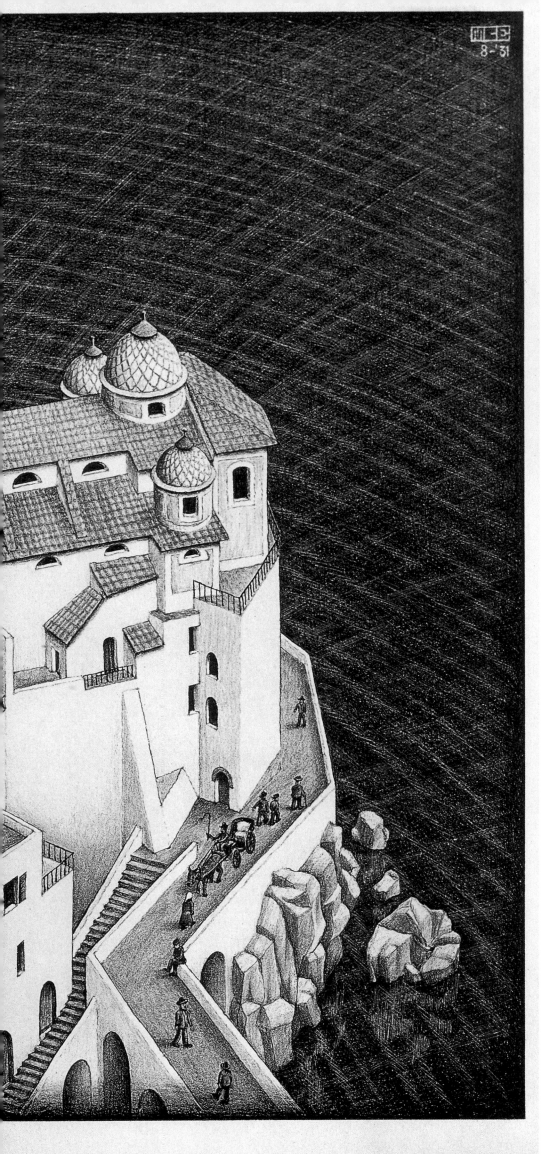

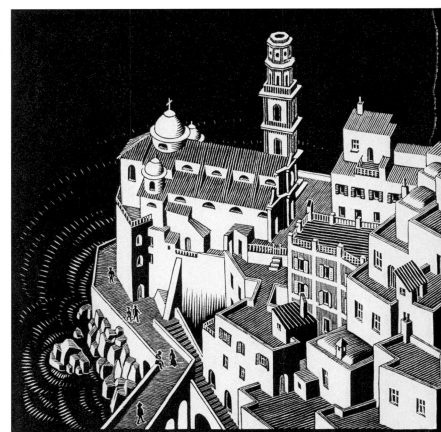

I could fill an entire second life
with working on my prints.
Lecture, Rosa Spierhuis, 1970

62 | 63A

62 **Atrani, Coast of Amalfi**
1931. Lithograph, 10 7/8 x 14 7/8" (275 x 379 mm)
63A Detail of **Metamorphosis I**
1937. Woodcut, 7 5/8 x 35 3/4" (195 x 908 mm)

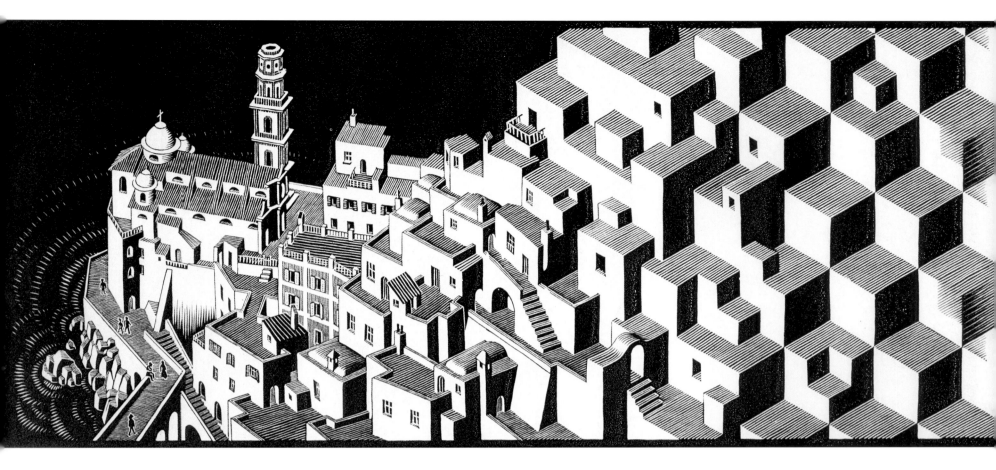

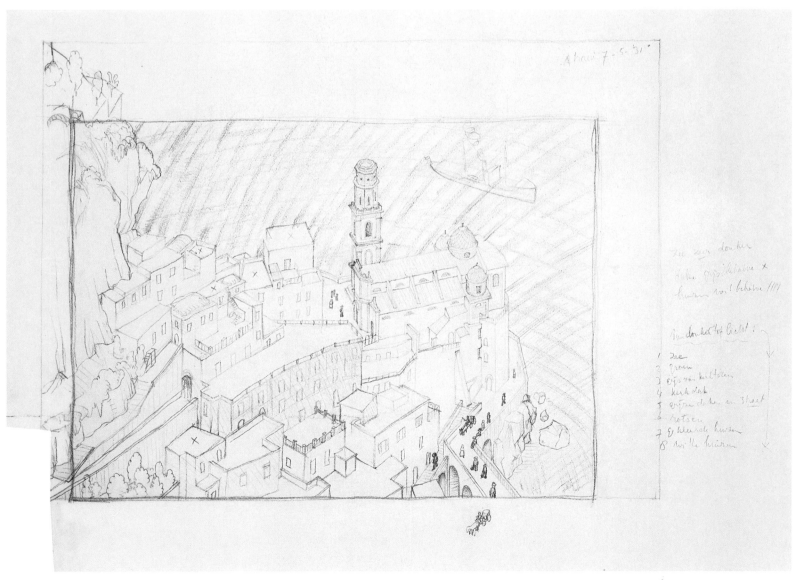

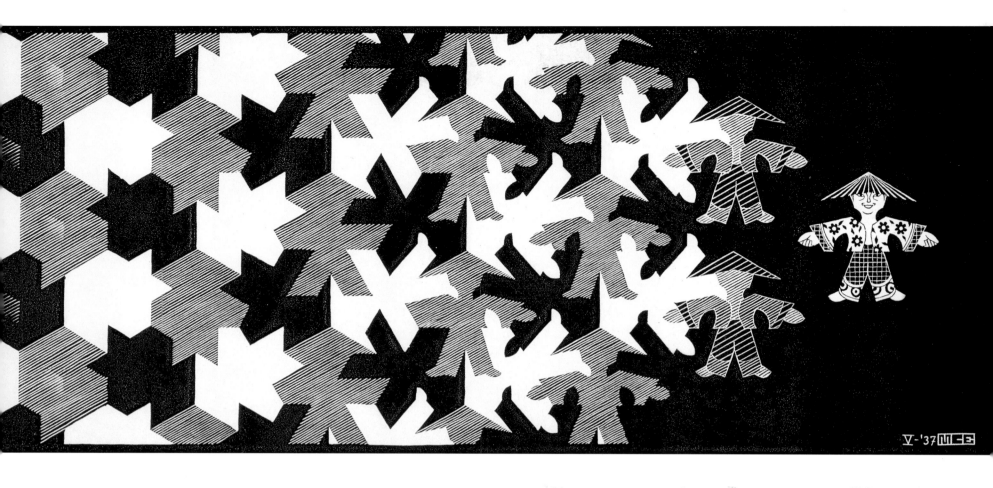

Perhaps all I pursue is astonishment and so I try to awaken only astonishment in my viewers. Sometimes "beauty" is a nasty business.
Letter to Brother Erich (Bruno Ernst), 12 October 1956

63 3
64 65

63 B **Metamorphosis I**
1937. Woodcut, 7 5/8 x 35 3/4" (195 x 908 mm)

64 Study for **Atrani, Coast of Amalfi**
1931. Pencil, 19 x 26" (482 x 660 mm)

65 Study of Atrani, in bathtub
Pencil, 8 1/8 x 6 1/2" (207 x 165 mm)

*Beginning and end of the first metamorphosis are still distant from each other. In **Metamorphosis II**, Escher not only expanded the development of the patterns that intertwine but he transformed the whole to an orbit (see pages 1-3). Orbits are constantly encountered in Escher's most famous pictures (see pages 55, 80, 85-86, 114, 116, 132, 146, 160, 162, 175, 171-172, and 186).*

J.L.L.

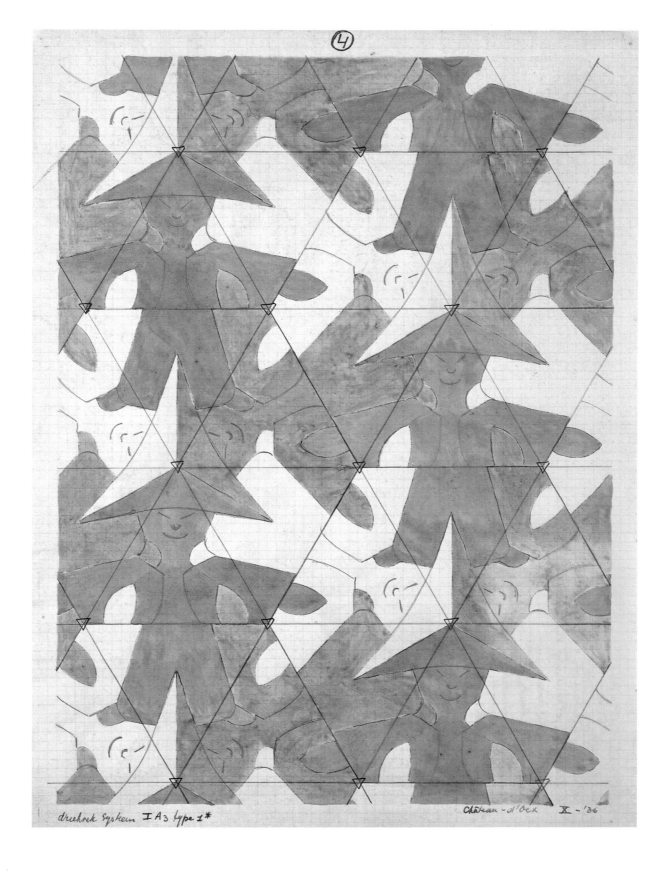

Your little daughter is not the first child to be amused
by my pictures. Their interest is a matter of pride to me.
 Letter to Mrs. L.H. Tate, 26 September 1964

66 **Regular Division of the Plane Drawing #4**
 1936. Ink, pencil and watercolor, 13 x 9 ⅝" (331 x 243 mm)
67 **Regular Division of the Plane Drawing #21**
 1938. Ink, pencil and watercolor, 13 x 9 ½" (332 x 242 mm)

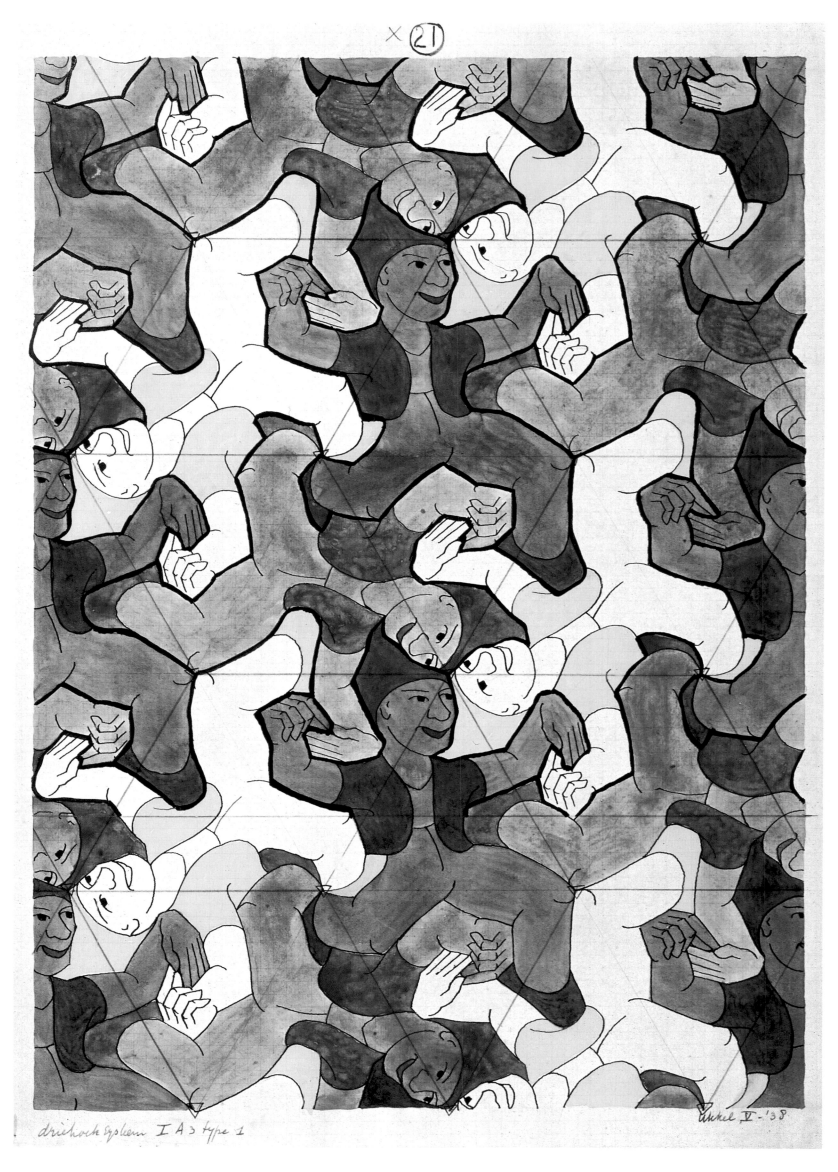

driehoek systeem I A 3 type 1

Vinkel V - '38

Where architecture is concerned, I have been heavily influenced in my pictures by southern Italian structures, in which one can often recognize Norman, Romanesque, Saracen and Moorish influences. I am, among other things, crazy about domes like bread rolls and flat, white-washed rooftops and stucco walls [see pages 55, 114, 132, 142, 146]. I saw almost all of these elements on the Amalfi coast (Positano, Amalfi, Atrani, Maiori, Minori, Ravello). What speaks in my pictures is a form of nostalgia for the sunny south.

Journal, Amalfi coast, 1969

68 | 69

68 **(Old) Houses in Positano**
 1934. Lithograph, 9 5/8 x 11 1/4" (245 x 286 mm)
69 **Cycle**
 1938. Lithograph, 18 3/4 x 11" (475 x 279 mm)

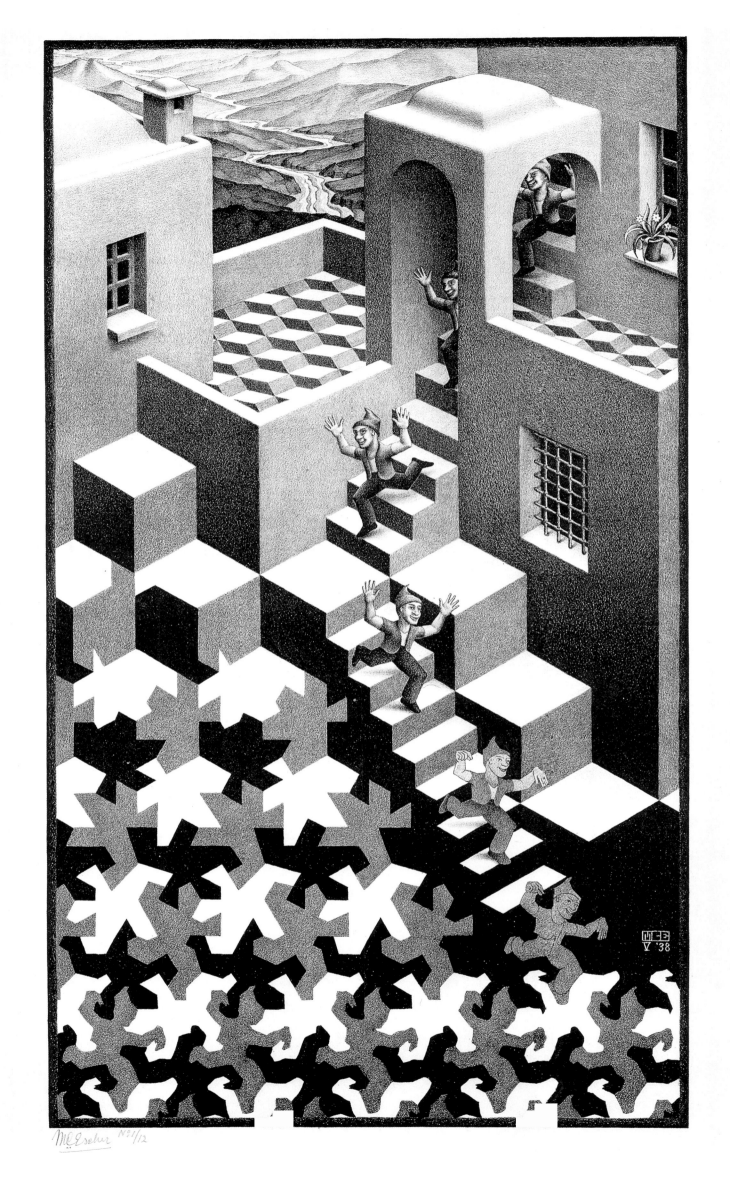

55

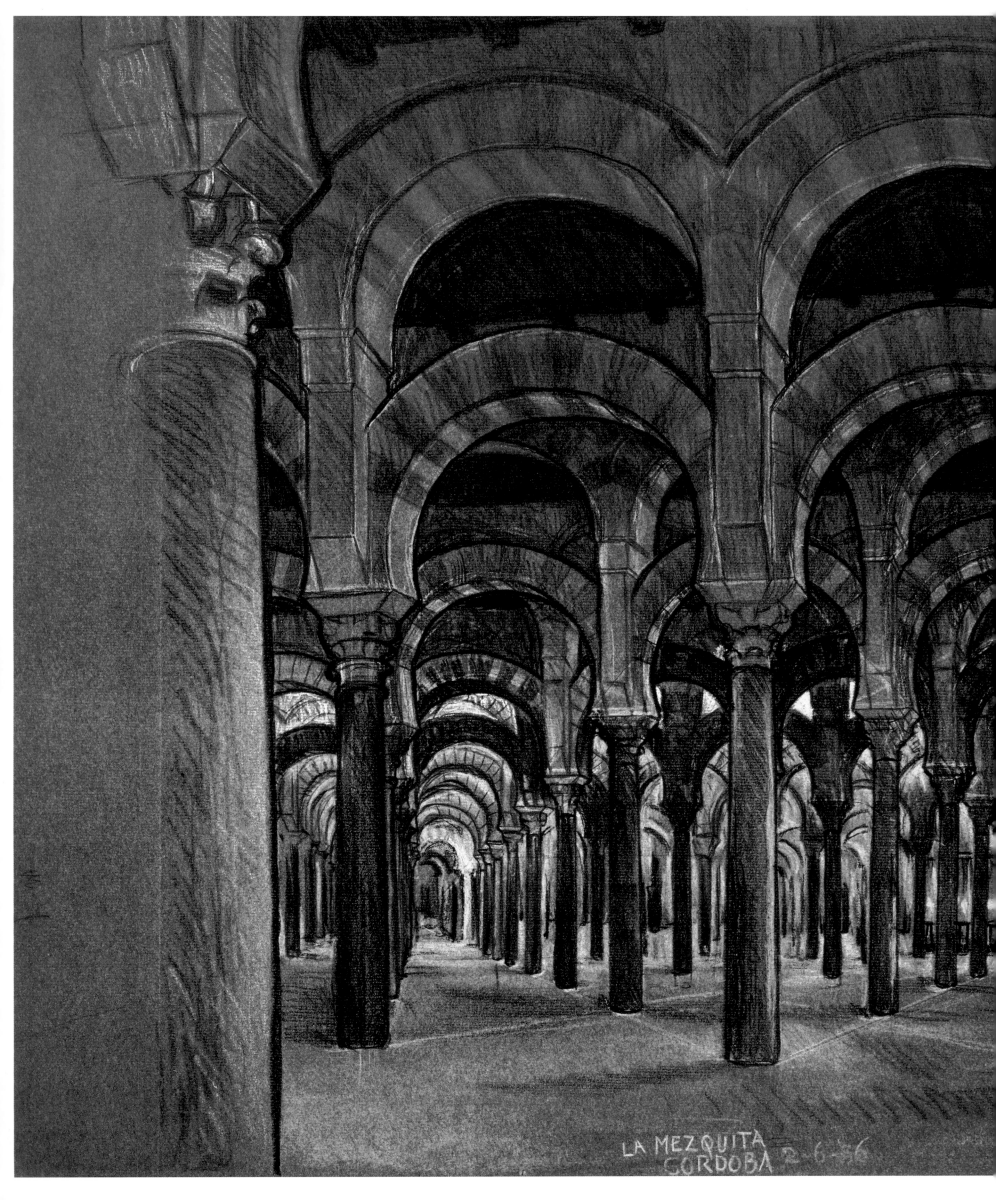

LA MEZQUITA
CORDOBA 2-6-96

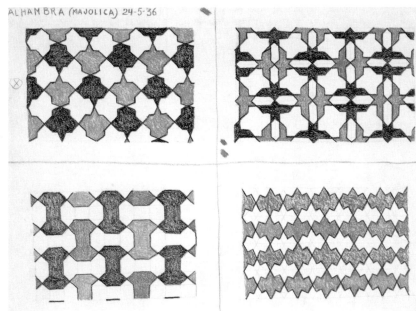

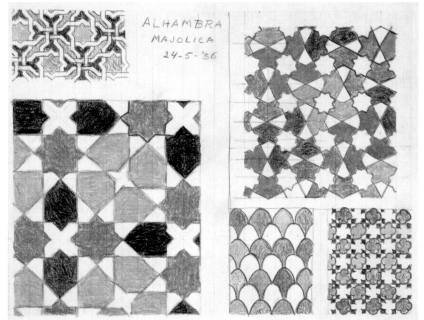

To have peace with this peculiar life; to accept what we do not understand; to wait calmly for what awaits us, you have to be wiser than I am.

Letter to his son George and daughter-in-law Corrie, 6 April 1960

70 | 71
 72

70 **La Mezquita, Córdoba**
 1936. Black and white crayons, 18 7/8 x 24 5/8" (480 x 625 mm)
71 **Alhambra Majolica**
 1936. Crayon and chalk, 9 3/8 x 12 1/2" (239 x 318 mm)
72 **Alhambra Majolica**
 1936. Crayon and chalk, 8 5/8 x 11 1/8" (220 x 282 mm)

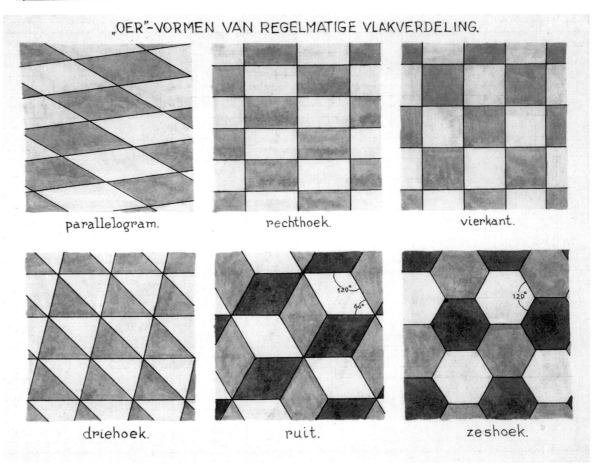

"OER"-VORMEN VAN REGELMATIGE VLAKVERDELING.

parallelogram.

rechthoek.

vierkant.

driehoek.

ruit.

zeshoek.

But occasionally people change and use somewhat more imagination, as proven by the previously mentioned Moorish tile patterns, which sometimes show broken boundary lines, too, and reflex angles. It is understandable that these shapes, rhythmically repeated, can be made more complicated if one wishes and that one can reach the point where the suggestion of something recognizable is evoked, a silhouette of a certain animal, for example.

This search for new possibilities, this discovery of new jigsaw puzzle pieces, which in the first place surprises and astonishes the designer himself, is a game that through the years has always fascinated and enthralled me anew.

Lecture on regular division of planes on audio-cassette, Stedelijk Museum, 15 February 1956

REGELMATIGE VLAKVERDELING.

vijf voorbeelden van vierkant-systemen.

de drie hoofdkenmerken zijn:
1. verschuiving.
2. assen. (o en □)
3. glijspiegeling.

alléén verschuiving.

alléén assen.

verschuiving en assen.

verschuiving en glijspiegeling.

verschuiving, assen en glijspiegeling

God, god, I wish I'd learn to draw a little better! What exertion and determination it takes to try and do it well. Now and then I am close to delirium tremens from pure nerves. It is really just a question of carrying on doggedly, with continuous and, if possible, pitiless self-criticism.

Letter to his son Arthur, 12 February 1955

81 | 82

81 **Regular Division of the Plane Drawing #70**
 1948. Ink and watercolor, 11 x 11" (280 x 280 mm)

82 Study for **Regular Division of the Plane Drawing #70**
 Pencil, 14 ⅜ x 9 ¼" (365 x 235 mm)

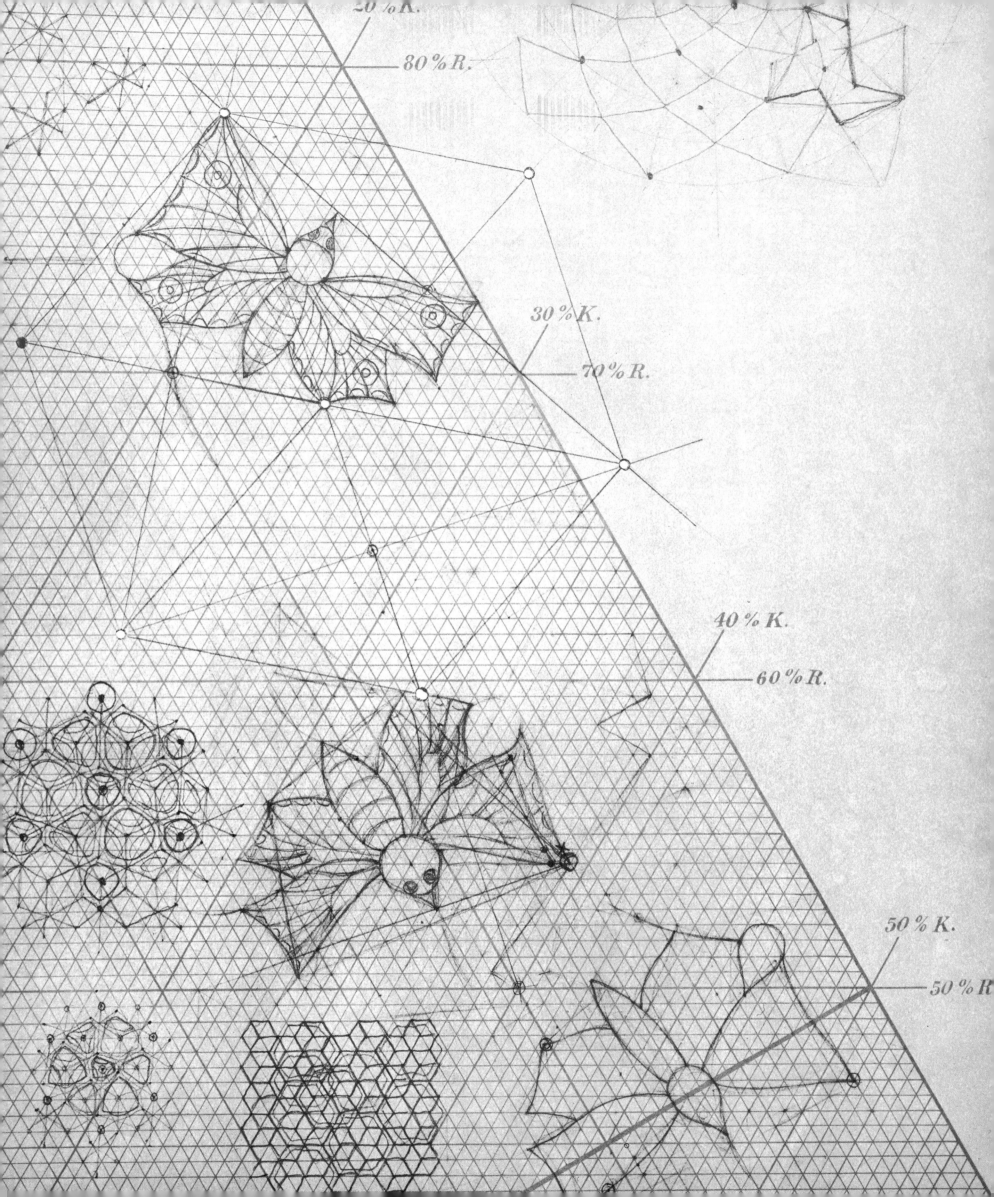

20 % K.

80 % R.

30 % K.

70 % R.

40 % K.

60 % R.

50 % K.

50 % R

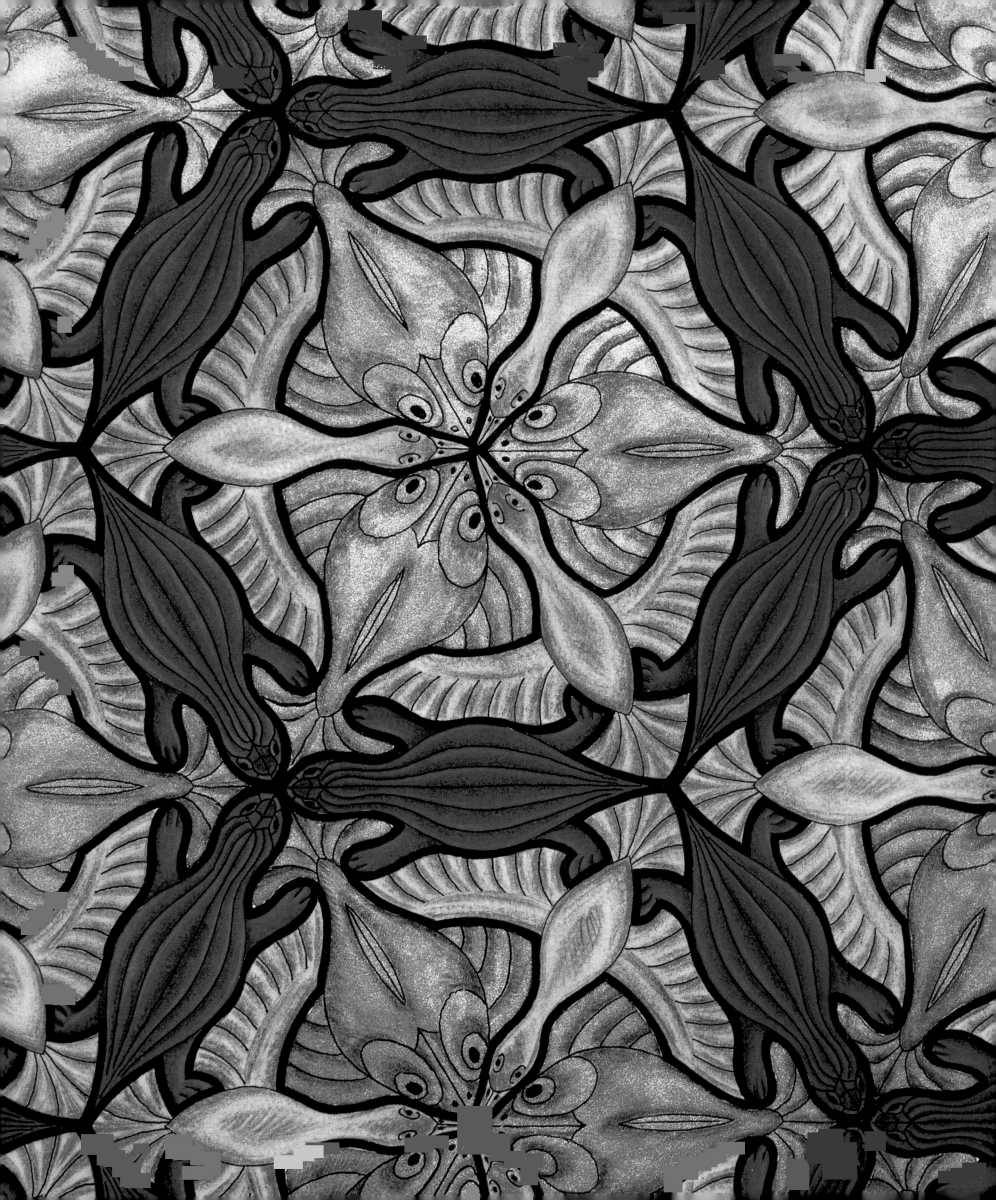

In the very first place my work is closely connected to the Regular Division of the Plane. All the images of the last few years have come from this, from the principle of congruent figures that, without leaving any "open spaces," endlessly fill the plane or at least unlimitedly so. As your father once expressed it perfectly: for me it is always a question of providing the unbordered plane with limits, "to put an end to it," make a "composition" of it. I have to struggle, so to speak, with two separate difficulties that together make the whole affair so enthralling for me: first, "finding" or puzzling or putting together the congruent figures I need; second, composing an enclosed plane with specific measurements in which those figures, which carry infinity or boundlessness inside, so to speak, lie chained or incarcerated.

This two-tiered basis of my pictures is therefore abstract. The motivation of my attempts has nothing to do with true reality.

Letter to his nephew Rudolf Escher, 17 January 1944

83 | 84

83 Detail of **Regular Division of the Plane Drawing #69**
1948. Ink and watercolor, 10 7/8 x 8 1/4" (275 x 208 mm)

84 **Regular Division of the Plane Drawing #22**
1938. Ink, colored pencil and watercolor,
9 x 9 5/8" (228 x 243 mm)

(Page 64)

85 **Regular Division of the Plane Drawing #101**
1956. Ink, pencil and watercolor, 11 5/8 x 5 3/4" (295 x 145 mm)

63

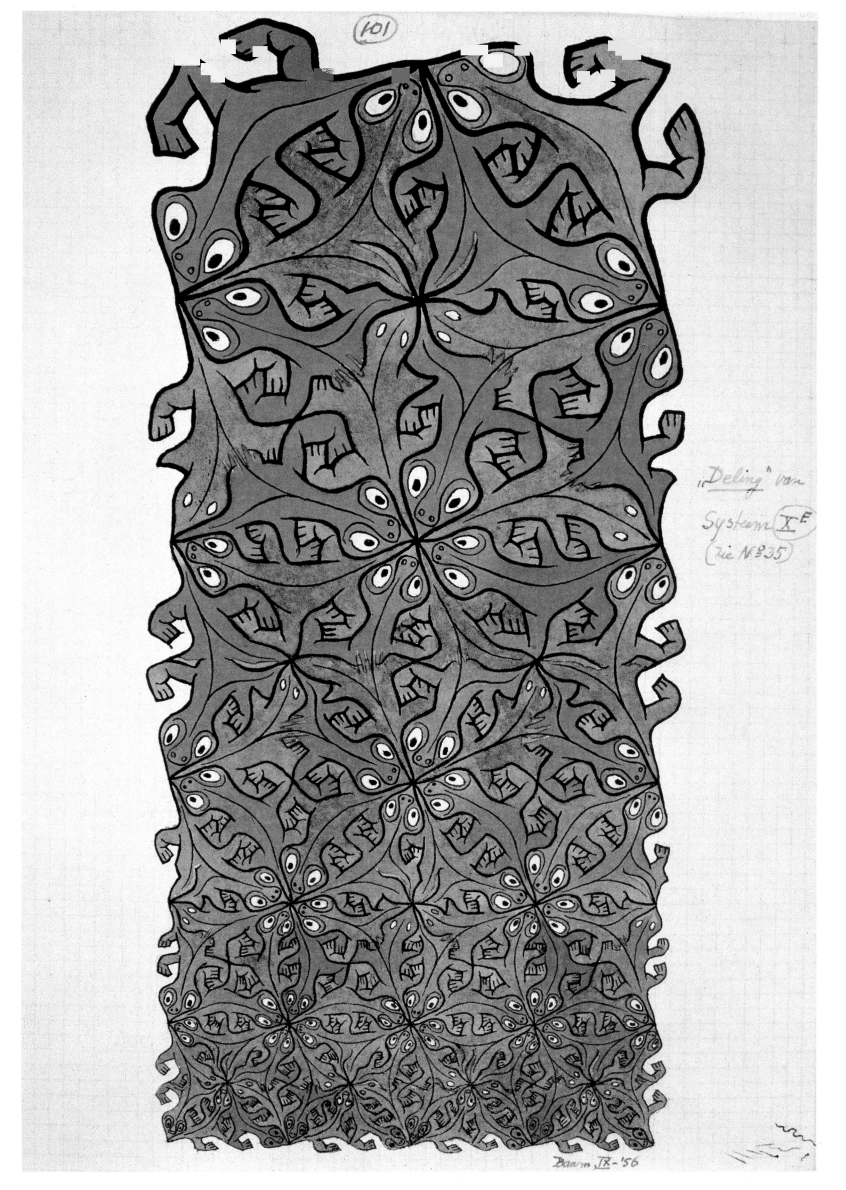

101

„Deling" van
Systeem X^E
(zie N^o35)

85

Baarn IX-'56

At moments of great enthusiasm it seems to me that no one in the world
has ever made something this beautiful and important.
Letter to his son Arthur, 24 March 1956

The lattice of **Development** is a miracle. Out of a vague gray the planes,
which subsequently develop into black and white reptiles, come into being
exclusively through a shift in the distances between the engraved lines. The
locked-up feeling of the image, no matter how beautiful, did not please
Escher. He preferred the unending patterns of **Smaller and Smaller**.
　　J.L.L.

86　87　|　88

86

86　Detail of **Development** I
87　**Development** I
　　1937. Woodcut, 17 ¼ x 17 ½" (437 x 446 mm)
88　**Smaller and Smaller**
　　1956. Wood engraving and woodcut, 15 x 15" (380 x 380 mm)

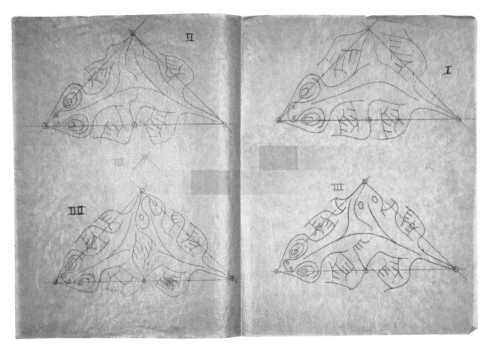

And all you do is drive yourself into the ground and continue to believe you're moving upwards. Nothing but absurdities. Every now and then it nauseates me.

Letter to his son Arthur, 24 January 1964

89 Studies for **Smaller and Smaller**
(from the notebooks)
Pencil and colored pencil, 8 ¼ x 6 ½" (210 x 165)

90 Studies for **Smaller and Smaller**
(from the notebooks)
Ink, pencil and colored pencil, 8 ¼ x 6 ½" (210 x 165)

91 Studies for **Smaller and Smaller**
(from the notebooks)
Pencil and colored pencil, 8 ¼ x 6 ½" (210 x 165)

92 Study for **Division**
(from the notebooks)
Pencil, 8 ¼ x 5 ⅞" (210 x 150)

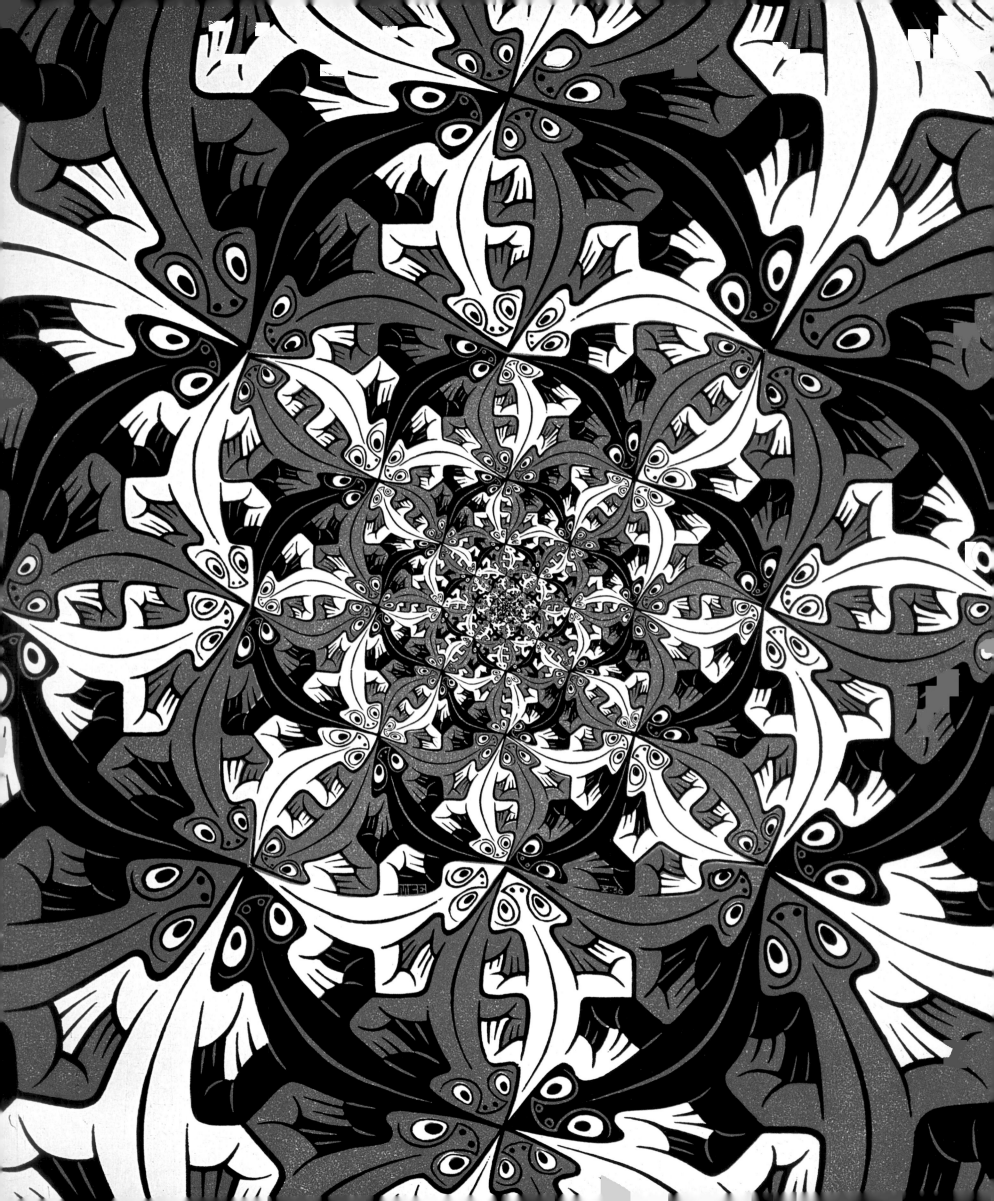

The things I want to express are so exquisite and pure.

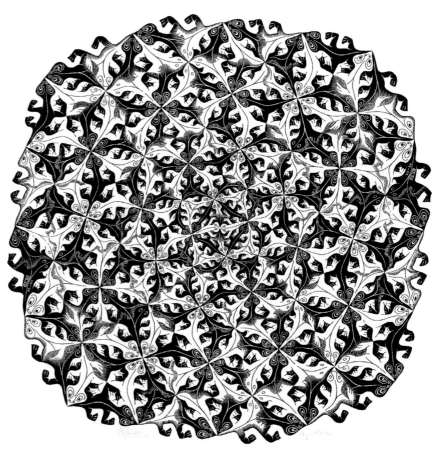

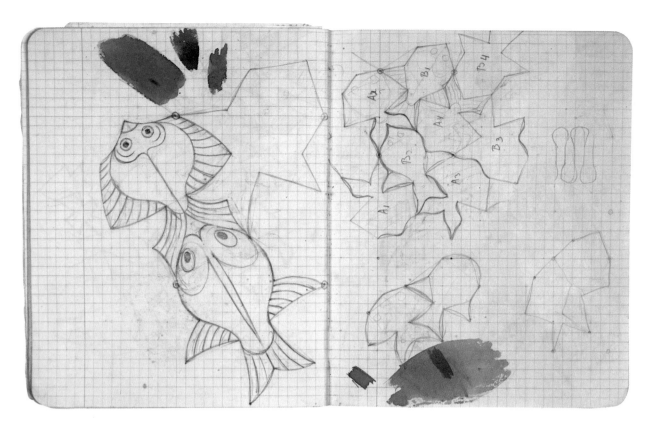

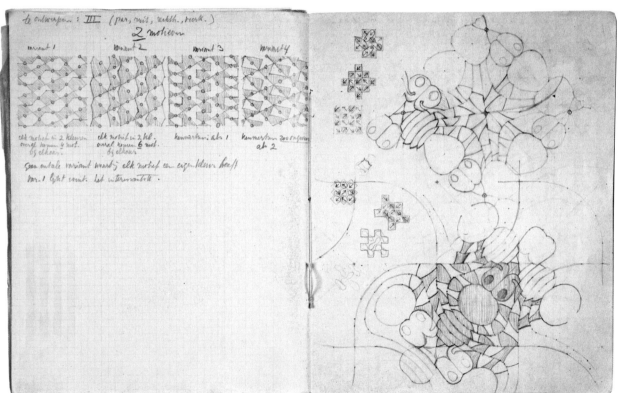

… as much trouble as it gives me, it brings me all the more satisfaction to solve a problem like this myself in my own clumsy way. But it continues to be a profoundly sad and disillusioning fact that I am beginning to speak a language these days only very few understand. It only increases my loneliness more and more. Finally, I no longer belong anywhere. The mathematicians may well nod their heads in a friendly and interested manner — I still am a tinkerer to them. And the "artistic" ones are primarily irritated. Still, maybe I'm on the right track if I experience more joy from my own little images than from the most beautiful camera in the world, with a lens of 1 comma this or that.

Letter to his son George and daughter-in-law Corrie, 15 February 1959

96 97 | 99
98

96 Studies (from the notebooks)
 Pencil and watercolor, 8 ¼ x 6 ½" (210 x 165 mm)
97 Studies (from the notebooks)
 Pencil, 8 ¼ x 6 ½" (210 x 165 mm)
98 Studies (from the notebooks)
 Pencil, 8 ¼ x 6 ½" (210 x 165 mm)
99 Studies (from the notebooks)
 Pencil, 8 ¼ x 6 ½" (210 x 165 mm)

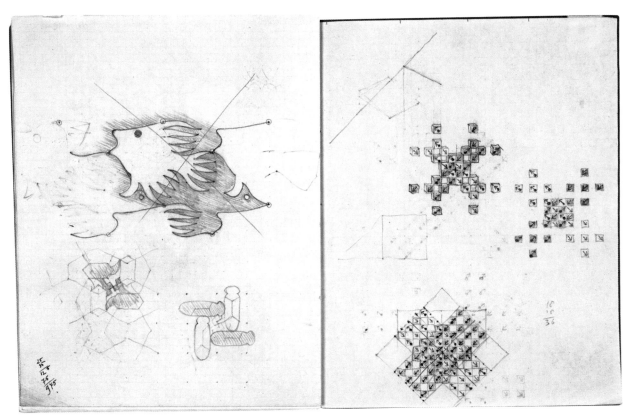

(Pages 74-75)

100 **Regular Division of the Plane Drawing #7**
1936. Ink and watercolor, 13 x 9 ⅝" (332 x 243 mm)

101 **Regular Division of the Plane Drawing #10**
1937/1938. Ink, pencil and watercolor, 13 x 9 ⅝" (332 x 243 mm)

102 **Regular Division of the Plane Drawing #12**
1937/1938. Ink, pencil and watercolor, 13 ⅛ x 9 ⅝" (333 x 244 mm)

103 **Regular Division of the Plane Drawing #13**
1937/1938. Ink, pencil and watercolor, 13 x 9 ⅝" (332 x 243 mm)

104 **Regular Division of the Plane Drawing #14**
1937. Ink, pencil and watercolor, 13 ⅛ x 9 ⅝" (333 x 243 mm)

105 **Regular Division of the Plane Drawing #16**
1938. Ink, pencil and watercolor, 13 ⅛ x 9 ⅝" (333 x 243 mm)

106 **Regular Division of the Plane Drawing #20**
1938. Ink, pencil, watercolor and gold paint, 9 x 9 ⅝" (229 x 243 mm)

107 **Regular Division of the Plane Drawing #24**
1938. Ink, pencil and watercolor, 9 x 9 ⅝" (228 x 244 mm)

108 **Regular Division of the Plane Drawing #25**
1939. Ink, pencil and watercolor, 9 ⅝ x 9 ⅝" (245 x 245 mm)

109 **Regular Division of the Plane Drawing #28**
1938. Pencil and watercolor, 9 ⅝ x 9 ⅝" (245 x 245 mm)

110 **Regular Division of the Plane Drawing #34**
1941. Ink, pencil, watercolor and gold paint, 9 ¾ x 10" (248 x 252 mm)

111 **Regular Division of the Plane Drawing #37**
1941. Colored ink, pencil and watercolor, 9 ¾ x 9 ⅜" (248 x 239 mm)

112 **Regular Division of the Plane Drawing #39**
1941. (improved 1963) Ink, colored pencil and watercolor,
9 ¾ x 9 ½" (247 x 240 mm)

113 **Regular Division of the Plane Drawing #42**
1941. Ink, colored ink, colored pencil and watercolor,
9 ⅝ x 9 ⅜" (244 x 239 mm)

114 **Regular Division of the Plane Drawing #46**
1942. Ink, colored pencil and watercolor, 11 ⅜ x 10 ⅛" (289 x 255 mm)

115 **Regular Division of the Plane Drawing #54**
1942. (improved 1963) Ink, colored ink, colored pencil and watercolor,
8 ⅝ x 8 ⅛" (220 x 206 mm)

116 **Regular Division of the Plane Drawing #55**
1942. Ink and watercolor, 8 ⅝ x 8 ⅛" (220 x 205 mm)

117 **Regular Division of the Plane Drawing #65**
1944. Ink, colored pencil and watercolor, 8 ⅛ x 8 ⅛" (206 x 206 mm)

118 **Regular Division of the Plane Drawing #67**
1946. Ink, colored pencil and watercolor, 8 ⅜ x 8 ⅜" (213 x 214 mm)

119 **Regular Division of the Plane Drawing #71**
1948. Ink, colored pencil and watercolor, 10 ½ x 8 ⅛" (267 x 206 mm)

120 **Regular Division of the Plane Drawing #72**
1948. Ink and colored pencil, 10 ½ x 7 ⅞" (267 x 200 mm)

121 **Regular Division of the Plane Drawing #76**
1949. Ink, colored pencil and watercolor, 8 x 8" (203 x 203 mm)

122 **Regular Division of the Plane Drawing #89**
1953. Ink, pencil and watercolor, 7 ½ x 7 ¾" (190 x 198 mm)

123 **Regular Division of the Plane Drawing #97**
1955. Ink, 7 ¾ x 7 ¾" (195 x 197 mm)

124 **Regular Division of the Plane Drawing #99**
1954. Ink, pencil and watercolor, 7 ⅞ x 7 ⅞" (200 x 200 mm)

125 **Regular Division of the Plane Drawing #111+112**
111: 1962. Pencil and watercolor, 4 ⅞ x 7 ⅞" (123 x 200 mm)
112: 1962. Pencil and watercolor, 4 ⅞ x 7 ⅞" (123 x 200 mm)

126 **Regular Division of the Plane Drawing #118**
1963. Chalk, ink and watercolor, 9 ¾ x 9 ⅝" (247 x 246 mm)

127 **Regular Division of the Plane Drawing #120+121**
120: 1964. Ink and watercolor, 6 ⅛ x 9 ⅝" (157 x 246 mm)
121: 1964. Ink and watercolor, 6 ⅛ x 9 ⅝" (157 x 246 mm)

128 **Regular Division of the Plane Drawing #122+123**
122: 1964. Ink, pencil and watercolor, 5 ⅞ x 8 ¼" (150 x 210 mm)
123: 1964. Ink, pencil and watercolor, 5 ⅞ x 8 ¼" (150 x 210 mm)

129 **Regular Division of the Plane Drawing #124**
1965. Ink, 9 ½ x 9 ½" (240 x 240 mm)

130 **Regular Division of the Plane Drawing #128**
1967. Ink and watercolor, 8 ⅛ x 7 ¾" (205 x 195 mm)

131 **Regular Division of the Plane Drawing #129**
1967. Ink, 9 ½ x 9 ½" (240 x 242 mm)

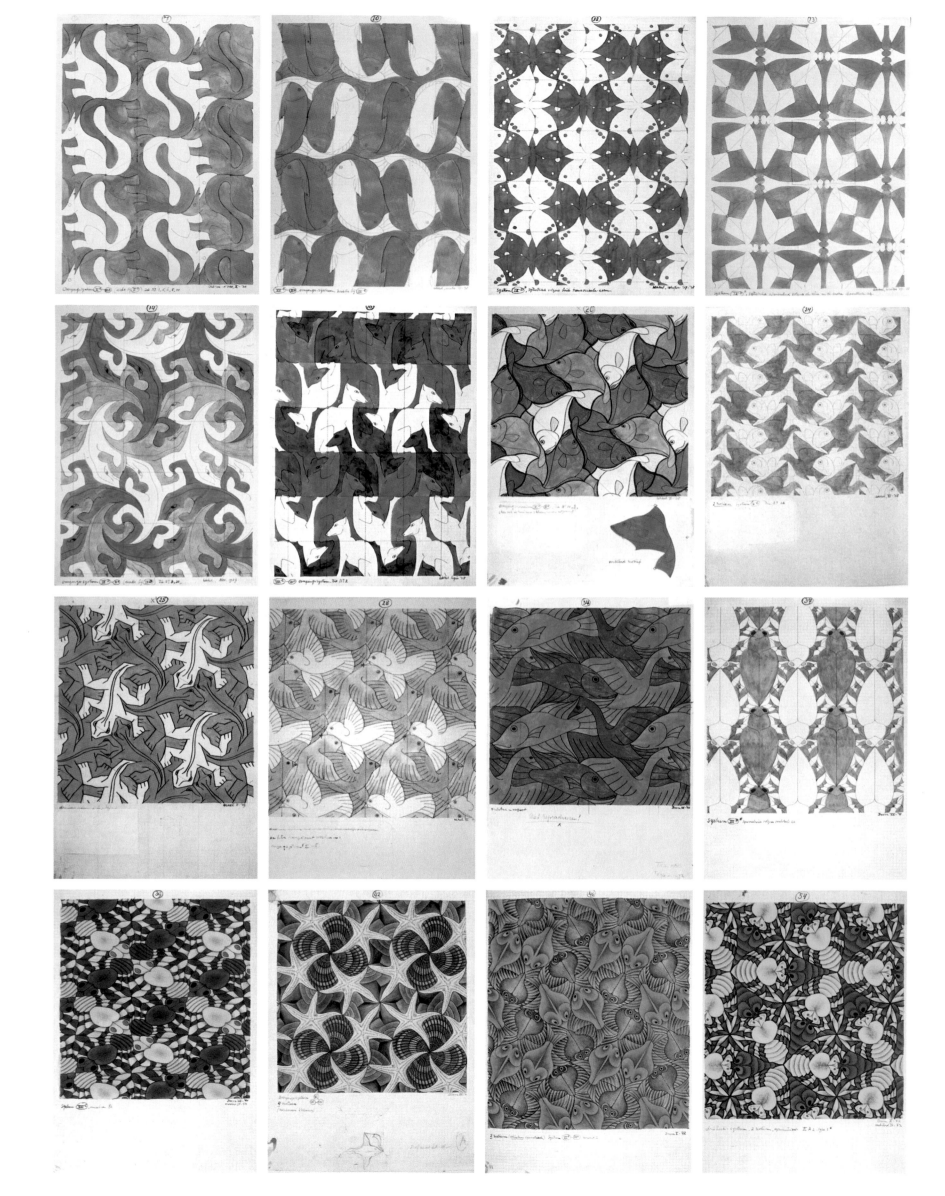

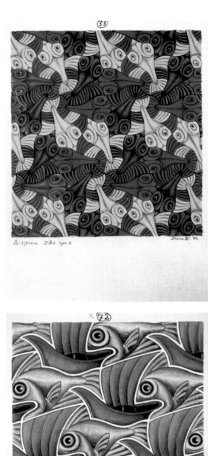
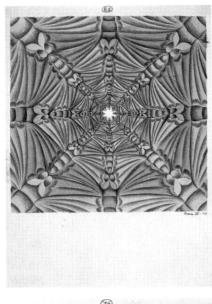
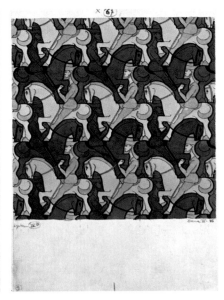
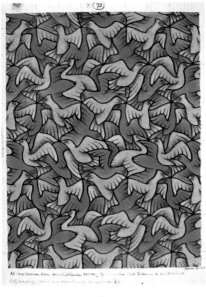
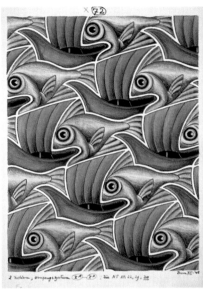
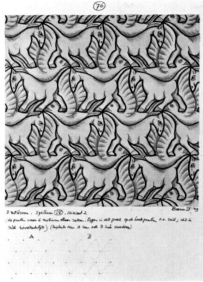
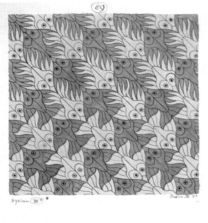
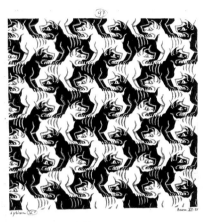
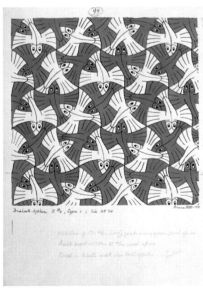
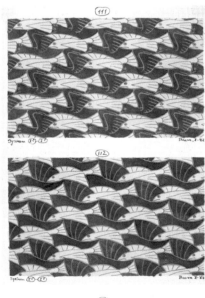
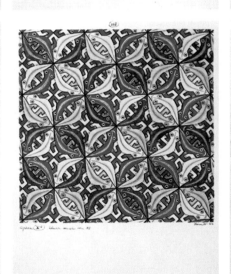
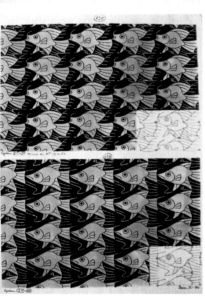
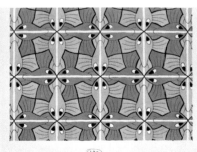
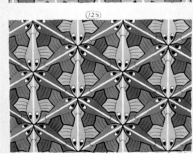
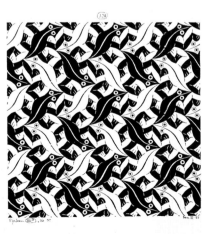
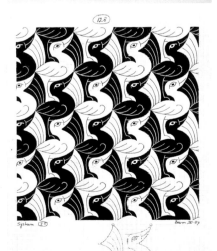
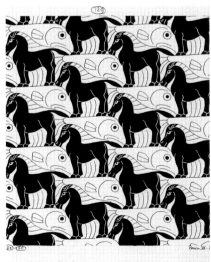

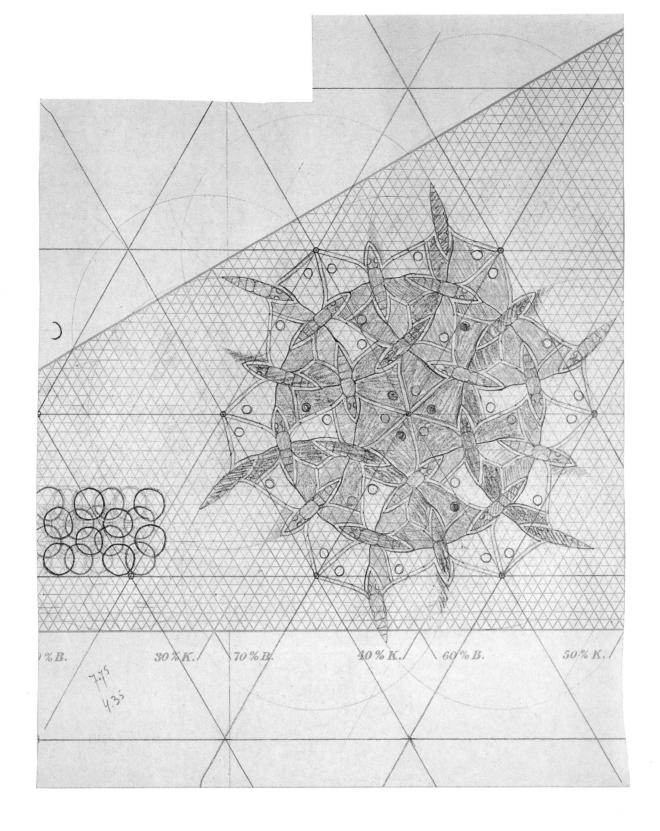

I'm walking around all alone in this splendid garden that does not belong
to me at all and the gate of which stands wide open for anyone; I dwell here
in refreshing but also oppressive loneliness. That is why I've been attesting
to the existence of this idyllic spot for years and that is why I'm putting this
book together in images and words, without expecting many strollers to
come, however. For what enthralls me and what I experience as beauty is
often judged to be dull and dry by others, apparently.

From **Regular Division of the Plane**, *De Roos Foundation, 1957*

132 | 133

132 Study for **Regular Division of the Plane Drawing #79**
 Pencil, 11 ¾ x 9" (298 x 227 mm)
133 Detail of **Regular Division of the Plane Drawing #79**
 1950. Watercolor, 11 x 11" (280 x 280 mm)

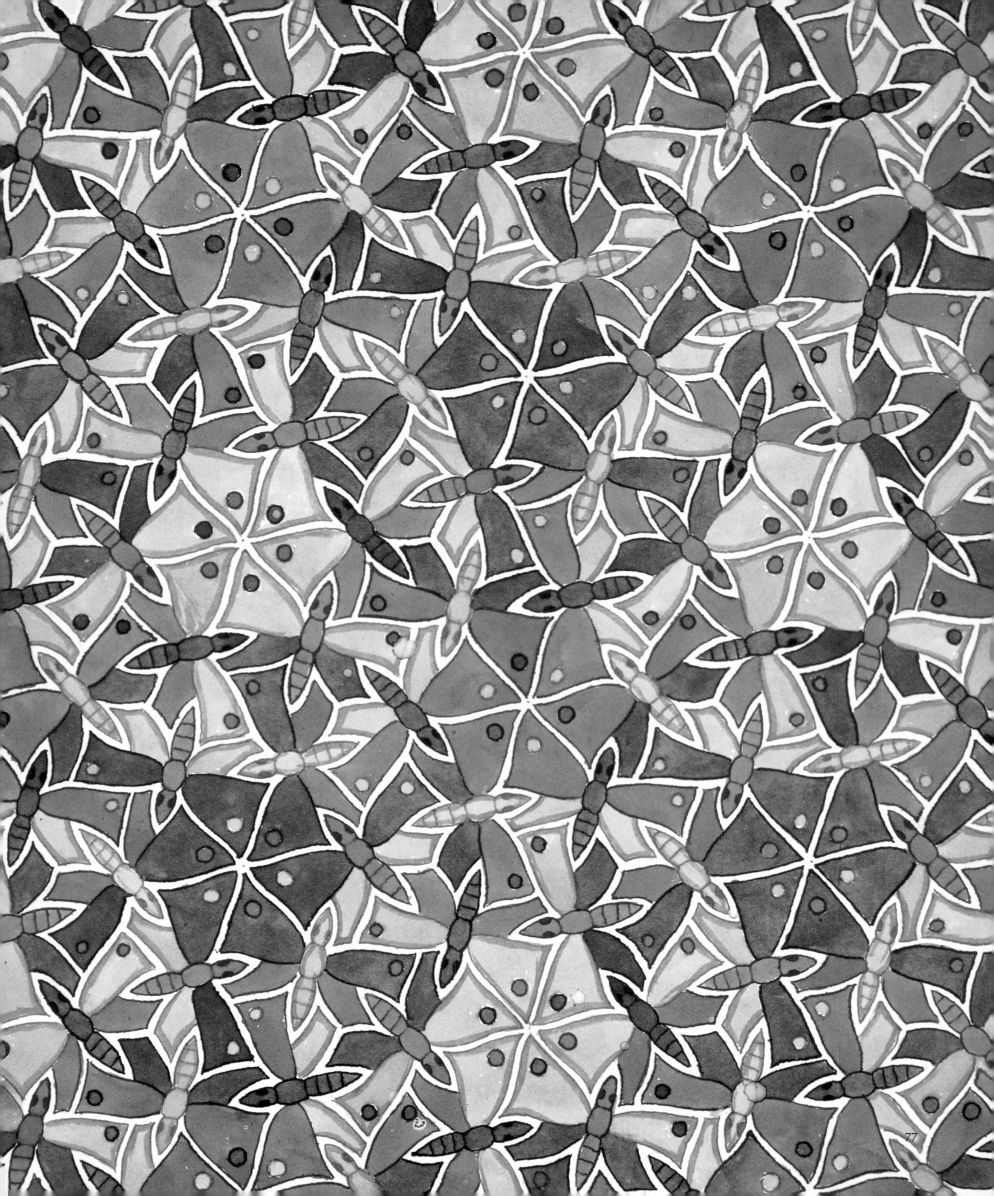

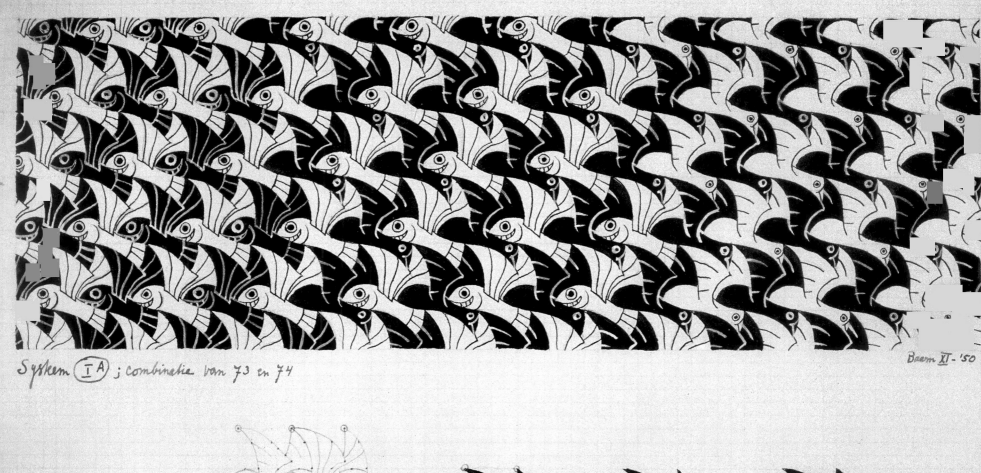

Systeem ⓘ; combinatie van 73 en 74 Baarn XI-'50

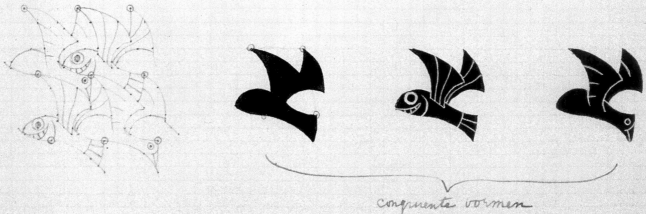

congruente vormen

Nobody can draw a line that is not a boundary line, every line separates
a unity into a multiplicity. In addition, every closed contour no matter
what its shape, pure circle or whimsical splash accidental in form,
evokes the sensation of "inside" and "outside," followed quickly by the
suggestion of "nearby" and "far off," of object and background.
*From **The World of Black and White**, 1959*

134 **Regular Division of the Plane Drawing #80**
 1950. Ink, pencil and opaque white, 3 ⅞ x 11 ⅜" (99 x 288 mm)
135 **Regular Division of the Plane I**
 1957. Woodcut, 9 ½ x 7 ⅛" (240 x 180 mm)

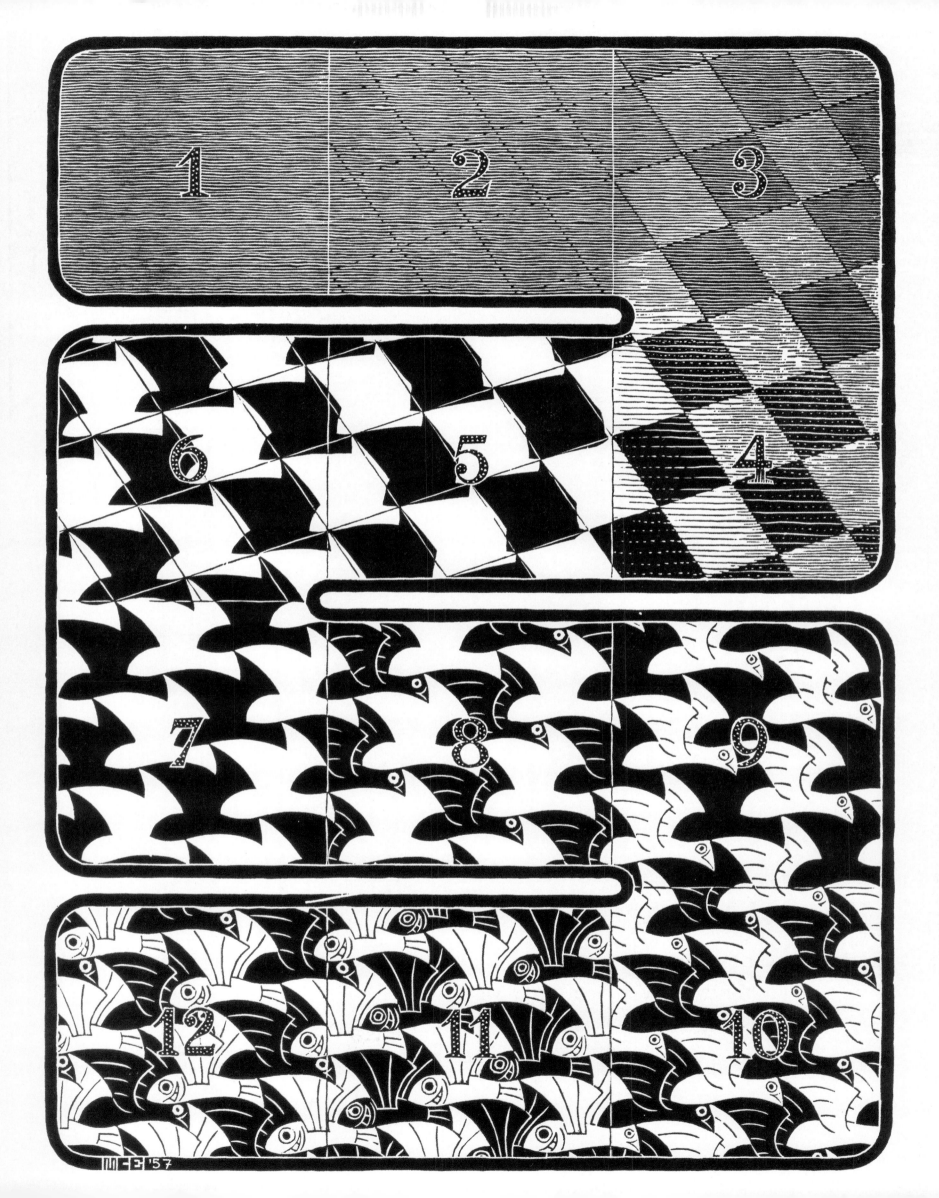

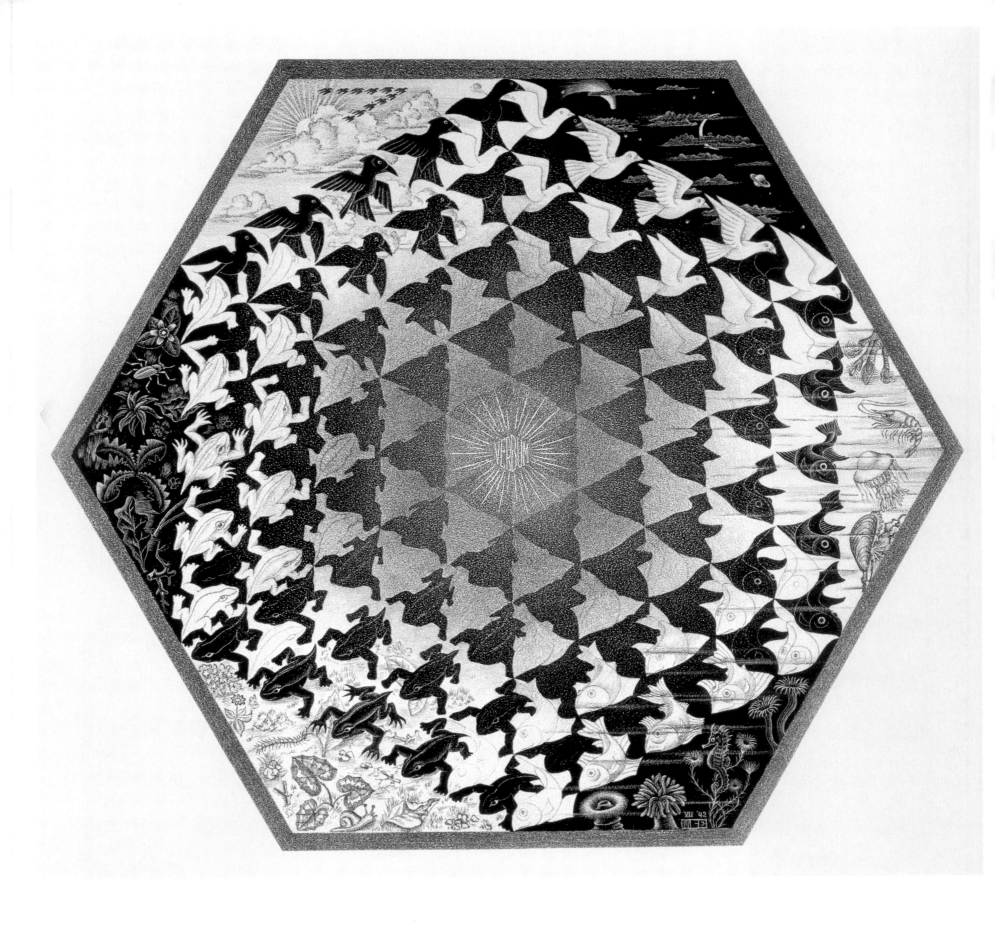

My little birds, little fish and frogs cannot be described: all they ask for is to be thought through, they ask for a mode of thought that I have found to be present in only very few people. It is a kind of small philosophy that has nothing to do with literature, a pleasure in arranging forms and in giving meaning to each part of the plane. It has much more to do with music than with literature.

Letter to Hein 's Gravesande, 14 March 1940

136 | 137

136 **Verbum (Earth, Sky and Water)**
1942. Lithograph, 13 1/8 x 15 1/4" (332 x 386 mm)
137 Detail of **Verbum** (Earth, Sky and Water)

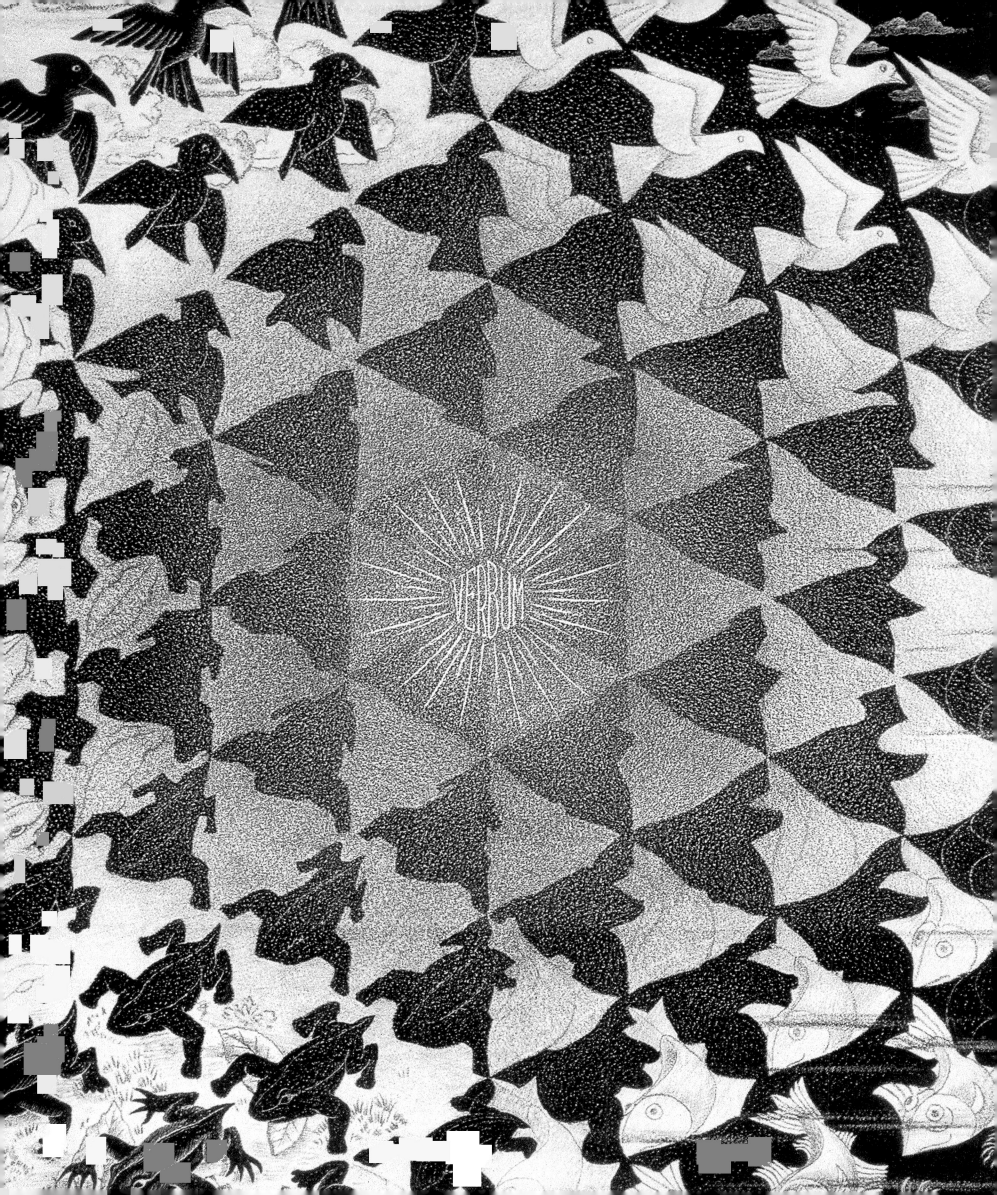

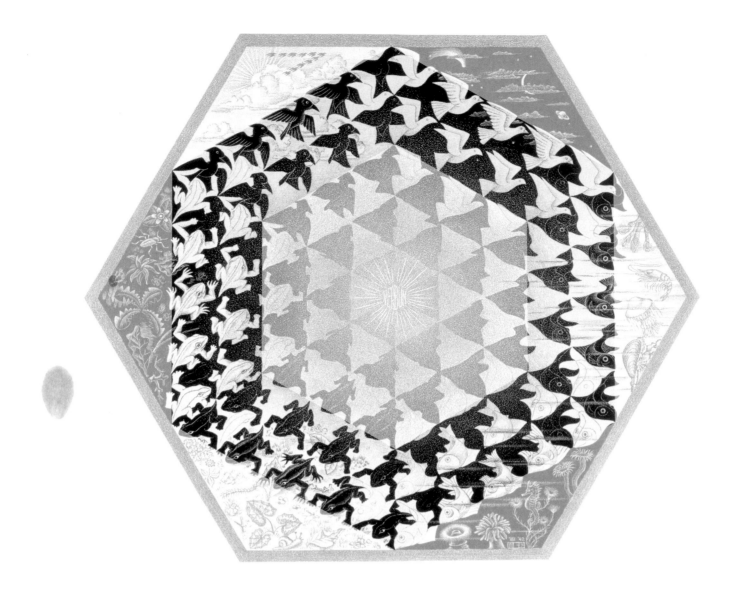

138 A B C Symmetry patterns in **Verbum**

138 D **Verbum** with highlighted areas showing where Escher prepared studies for the final work

139 **Regular Division of the Plane Drawing #52**, Study for **Verbum**
1942. Ink and watercolor, 8 ⅛ x 8 ¼" (205 x 208 mm)

140 **Regular Division of the Plane Drawing #47 + 48**, Study for **Verbum**
#47: 1942. Ink and watercolor, 6 ⅞ x 8 ¾" (175 x 223 mm)
#48: 1942. Ink and watercolor, 6 ⅞ x 8 ¾" (175 x 223 mm)

141 **Regular Division of the Plane Drawing #51**, Study for **Verbum**
1942. Ink and watercolor, 8 ⅛ x 8 ⅛" (205 x 205 mm)

142 **Regular Division of the Plane Drawing #49 + 50**, Study for **Verbum**
#49: 1942. Ink and watercolor, 6 ⅞ x 8 ¾" (175 x 223 mm)
#50: 1942. Ink and watercolor, 6 ⅞ x 8 ¾" (175 x 223 mm)

After having studied these constructed accentuations, it is enlightening to take another close look at the actual picture on page 80 with its ingenious development from inside to outside, from the formless to the formed, and from fish to reptiles to birds.
 J.L.L.

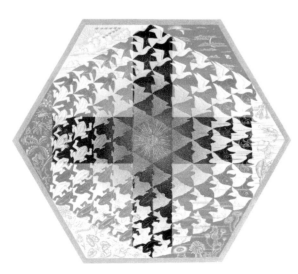
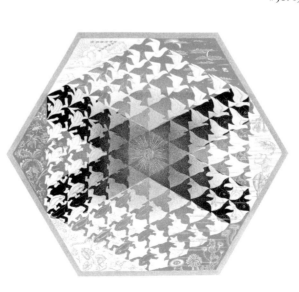
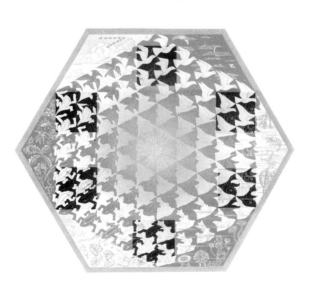

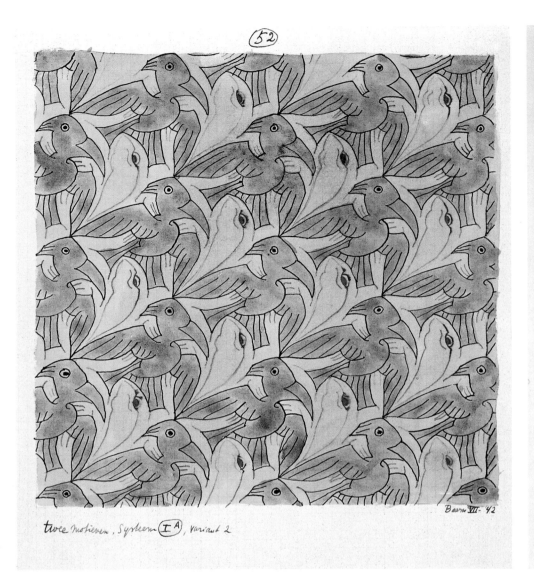

twee motieven, Systeem I A, Variant 2

Baarn VII-'42

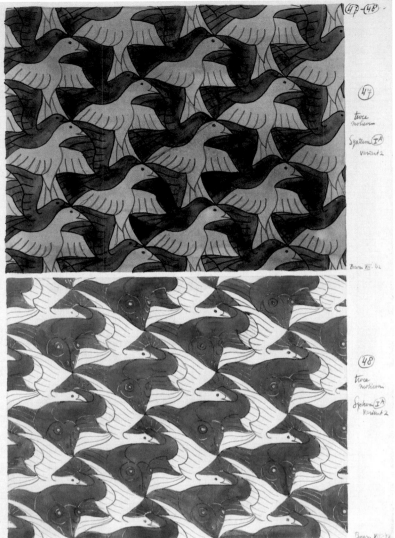

47

twee motieven

Systeem I A

Variant 2

Baarn VII-'42

48

twee motieven

Systeem I A

Variant 2

Baarn VII-'42

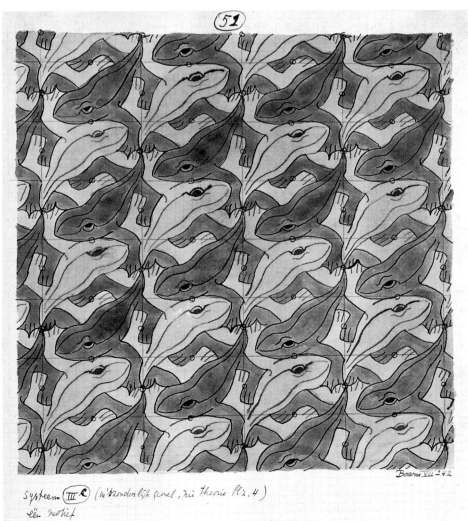

Systeem III C (uitzonderlijk geval, zie theorie Pl. 4)

één motief

Baarn VII-'42

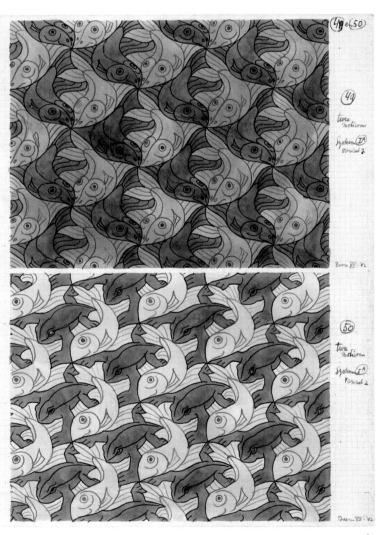

49

twee motieven

Systeem I A

Variant 2

Baarn VII-'42

50

twee motieven

Systeem I A

Variant 2

Baarn VII-'42

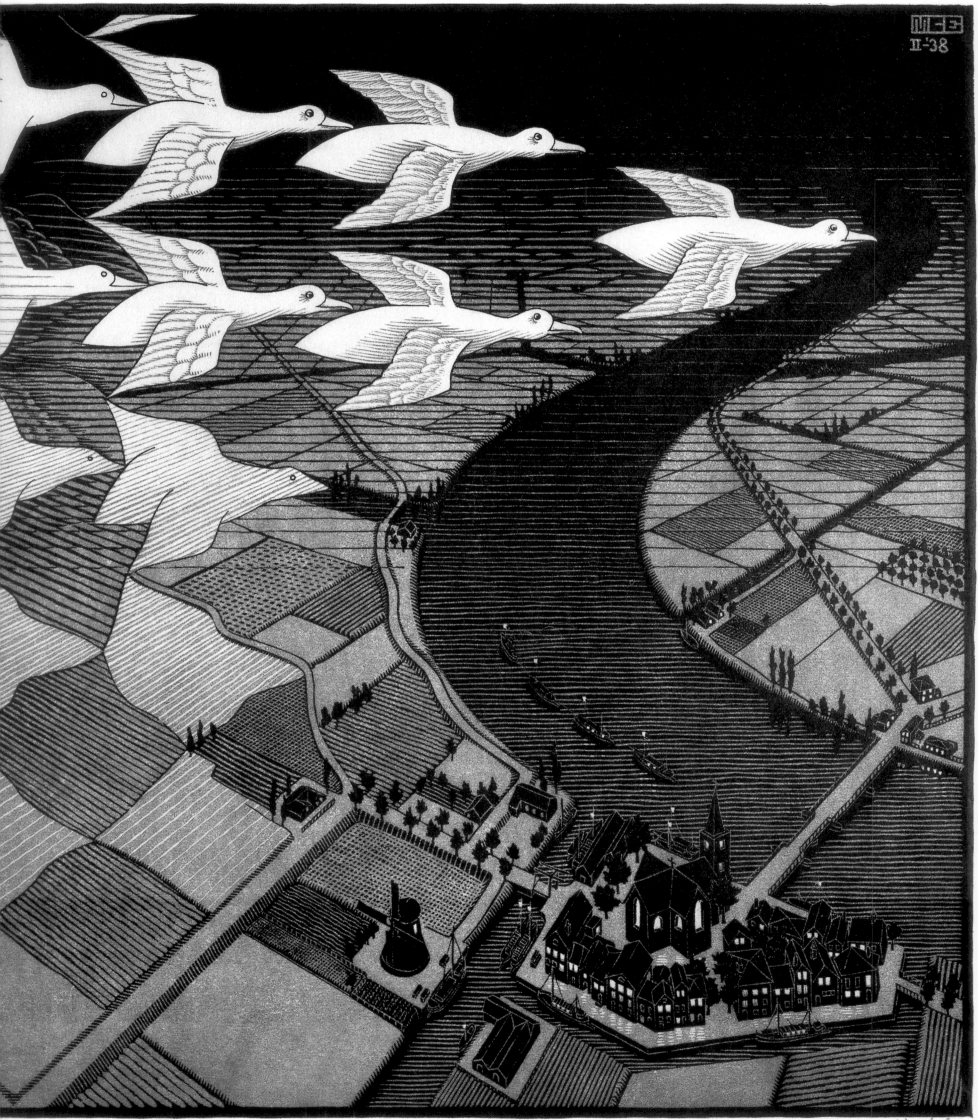

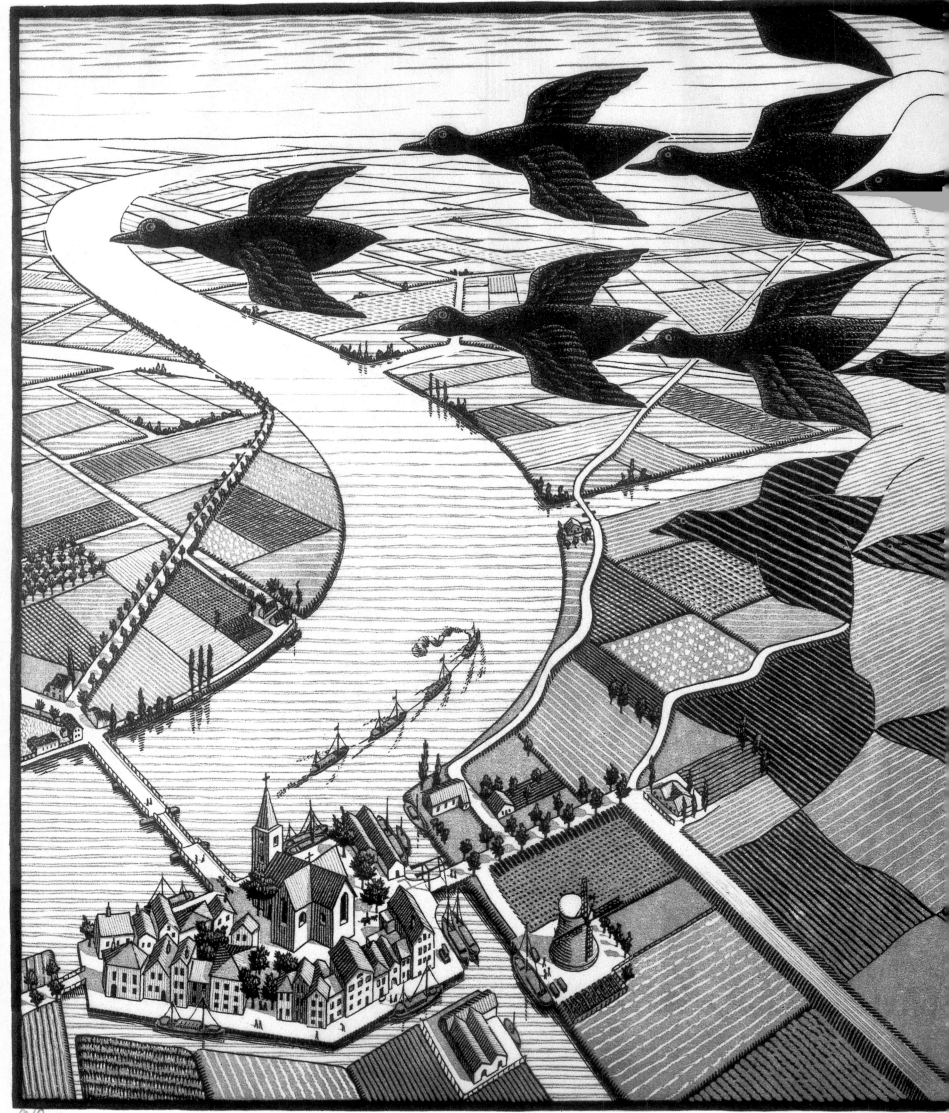

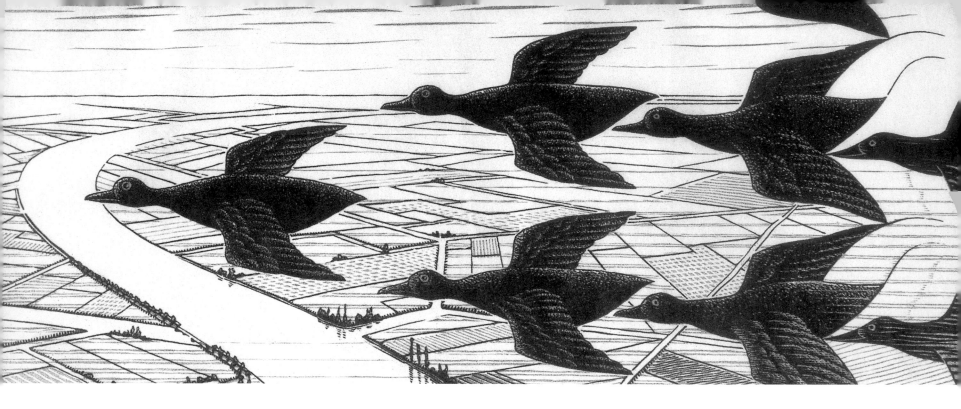

You ask what I'm doing? Well, I'm reprinting, unendingly. And I actually enjoy it, too! Not easy at all to make decent prints of a two-tone picture such as **Day and Night**, almost 40 x 70 cm and more than thirty years old. And all that with a little eggspoon made of bone. I'm busy now with an impression of forty copies. That will take about another month. If I don't do it, my American clients will kill me.

Letter to Gerd Arntz, 10 March 1969

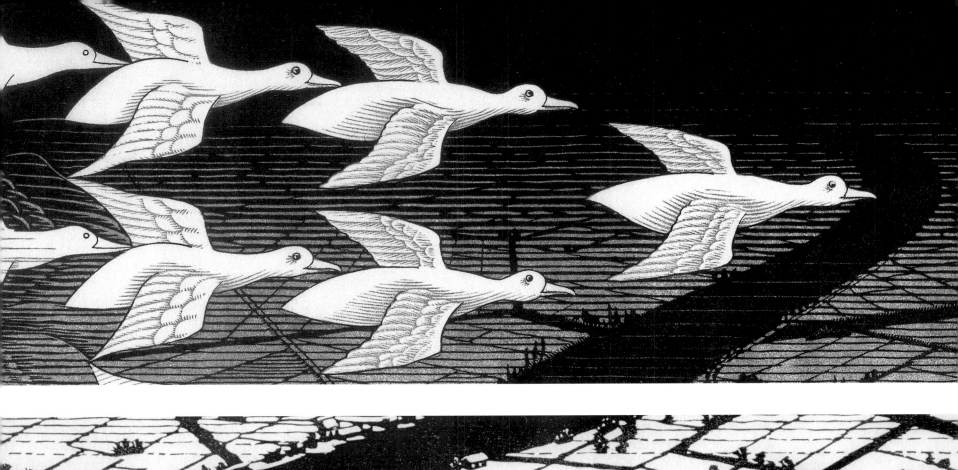

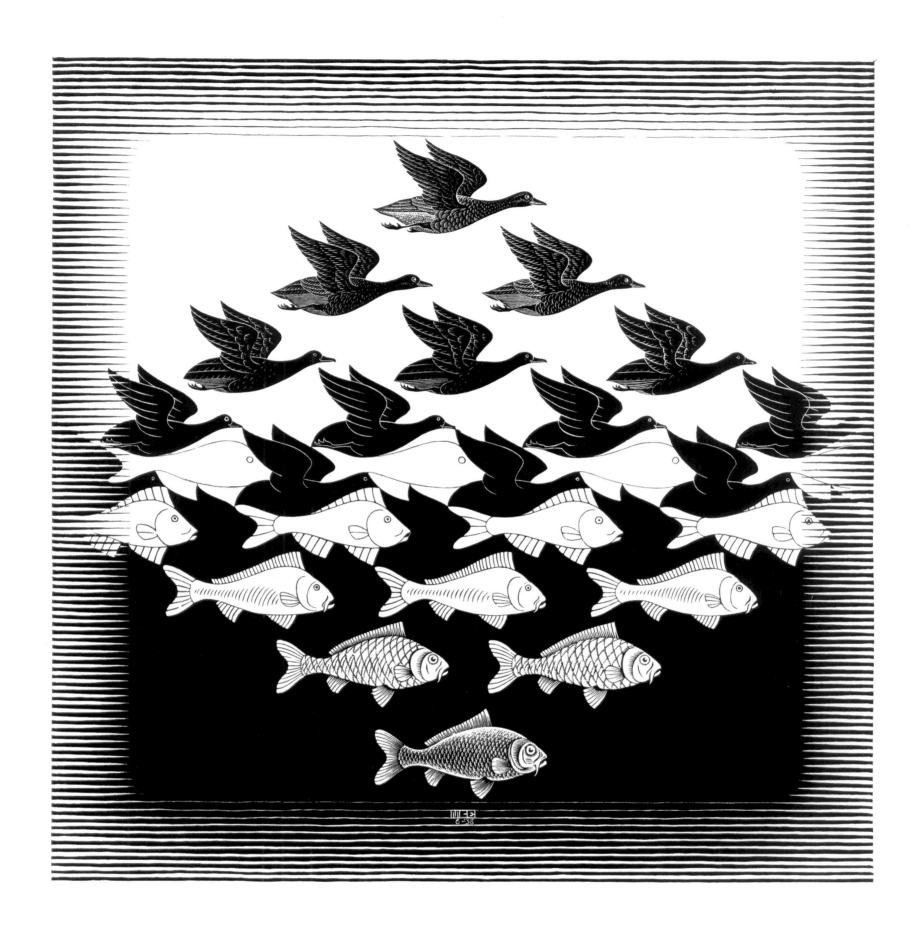

I believe that every artist, in the final analysis, wants nothing
other than to tell his fellow men what he has on his mind.
Letter to B. Merema, 10 May 1952

Every time something is said about my work, that odd feeling comes over me: a kind of awkward pride and contentment, mixed with fear of overrated value, importance. I am afraid they're going to see me as a fussbudget or an advertising man. That would be a pity, and so then I'd rather keep a low profile…

Letter to Hein 's Gravesande, 5 March 1940

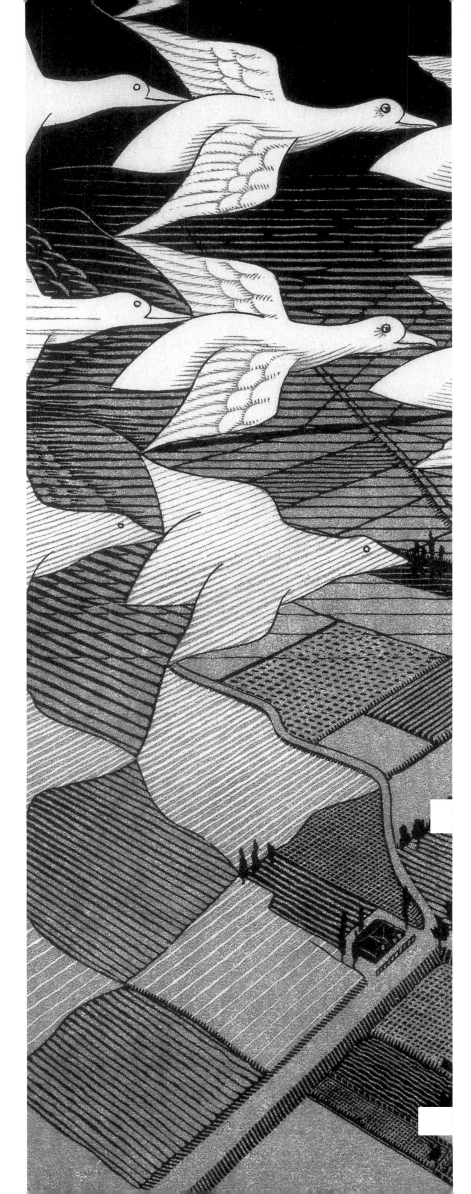

146 | 147 148

146 **Day and Night**
1938. Woodcut, 15 ³/₈ x 26 ⁵/₈" (391 x 677 mm)

147 Detail of **Day and Night**

148 **Sky and Water I**
1938. Woodcut, 17 ¹/₈ x 17 ¹/₄" (435 x 439 mm)

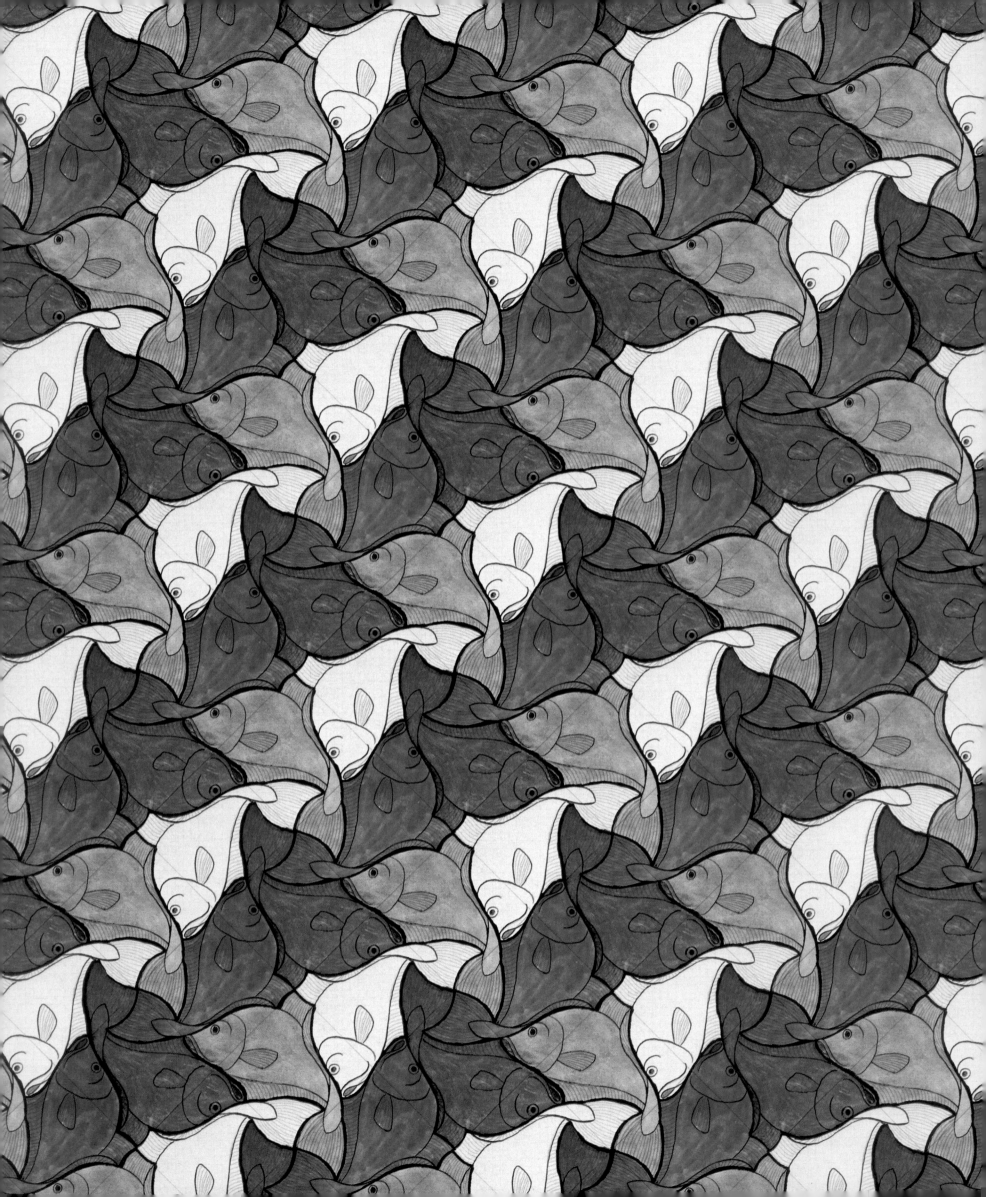

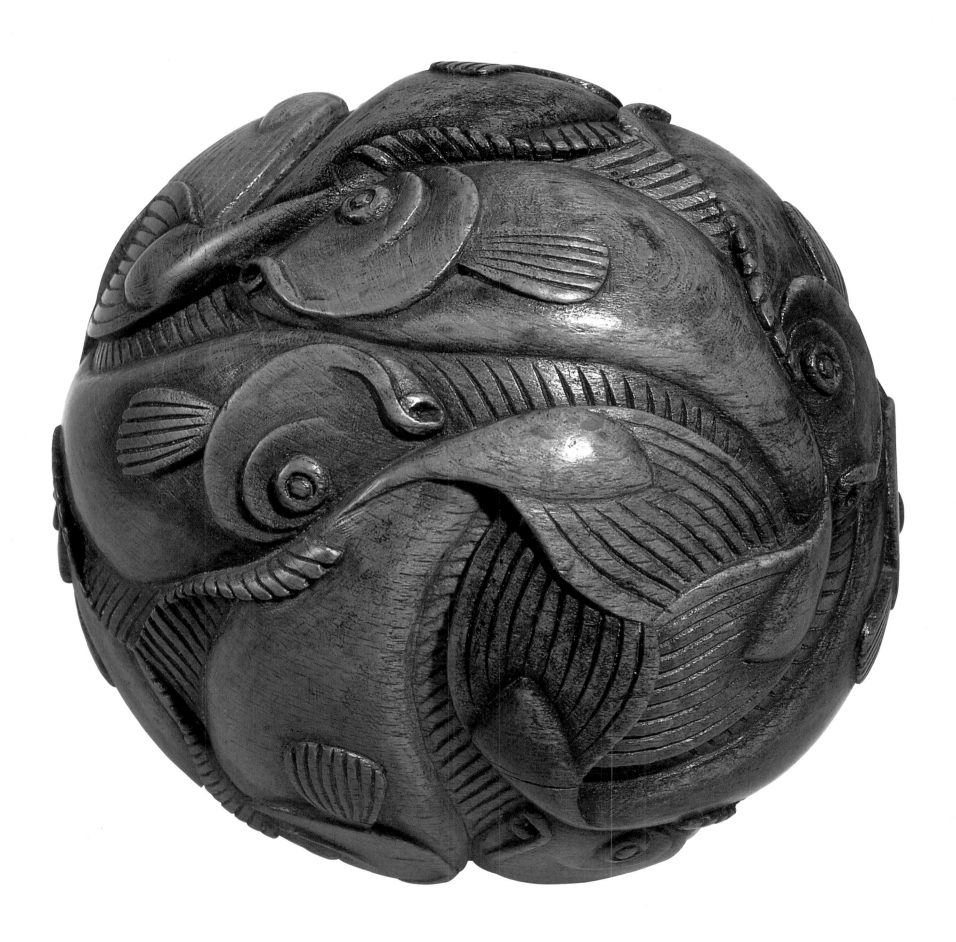

149 | 150 149 **Regular Division of the Plane Drawing #20,**
 (extended to fill the page, see 106)

 150 **Sphere with Fish**
 1940. Beechwood, diameter 5 ⅛" (130 mm)

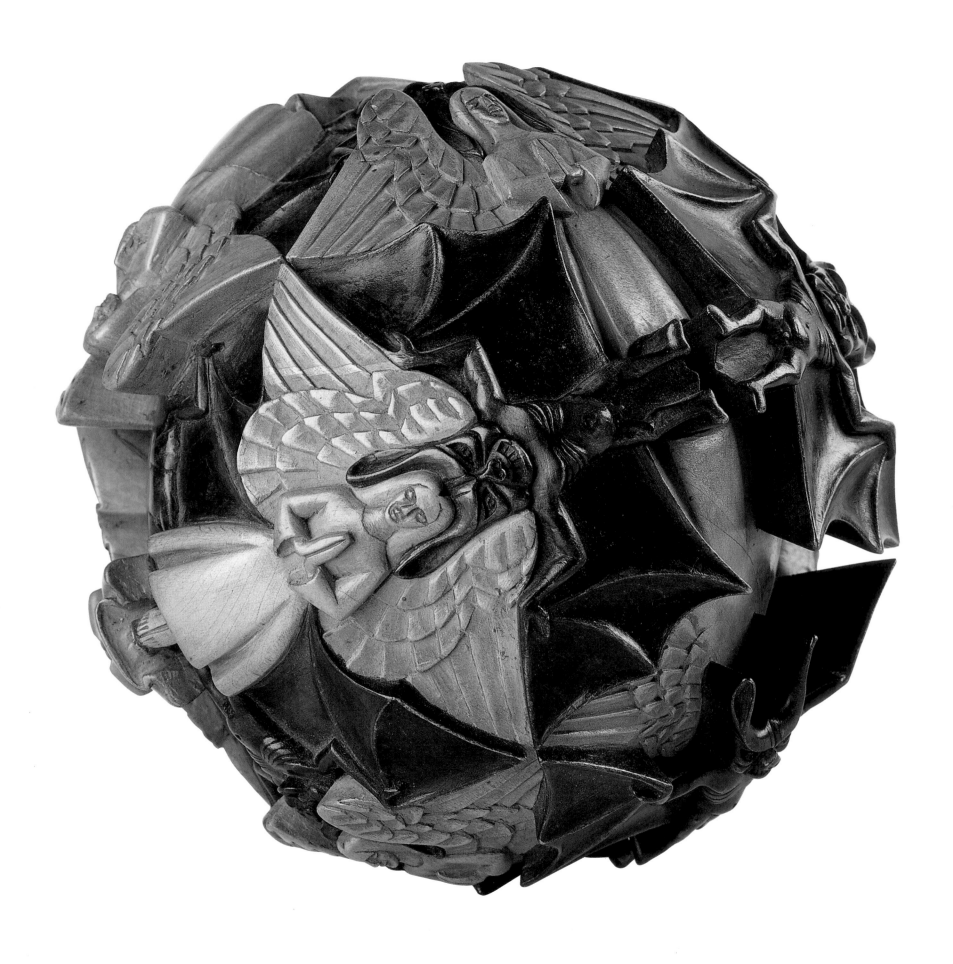

151 | 152 151 **Sphere with Angels and Devils**
 1942. Maple, diameter 9 ¼" (235 mm)
 152 **Regular Division of the Plane Drawing #45,**
 (extended to fill the page)

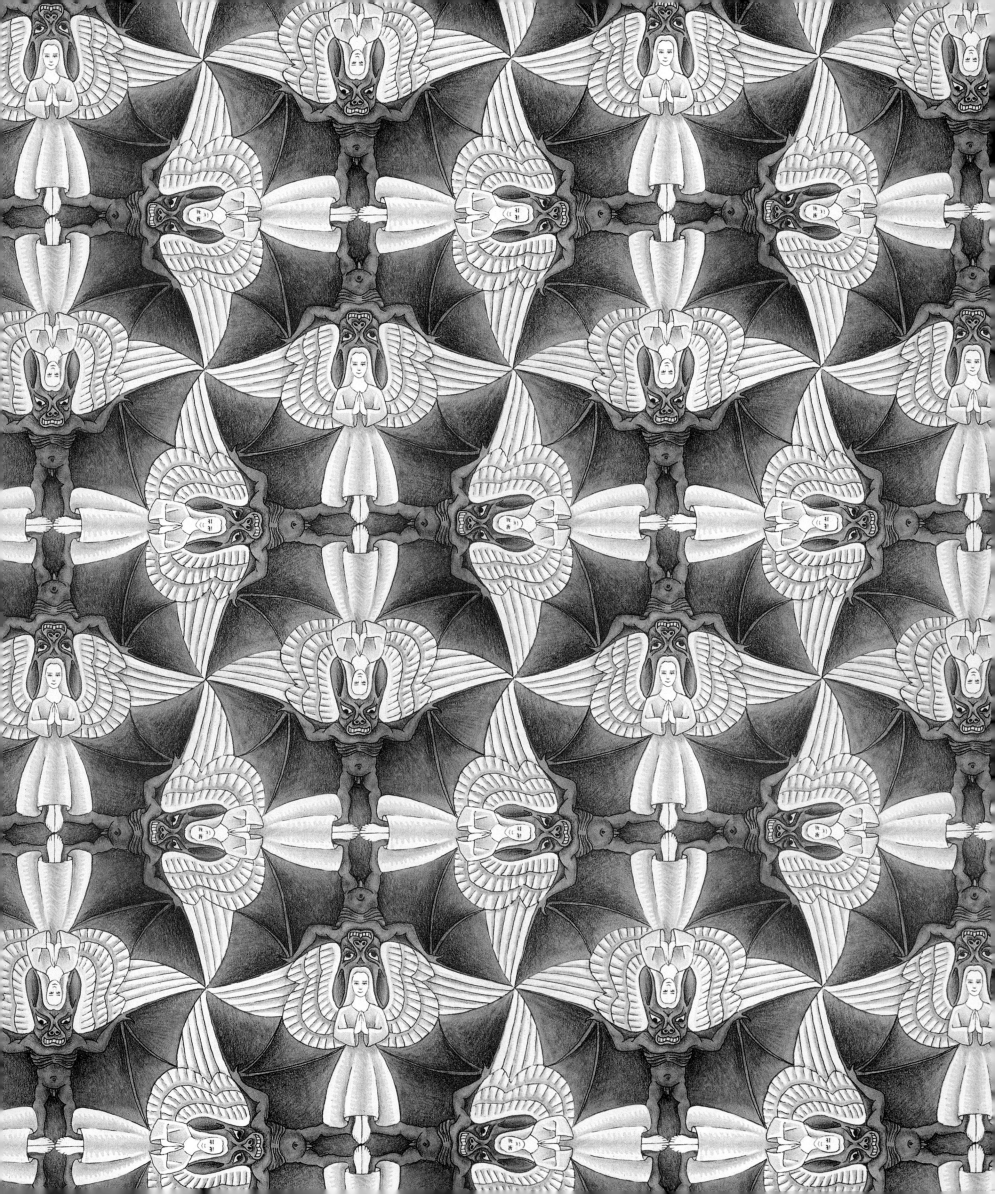

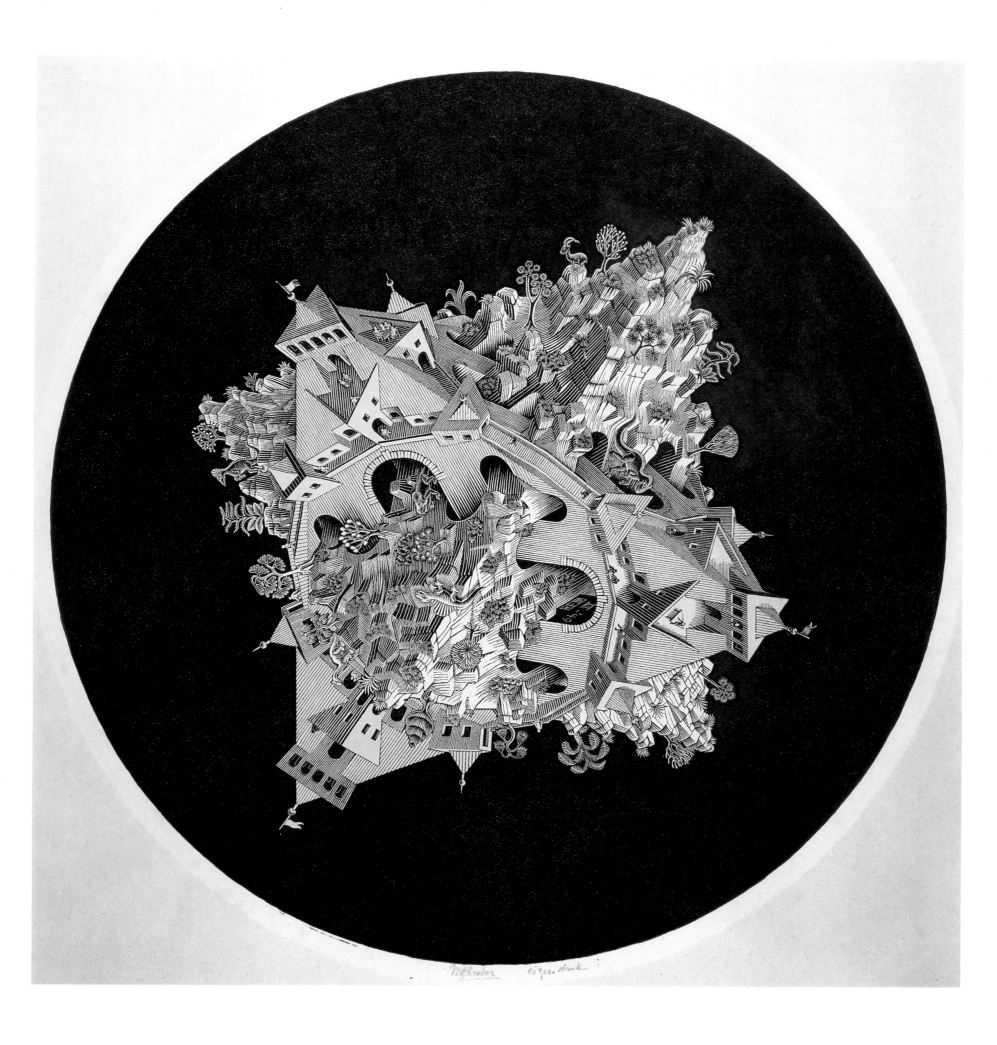

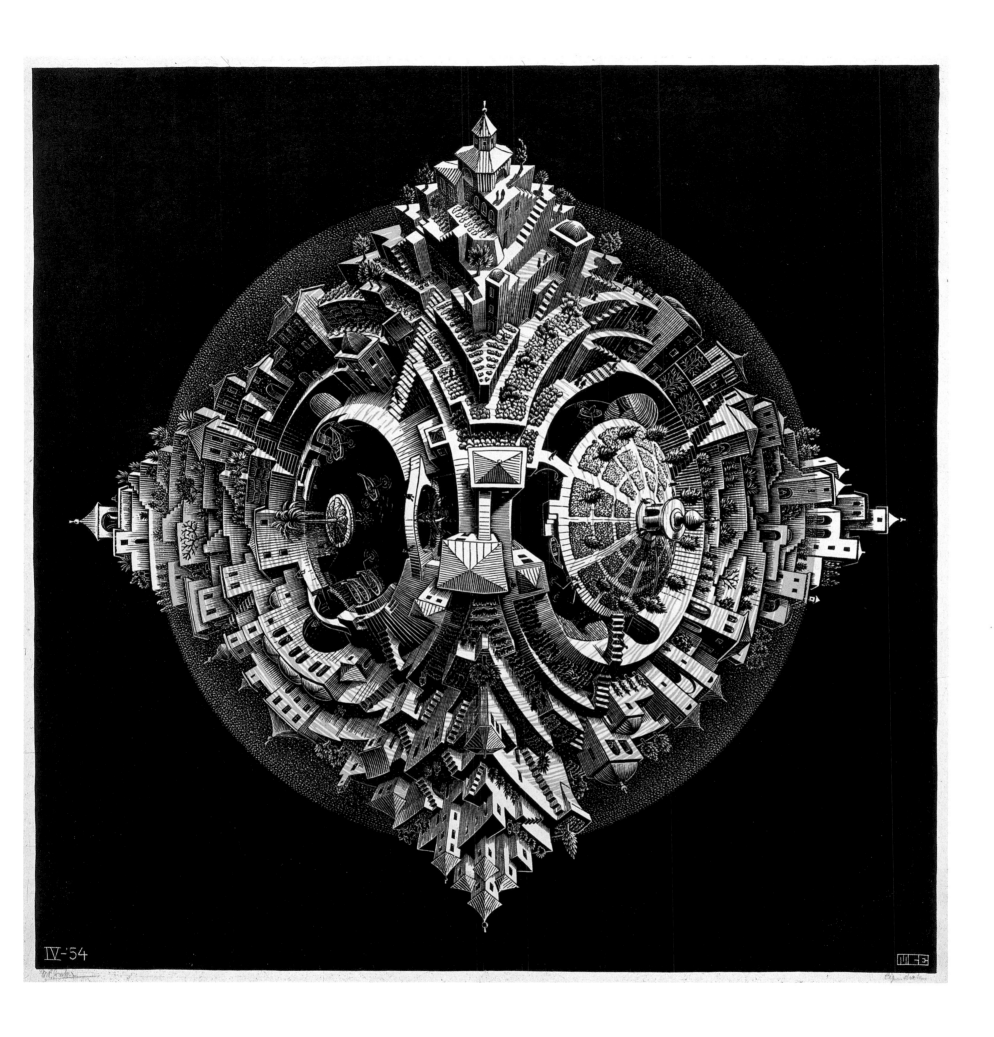

In the time between two pictures I find suicide an interesting thought.
Lecture, Rosa Spierhuis, 1970

153 | 154

153 **Double Planetoid**
1949. Wood engraving, diameter 14¾" (374 mm)

154 **Tetrahedral Planetoid**
1954. Woodcut, 16⅞ x 16⅞" (430 x 430 mm)

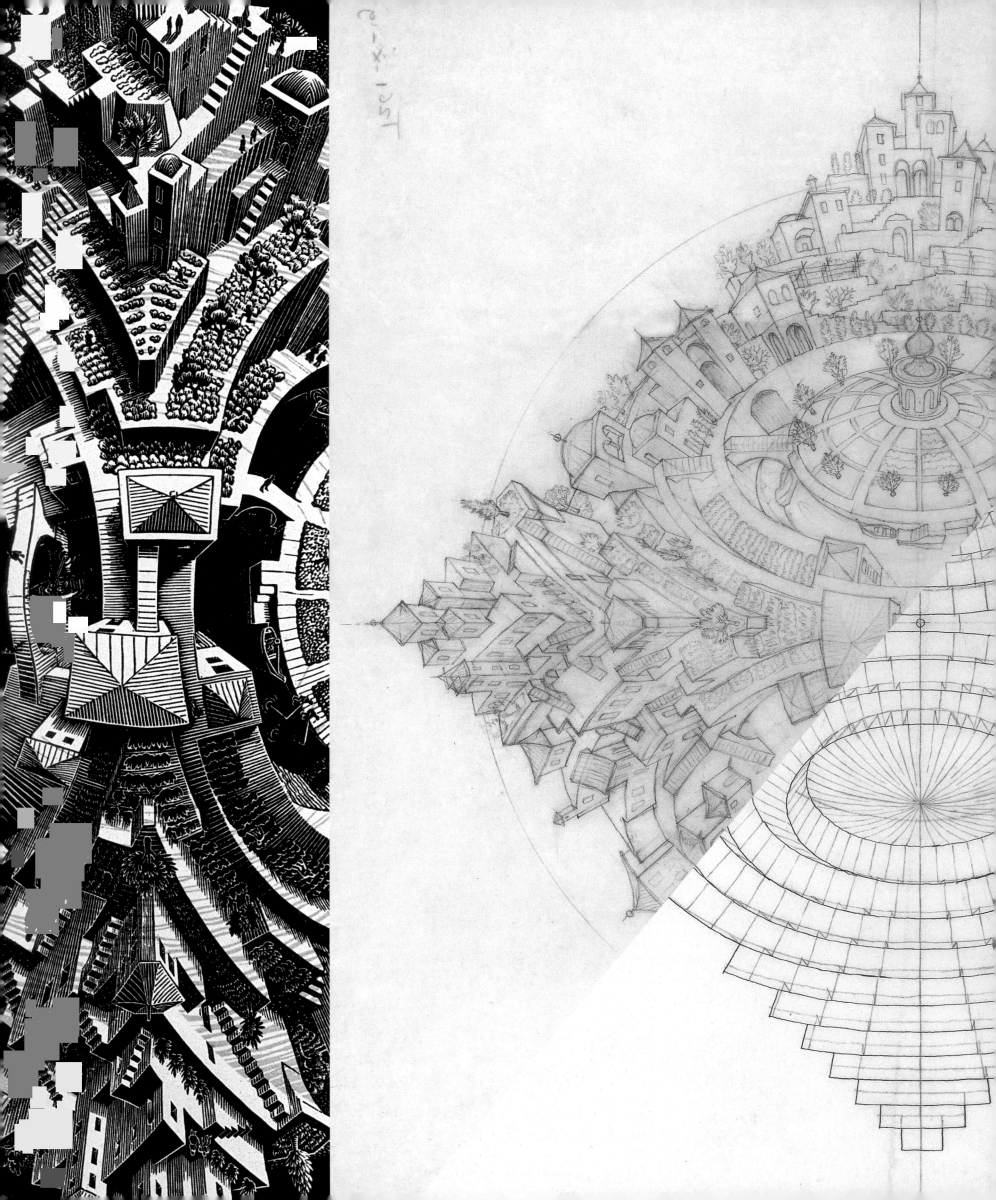

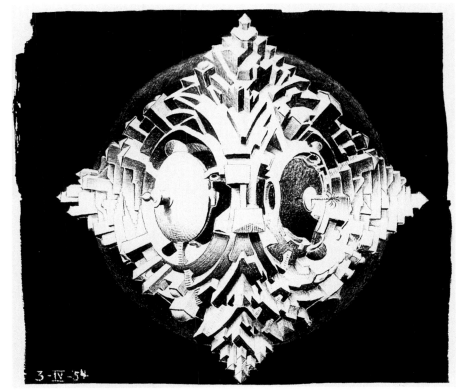

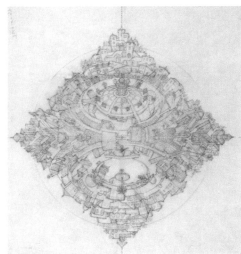
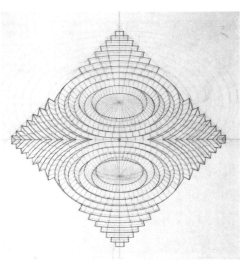

The reaction of my colleagues to whom I showed the picture [**Double Planetoid**] was so minimal, that is to say they were looking at it without any sign of interest, that it was a little discouraging to me after all that slaving.

The whole question of slicing the various planes has cost me infernal trouble. My imagination leaves a lot to be desired and when one starts off on a piece such as this, it really is nothing but continuous exasperation with one's own shortcomings. In addition, the technical realization was especially laborious this time and, despite all my enthusiasm, it was actually one continuous failure.

Letter to Paul Kessler, 15 February 1950

155 156 | 157 158
 159 160

155 Detail of **Tetrahedral Planetoid** (see 154)

156 Detail of study for **Tetrahedral Planetoid** (see 159)

157 Detail of study for **Tetrahedral Planetoid** (see 160)

158 Study for **Tetrahedral Planetoid**
Pencil, ink and watercolor, 15 ¼ x 18 ¼" (386 x 462 mm)

159 Study for **Tetrahedral Planetoid**
Pencil, 16 ⅝ x 18 ¾" (423 x 477 mm)

160 Study for **Tetrahedral Planetoid**
Pencil and ink, 16 ⅞ x 16 ⅝" (427 x 423 mm)

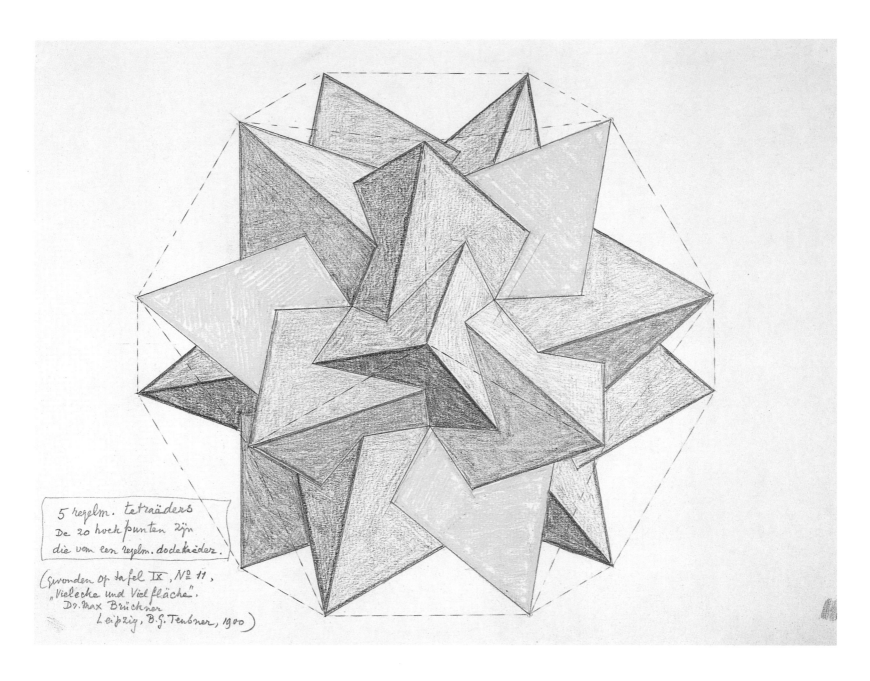

5 regelm. tetraäders
De 20 hoekpunten zijn
die van een regelm. dodekaëder.

(gevonden op tafel IX, N⁰ 11,
"Vielecke und Vielfläche".
Dr. Max Brückner
Leipzig, B.G. Teubner, 1900)

A human being truly is never happy. The uselessness, the hollowness, the impotence, the sense of flattery, the insufferability of yourself afterwards, when you feel like a squeezed-out lemon. I have always known that silence is golden and speaking is mud, and I'm speaking more all the time.

Letter to his son George and daughter-in-law Corrie, 26 March 1961

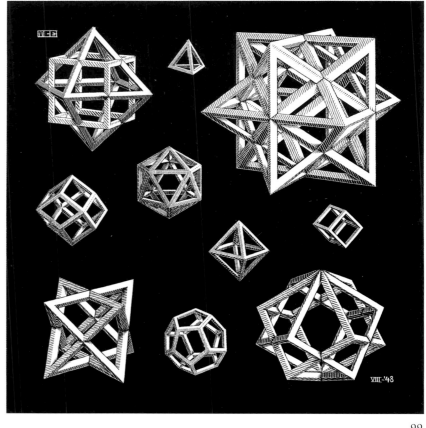

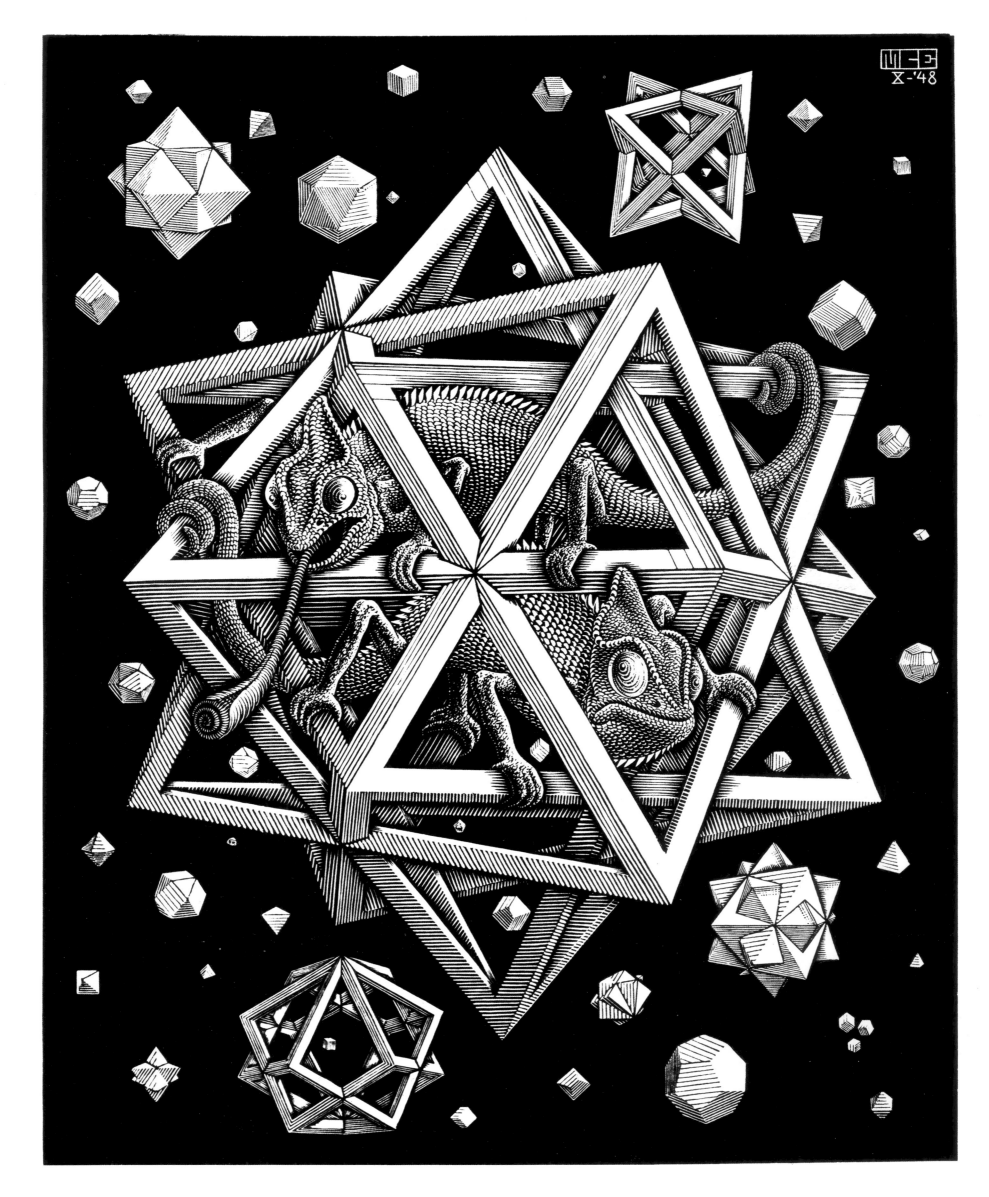

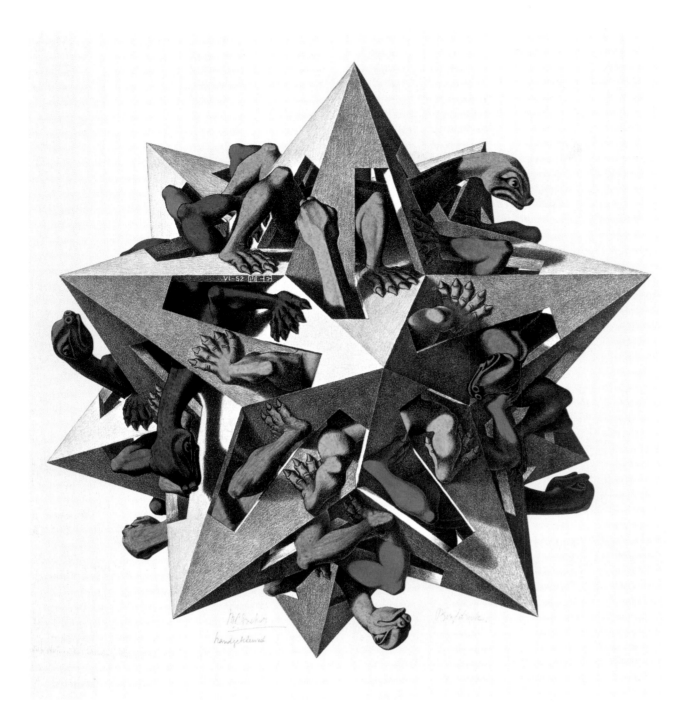

I'm always wandering around in enigmas.
There are young people who constantly come
to tell me: you, too, are making Op Art.
I haven't the slightest idea what that is, Op Art.
I've been doing this work for thirty years now.
Lecture, Rosa Spierhuis, 1970

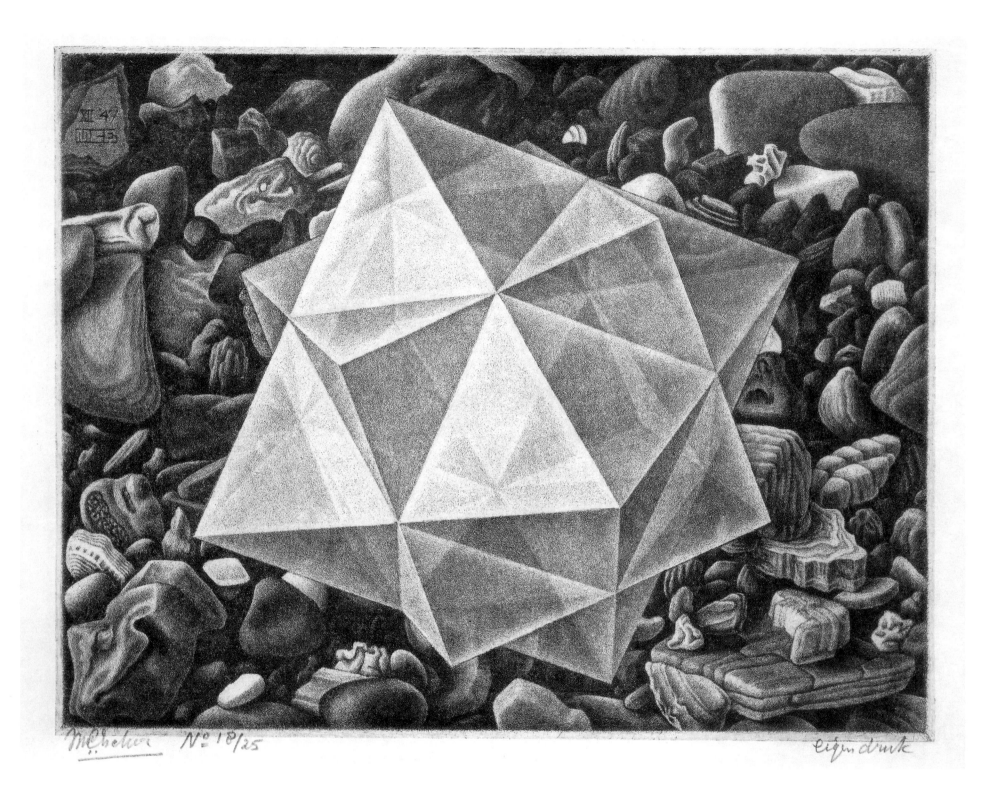

The consistency of the phenomena around us, order, regularity, cyclical repetitions and renewals, have started to speak to me more and more strongly all the time. The awareness of their presence brings me repose and gives me support. In my pictures I try to bear witness that we are living in a beautiful, ordered world, and not in a chaos without standards, as it sometimes seems.

My topics are often very playful, too. I cannot stop fiddling around with our incontestable certainty. It is a pleasure, for example, to deliberately mingle two- and three-dimensions, flat and spatial, and to poke fun at gravity.

Speech upon receiving the Culture Prize of the City of Hilversum, 5 March 1965

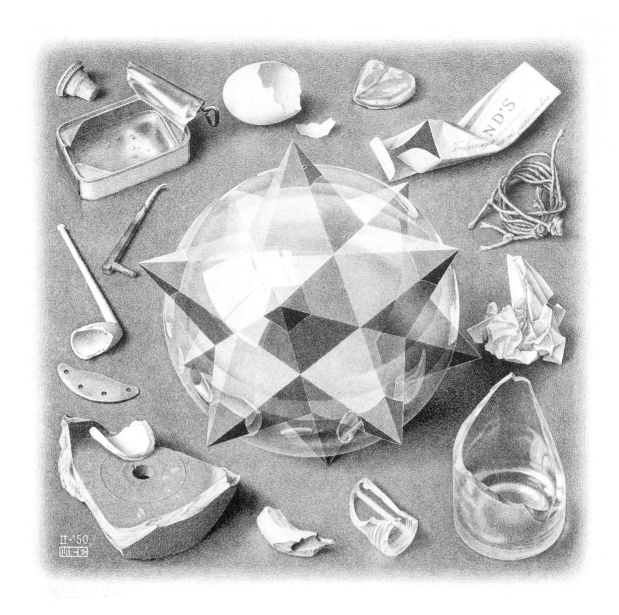

There are people who think it is ugly.
Well, God, I really am terribly sorry.
Lecture, Rosa Spierhuis, 1971

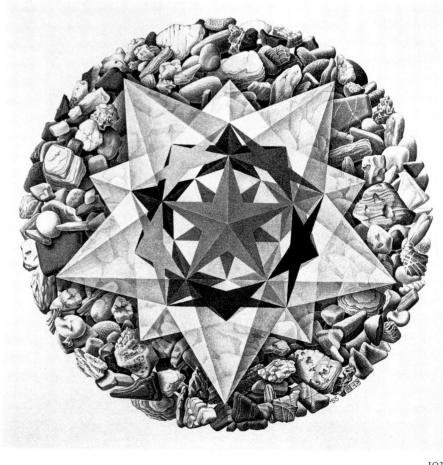

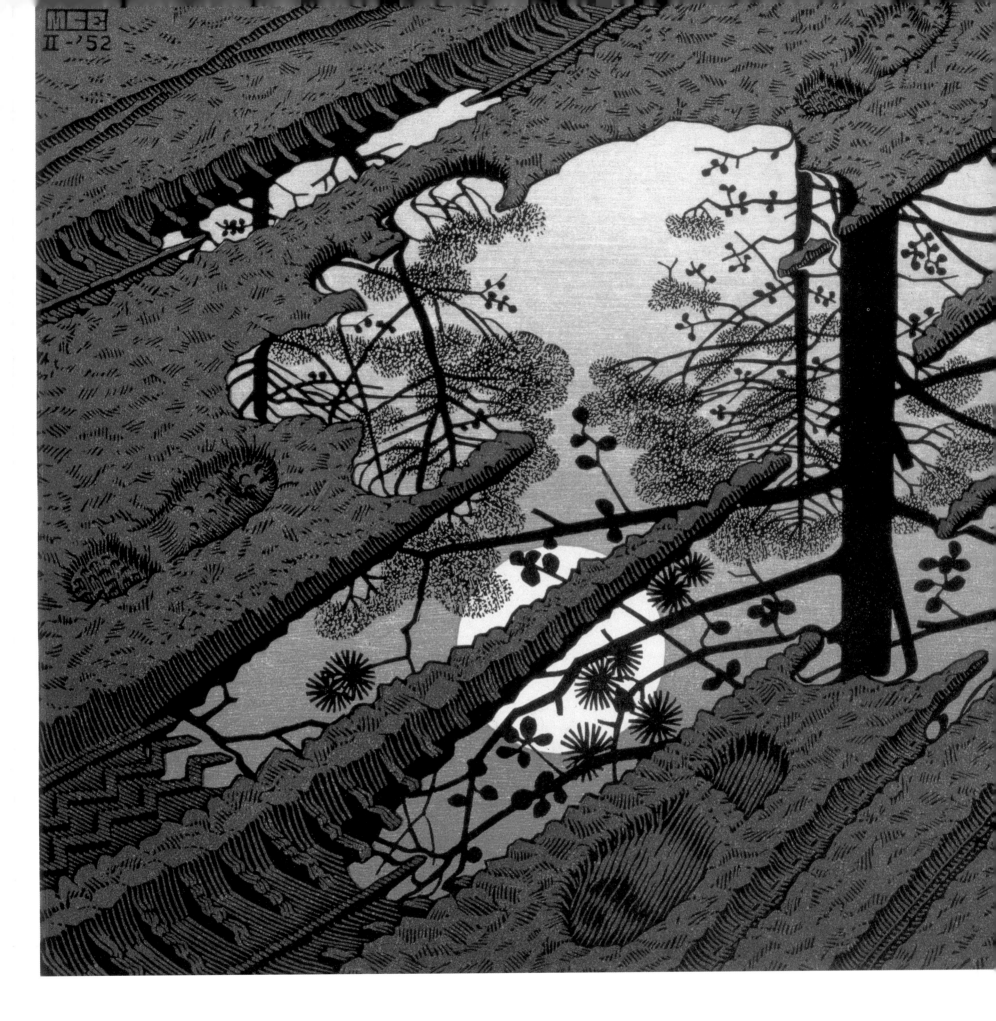

In addition, I also finished the **Puddle**, a woodcut in three colors, a very impressionistic theme to be sure (for me), but the symbolism of which fascinated me in the manner of Antoine de Saint-Exupéry who says somewhere: "Une mare en relation avec la lune révèle des parentés cachées" ("A puddle in relation to the moon reveals hidden connections").
Letter to Paul Kessler, 4 March 1952

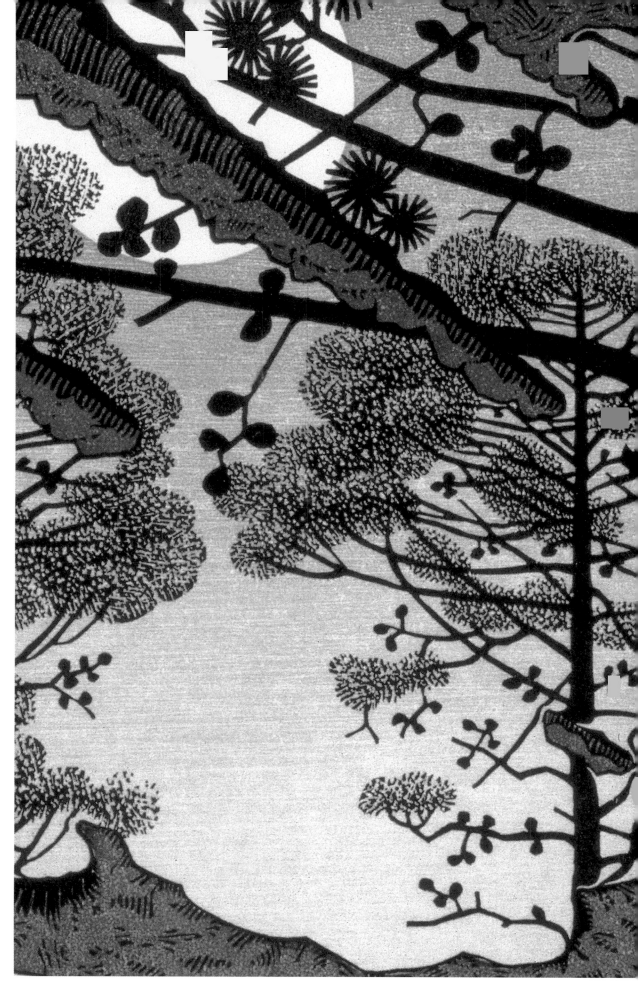

173 | 174 173 **Puddle**
 1952, Woodcut, 9 ½ x 12 ½" (240 x 319 mm)
 174 Detail of **Puddle**

I have absolutely no reason to complain about "success" with my work; nor about a lack of new ideas, there are plenty of those. And yet, from time to time a boundless sense of inferiority plagues me, a desperate feeling of general failure; how does a person acquire such bits of lunacy? And in the meantime, that blackbird is starting up again in his attempt to see if on the last day of February he still knows last year's ditty.
 Letter to his son Arthur, 28 February 1959

175 | 176
 177 178 179

175 Study for **Rippled Surface**
 1950. Ink and graphite, 10 ⅝ x 13" (270 x 331 mm)
176 Study for **Rippled Surface**
 1950. Ink and graphite, 12 ¾ x 16 ⅛" (325 x 410 mm)
177 Study for **Rippled Surface**
 1950. Ink and graphite, 12 ⅝ x 16 ¼" (322 x 415 mm)
178 Study for **Rippled Surface**
 1950. Ink and graphite, 7 ½ x 13 ¾" (190 x 350 mm)
179 Study for **Rippled Surface**
 1950. Ink and graphite, 12 x 16 ¾" (305 x 425 mm)

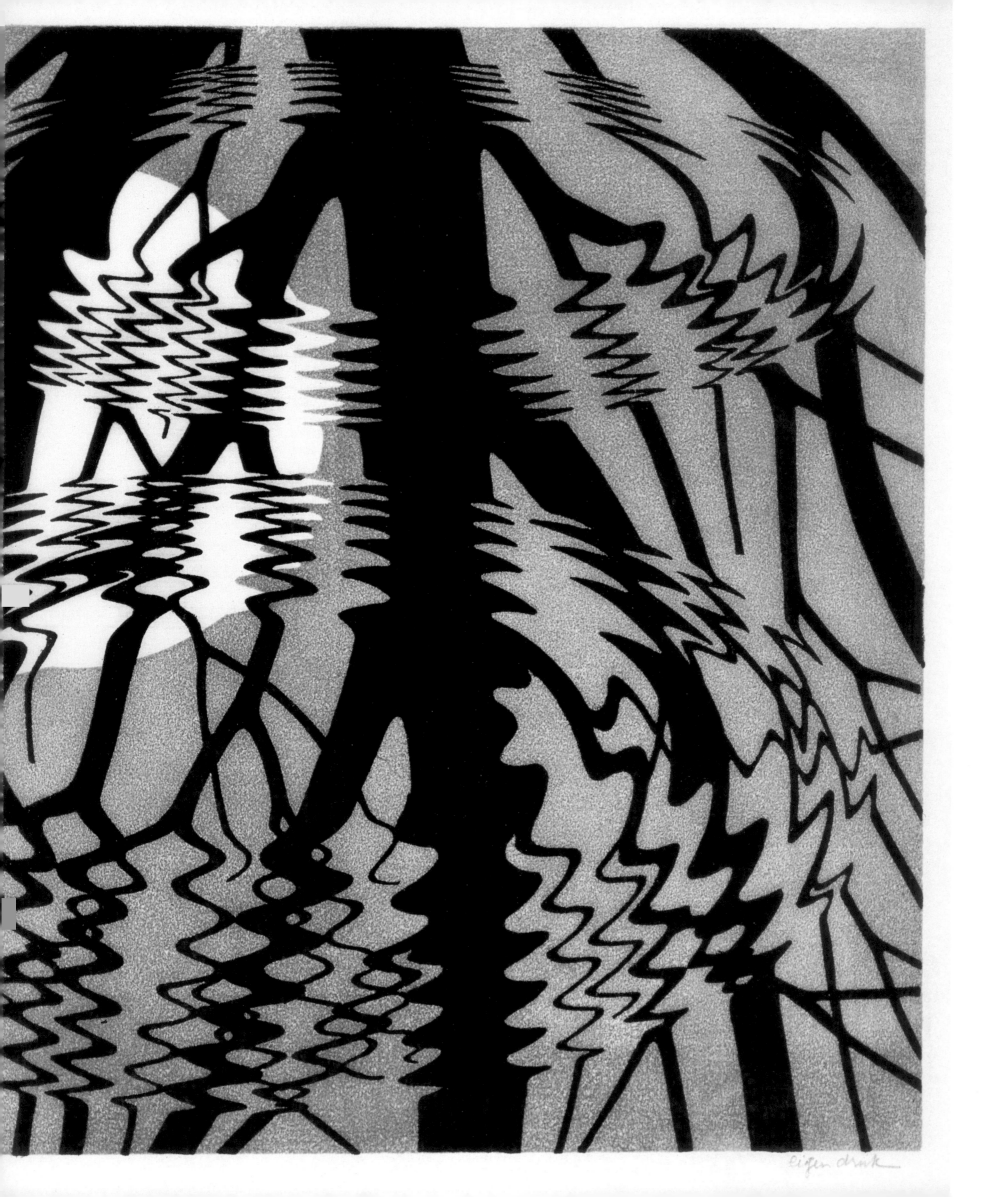

eigen druk

With every artistic expression, whether it concerns music, literature or the visual arts, it's first of all a question of sending a message to the outside world, that is to say, making a personal thought, a striking idea, an inner emotion visible to others in a sensual manner and this in such a way that the viewer does not remain uncertain about the constructor's intention.

Letter to B. Merema, 10 May 1952

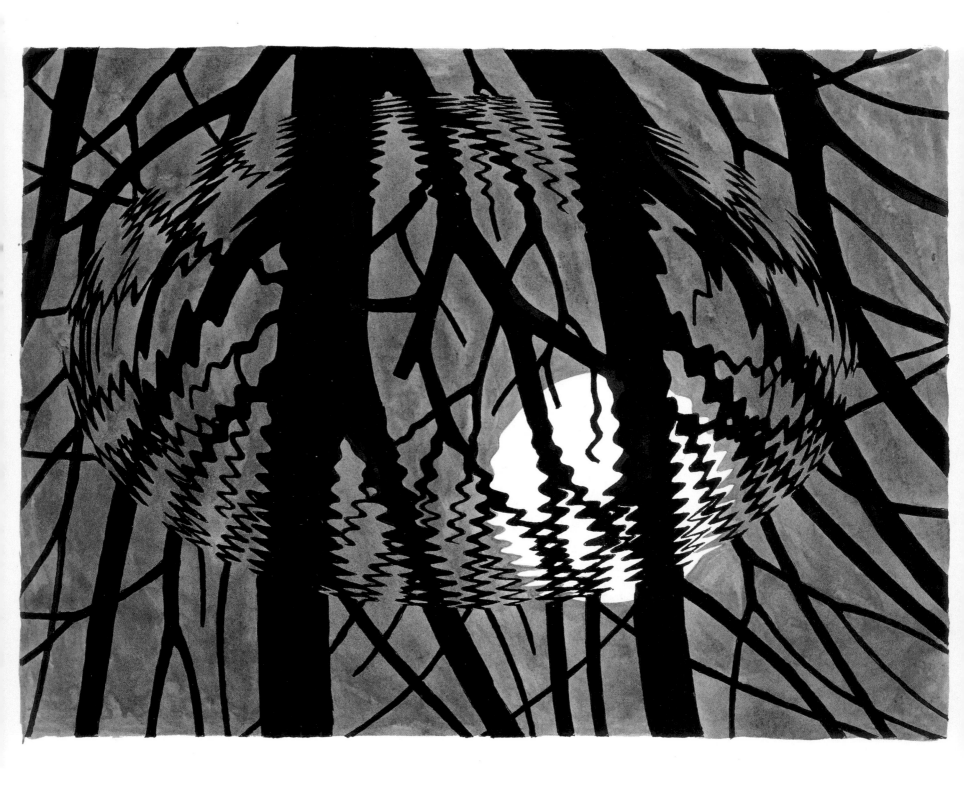

180 Study for **Rippled Surface**
1950. Ink, 11 ½ x 15" (293 x 380 mm)

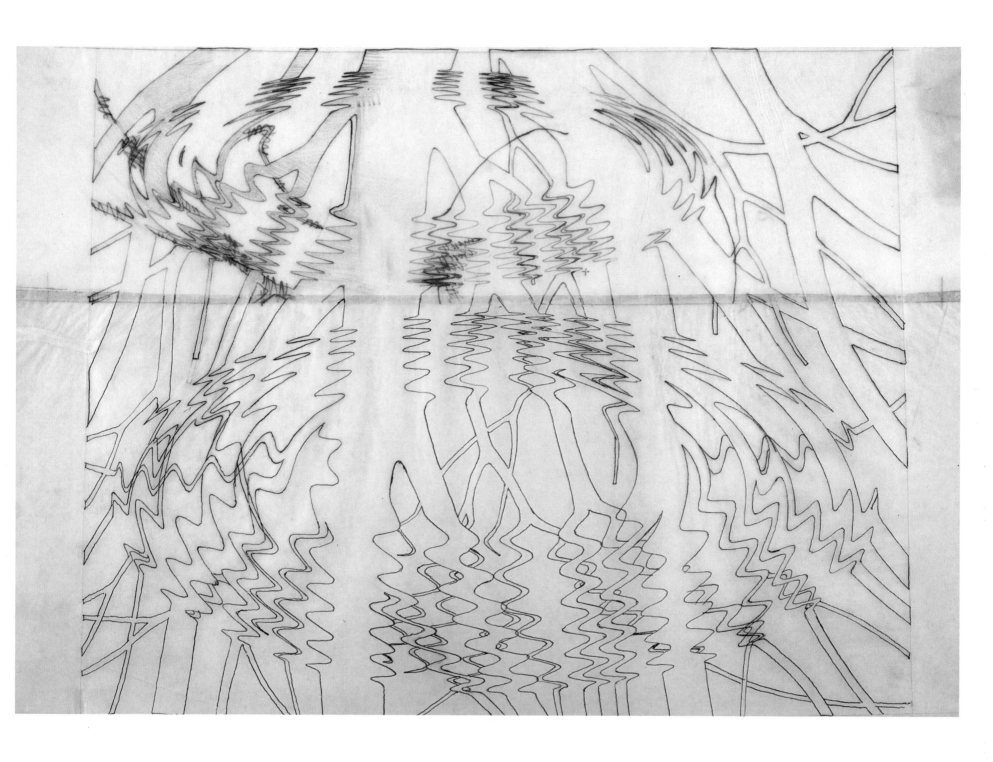

181 **Rippled Surface**
 1950. Woodcut and linoleum cut, 10 ¼ x 12 ⅝" (260 x 320 mm)
182 Study for **Rippled Surface**
 1950. Ink and graphite, 11 ⅝ x 15 ⅞" (295 x 404 mm)

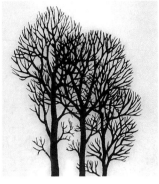
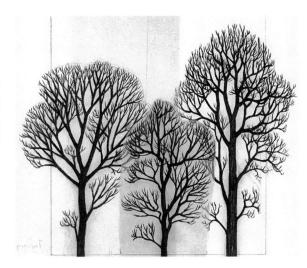

It has happened to me, while taking solitary walks through the woods of Baarn, that I would suddenly stop in my tracks and stand stiff as a board, overcome by a frightening, unreal and yet blissful sense of standing eye to eye with the inexplicable. That tree there in front of me, as an object, as part of the woods, is perhaps not so amazing, but the distance, the space between it and me, suddenly seems unfathomable.

He who wants to depict something nonexistent has to follow certain rules. Those rules are more or less the same ones as for fairy tales.

The element of the inscrutable, on which he now wants to focus attention, needs to be surrounded, to be veiled by a perfectly common everyday evidence, recognizable to all. That true-to-nature environment, acceptable to any superficial spectator, is indispensable for creating the desired shock.

*From **The Impossible**, lecture, 5 November 1963*

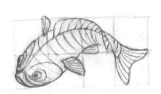

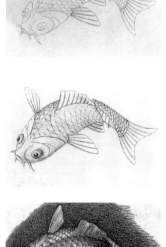

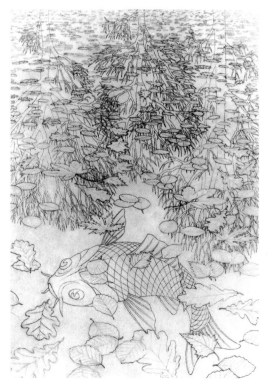

195 | 196

195 **Waterfall**
 1961. Lithograph, 15 x 11¾" (380 x 300 mm)
196 Study
 Ink, 8 x 9⅜" (202 x 237 mm)

I want to delight in the smallest of small things, a bit of moss 2 cm in diameter on a little piece of rock, and I want to try here what I have been wishing for so long, namely to copy these tiniest bits of nothing as accurately as possible just to realize how great they are. I've already started that but it is so dreadfully difficult. With your nose right on top of it, you see all of its beauty and all of its simplicity, but when you start drawing, only then do you realize how terribly complicated and shapeless that beauty really is.

Letter to Jan van der Does de Willebois, Ravello, spring 1923

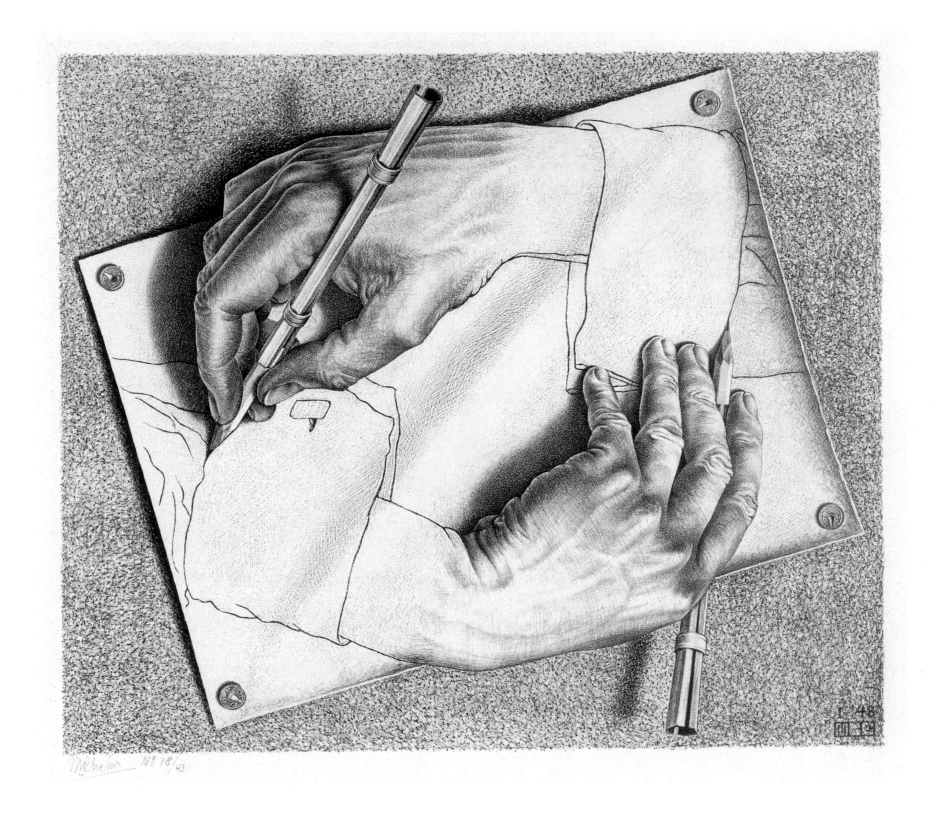

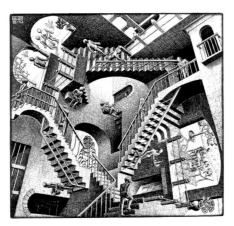 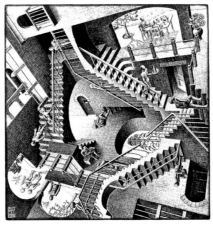 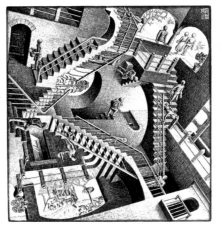 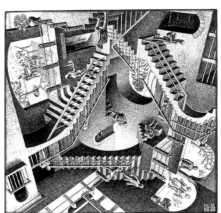

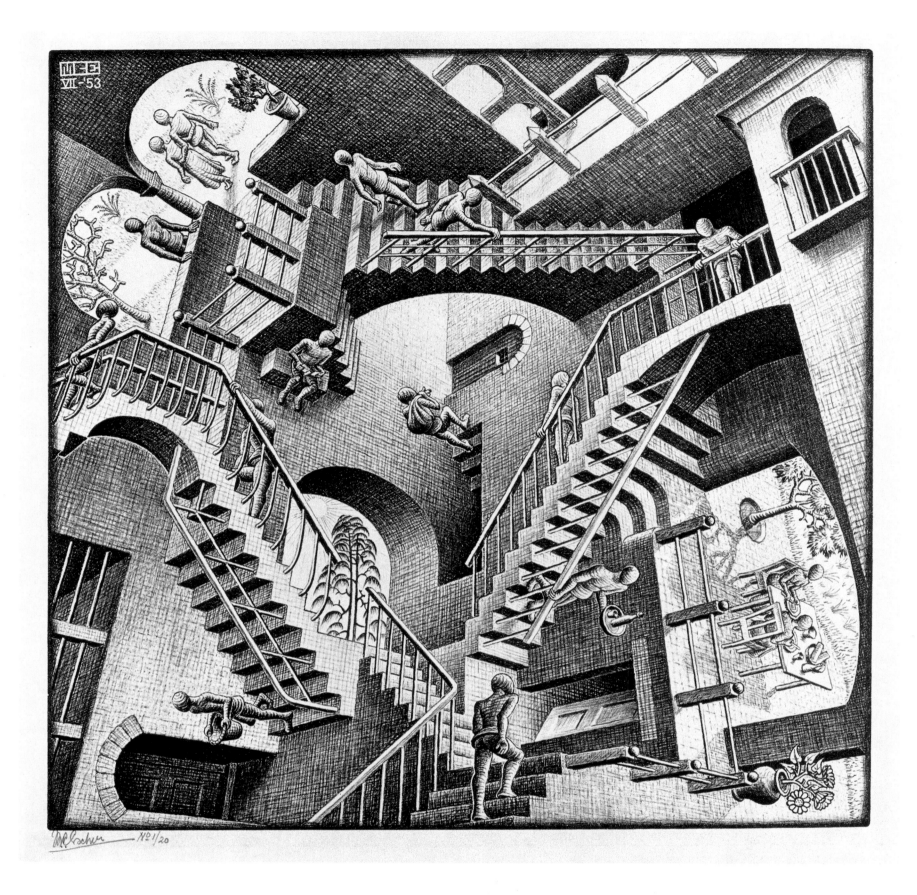

What pathetic slaves we turn out to be of gravity's dominant power over everything on earth! And then that right angle between the horizontal and the vertical! Almost everything we construct and put together: houses, rooms, closets, tables, chairs, beds, books, in principle they're all right-angled boxes. They really are dreadfully boring and annoying, those walls of our rooms, always with the same old angles of 90 degrees. Our only consolation is that we cannot help it. It isn't our fault; we must, like it or not, obey gravity, our tyrant.

*From **Perspective**, lecture, Gemeentemuseum, The Hague, 3 March 1954*

Only in a virtual world can a hand both be drawing and be drawn at one and the same time, can one plane be both floor and wall, and can a single staircase be used in the same direction both for climbing and descending.
 J.L.L.

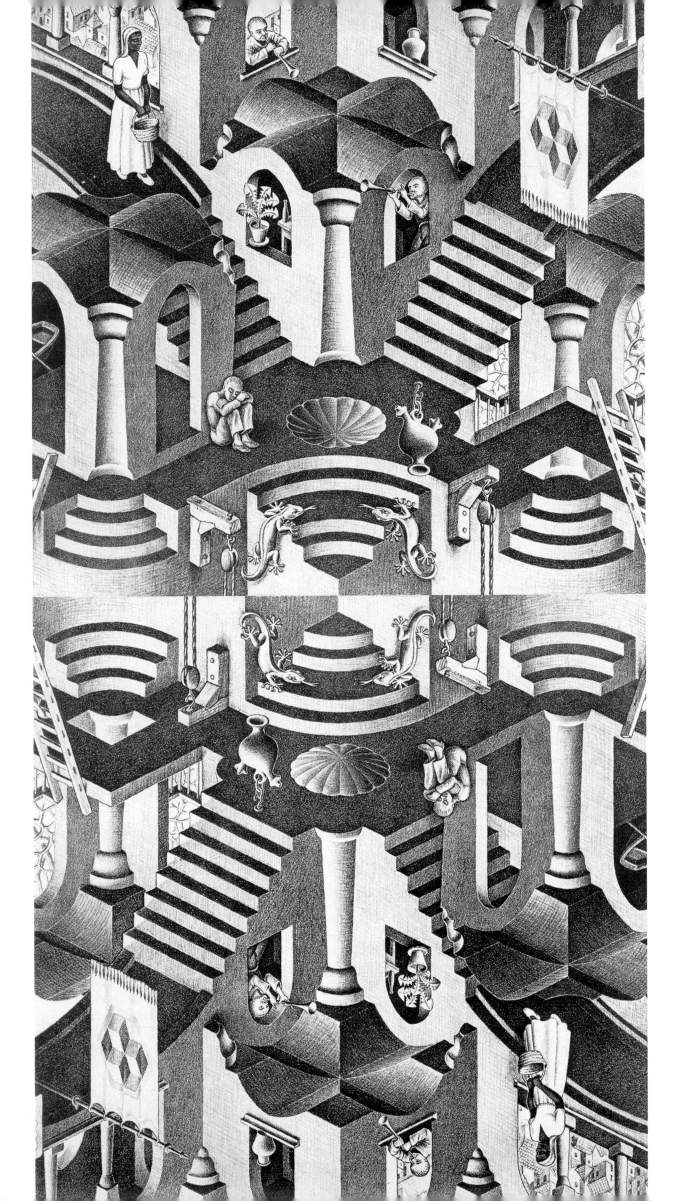

Two boys playing the flute are depicted. The one on the left is looking down on the cross vault of a little house. He could climb out through the window against which he is leaning, walk across the roof and he could jump down onto the dark floor in front of the little house. However, if he bends forward, the flute player on the right sees the same roof as a dome above his head and he's sure to know better than to climb out, because for him an unfathomable chasm lies gaping below.

*On **Convex and Concave**, 1955*

199 | 201

200

199 Detail of **Convex and Concave**

200 Detail (upside down) of **Convex and Concave**

201 **Convex and Concave**
1955. Lithograph, 10 ⅞ x 13 ¼" (275 x 335 mm)

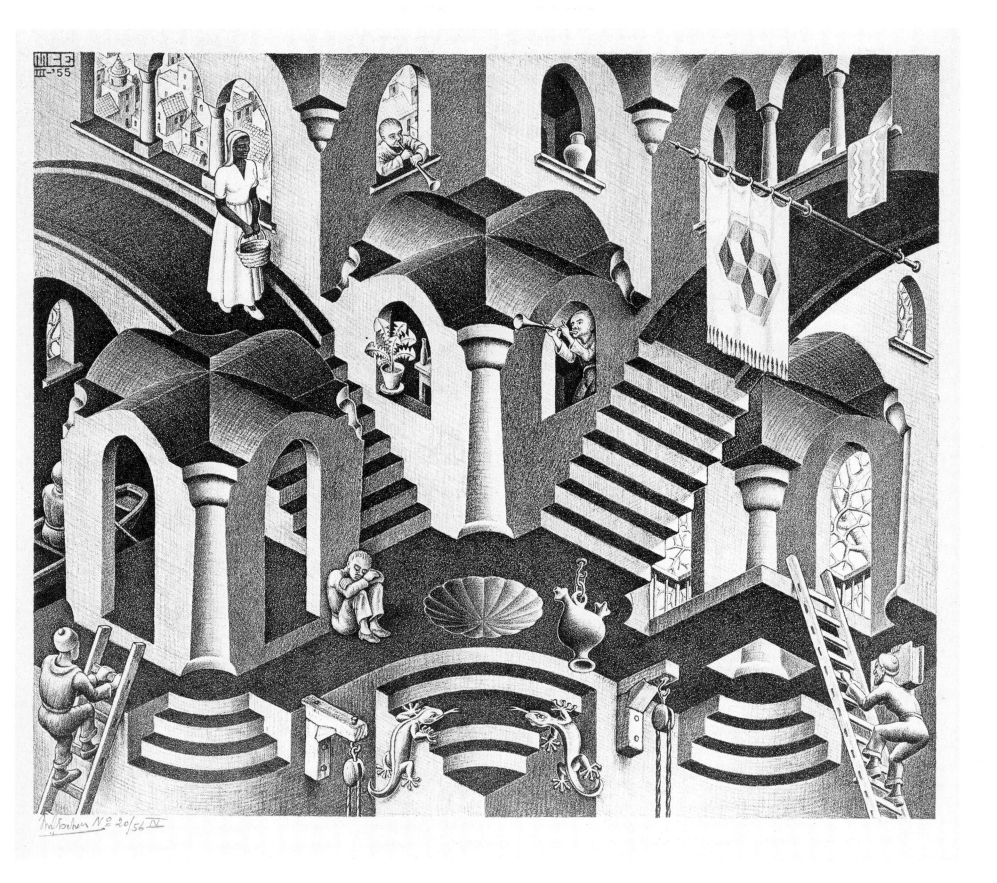

I really do feel these days like a kind of "specialist," and I don't want to "depend" on my specialty alone, but I also feel it to be my duty to devote myself to that as much as possible. I hope that with these words I'm not giving the impression of narcissism: that is not at all my intention. I am the only one who can judge how far I constantly remain below the quality I would like to attain.

Letter to J.C. Asselbergs, engineer, 17 May 1956

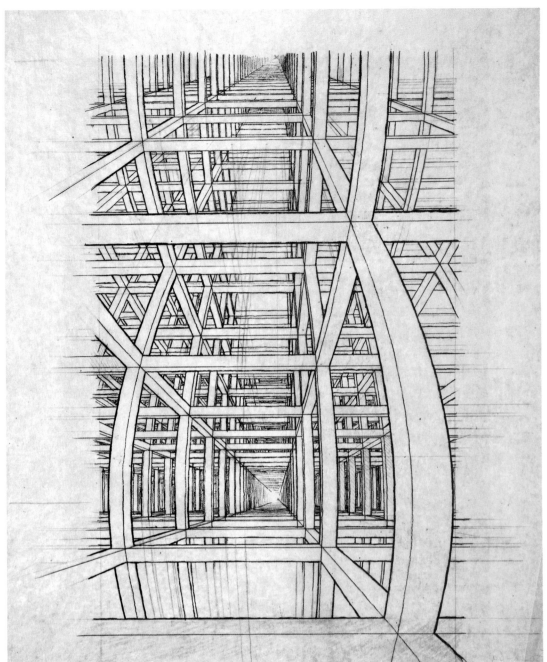

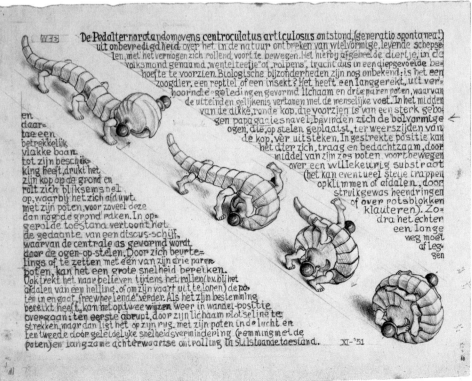

202 203 | 205 206 207

204

202 Study for **House of Stairs**
1951. Pencil and ink, 27 3/4 x 11 3/8" (705 x 290 mm)

203 Study for **House of Stairs**
1951. Pencil and ink, 16 1/4 x 12 1/8" (415 x 308 mm)

204 Study for **Curl-up**
1951. Pencil, 8 1/8 x 10 1/4" (207 x 261 mm)

205 Study for **House of Stairs**
1951. Pencil, 33 3/8 x 10 1/4" (846 x 260 mm)

206 Study for **House of Stairs**
1951. Pencil, 9 3/4 x 7 1/2" (249 x 191 mm)

207 Study for **House of Stairs**
1951. Pencil, 16 3/4 x 8 1/8" (424 x 206 mm)

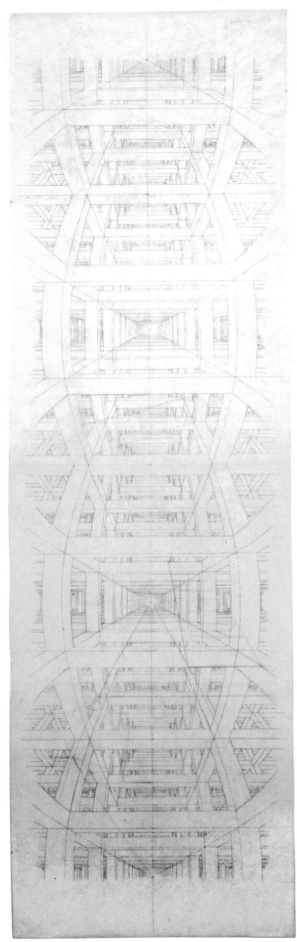

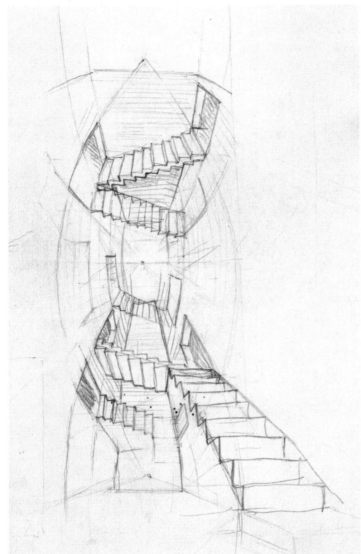

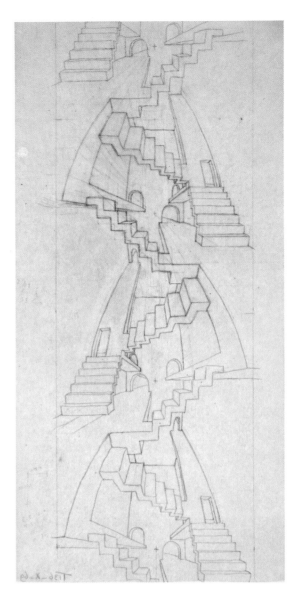

The original Dutch title of **Curl-up** *is* **Wentelteefje**. *For Escher, in the following passage, "wentelteef en rolpens" suggests the idea of "curl-up and roll," but it is also a rich play on words. "Wentelteefje" is the Dutch word for "French toast," a contraction of "wentel het eventjes" ("turn it over briefly"): "wentelen" means "to turn (over)" and "eventjes" means "briefly"; in addition, however, as a noun a "teefje" is a female dog. "Rolpens" is a dish, chopped meat wrapped in a roll, then fried or baked; "een pens" is a belly, especially used colloquially, as in the phrase "beer belly."*

Wentelteefje
… is the first specimen that originated from dissatisfaction. It was, so to speak, so dissatisfied with the fact that it did not exist that this irritation spontaneously led to its birth. There is a vague indication of sex in the names wentelteef en rolpens. A teef according to the Koenen [Dutch-Dutch dictionary] is a female dog. So the Wentelteef is — presumably — the female specimen. Personally, I associate "pens" with something male (a question of intuition). So the Rolpens is probably the masculine version. Therefore Rolpens and Wentelteefje will probably mate. How does that work? Most likely they're groping in the dark. From this I conclude that copulation takes place at night, nothing special. Possibly the result is an egg, a discus-shaped egg. However, I've been told on good authority that reproduction occurs asexually, through the lithographic printing press. I fear that this manner of reproduction will lead to only a very few specimens because, for the time being, it is a limited edition. Perhaps they can tell you more in the Congo.
 Letter to H. Weerink, 27 January 1952

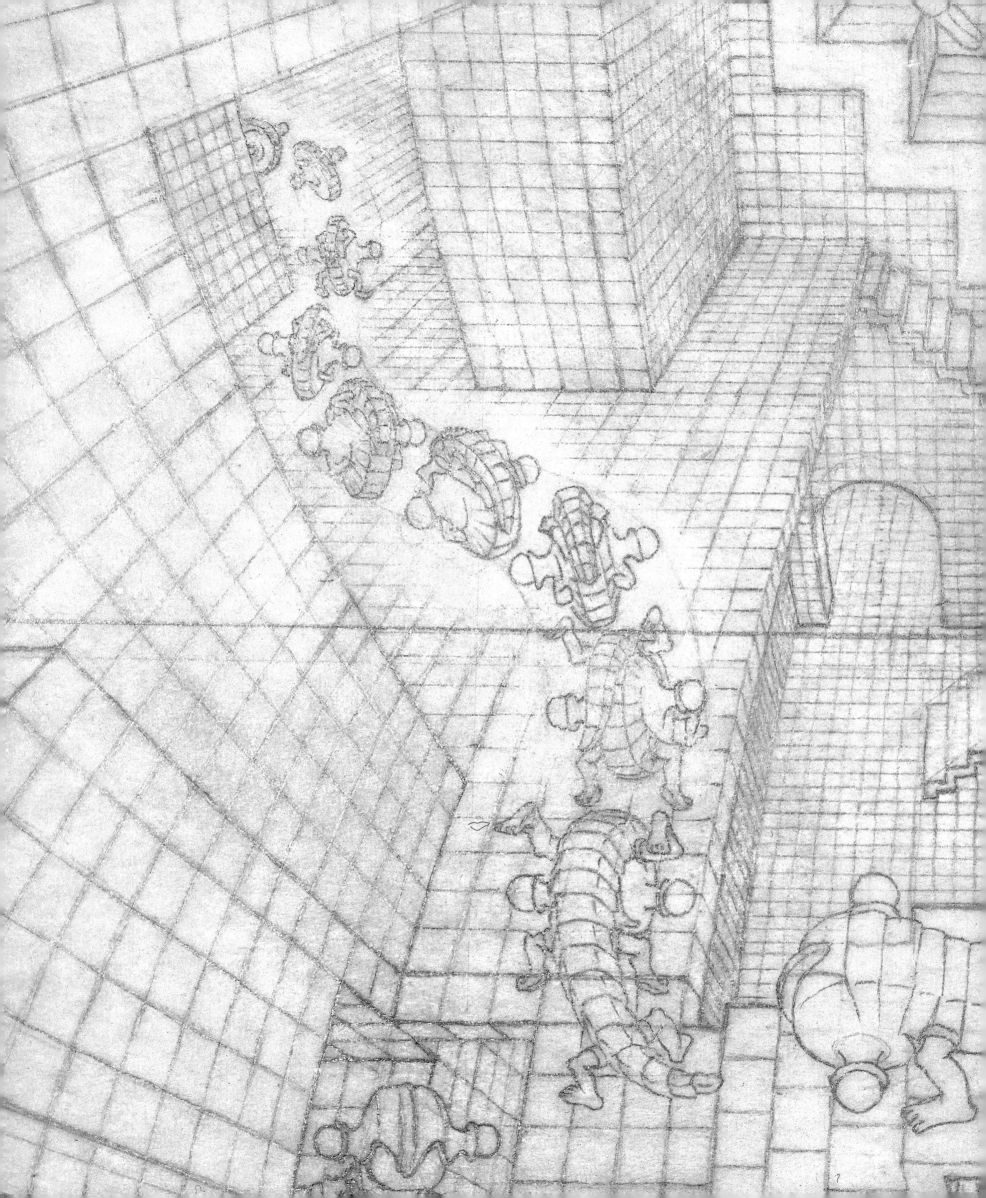

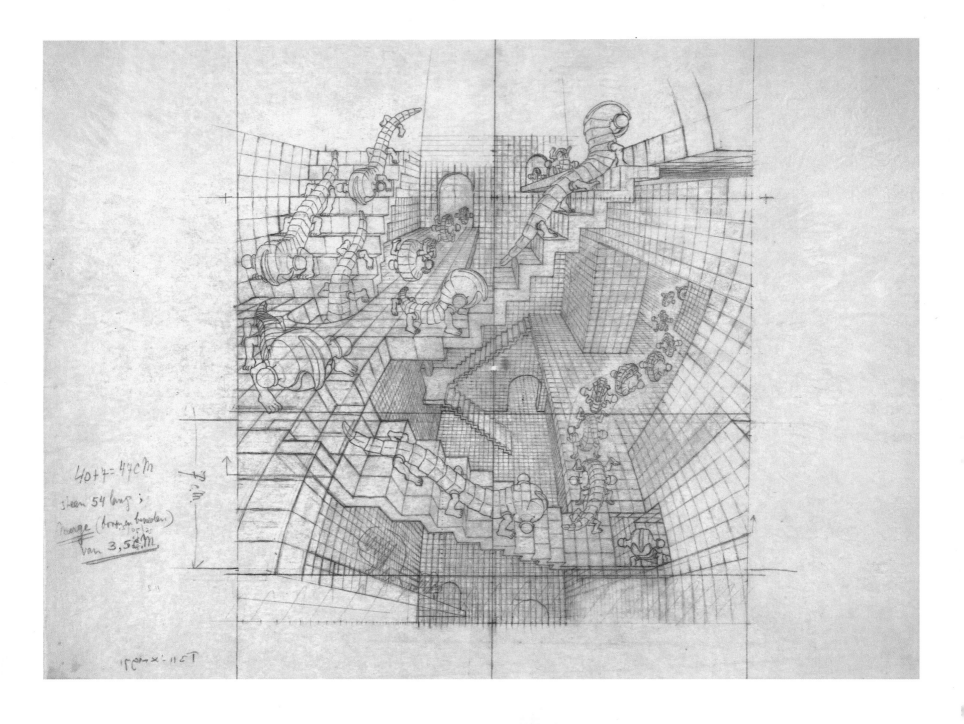

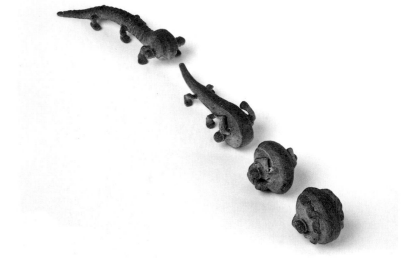

If only you knew how entrancing, how stirringly
beautiful the images in my head are, the ones I am
unable to express.

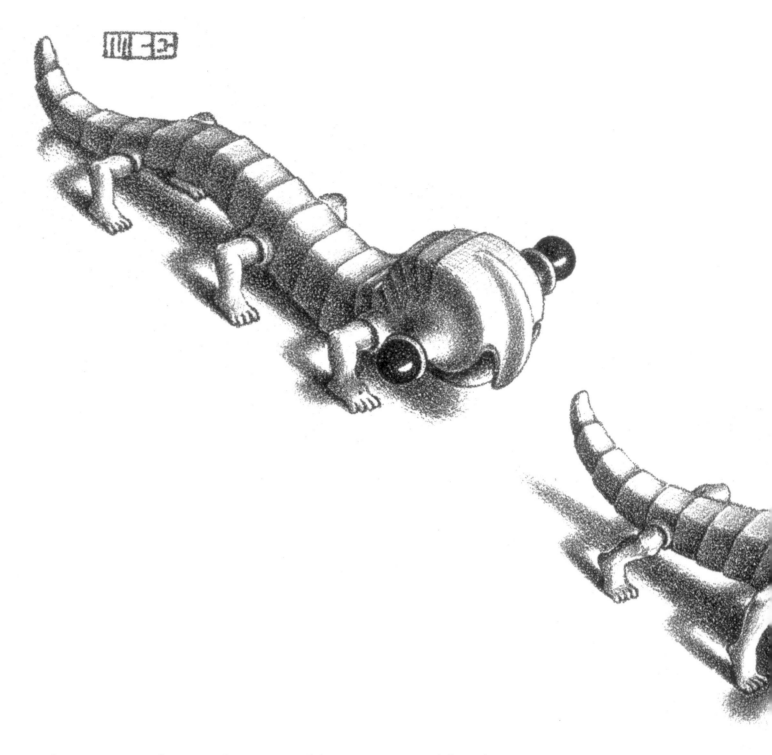

The Pedalternorotandomovens centroculatus articulosus originated (generatio spontanea!) from the dissatisfaction with nature's lack of wheel-shaped, living creatures capable of moving forward in rolling fashion. The little animal here depicted, popularly known as "wentelteefje" or "rolpens," is thus trying to meet a deep-seated need. Biological particularities are scarce as yet: is it a mammal, a reptile or an insect? It has a body made up of elongated, keratinized joints and three pairs of legs, the extremities of which show a resemblance to the human foot. In the center of the thick, round head, equipped with a strongly curved parrot's beak, are the bulbous eyes, placed on stems, which stick out far on both sides of the head. In a stretched position the animal is able to advance slowly and thoughtfully by means of his six legs across any given substratum (it could possibly climb or descend steep stairs, could penetrate bushes or clamber across rocks). However, as soon as it has to cover a long distance and has a fairly flat path available, he presses his head to the ground and curls up fast as lightning, while he pushes himself off with his legs insofar as these are still touching the ground. In curled-up configuration he appears as a discus, the central axis of which is formed by the eyes-on-stems. By pushing himself off alternately with one of his three pairs of legs he can reach high speed. As he sees fit, he also retracts his legs when he rolls (for example when descending a slope or to slow down his speed) and continues in "freewheeling" fashion. When there is a reason for doing so, it can change back to a walking position again in two ways: first abruptly, by suddenly stretching his body but then he is on his back with his legs in the air, and second by a gradual slowing down of the speed (braking with his legs) and a slow backwards unrolling in a stationary position.

 Translation of the text in **Curl-up** *(215)*

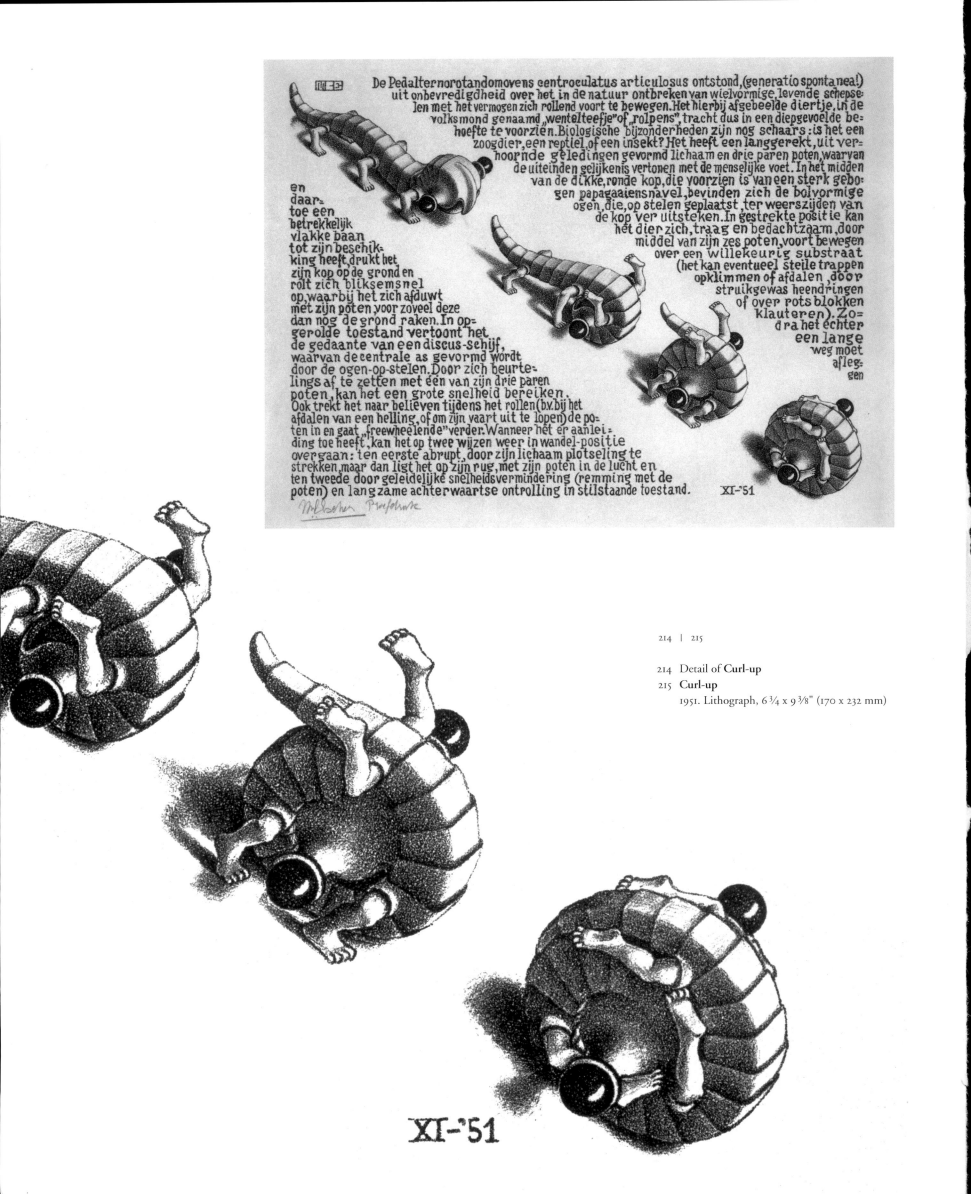

214 Detail of **Curl-up**

215 **Curl-up**
1951. Lithograph, 6 3/4 x 9 3/8" (170 x 232 mm)

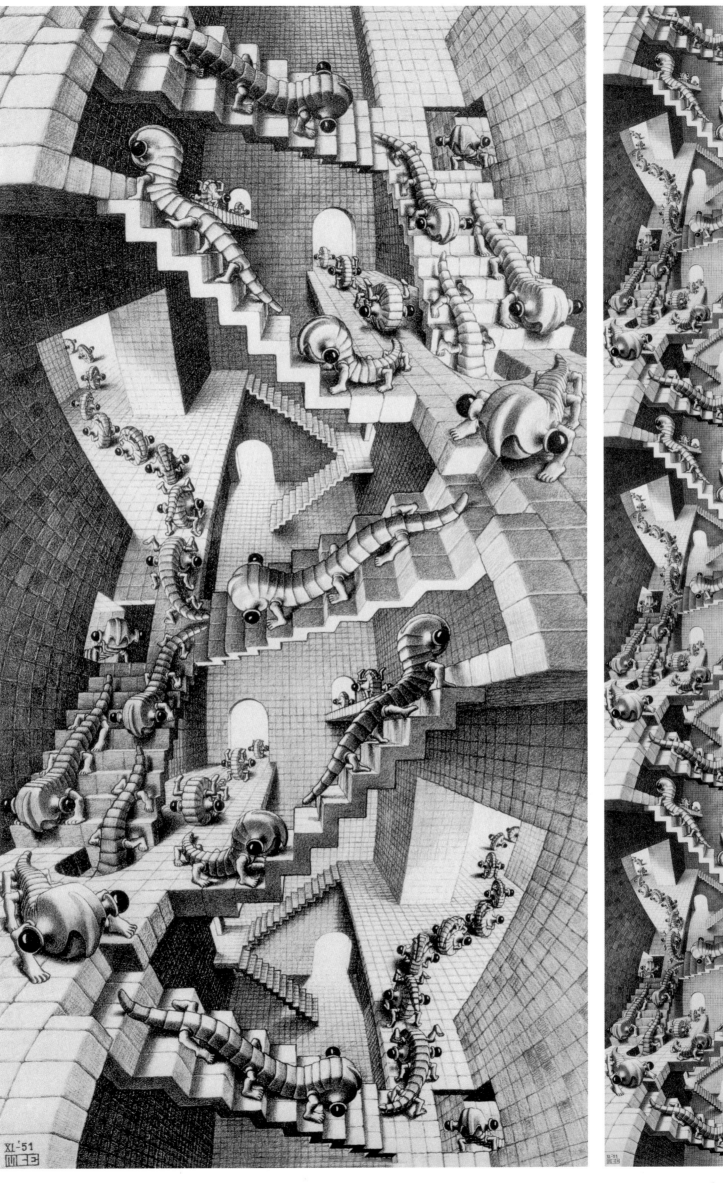
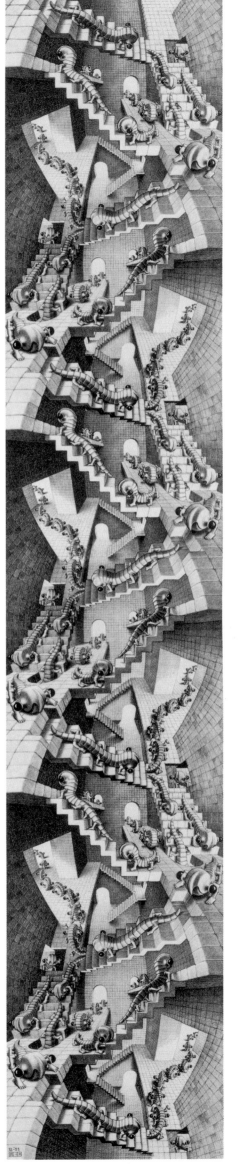

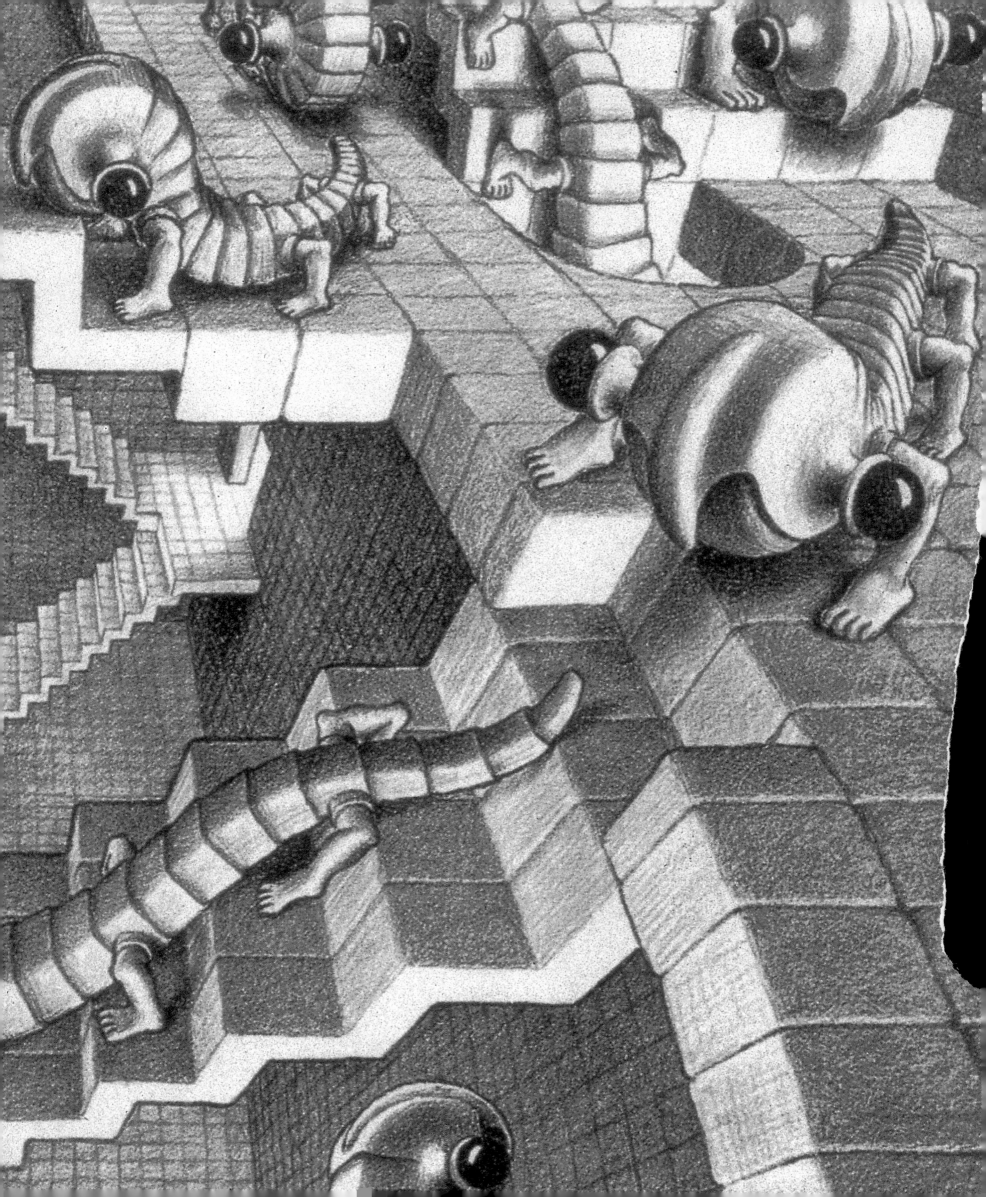

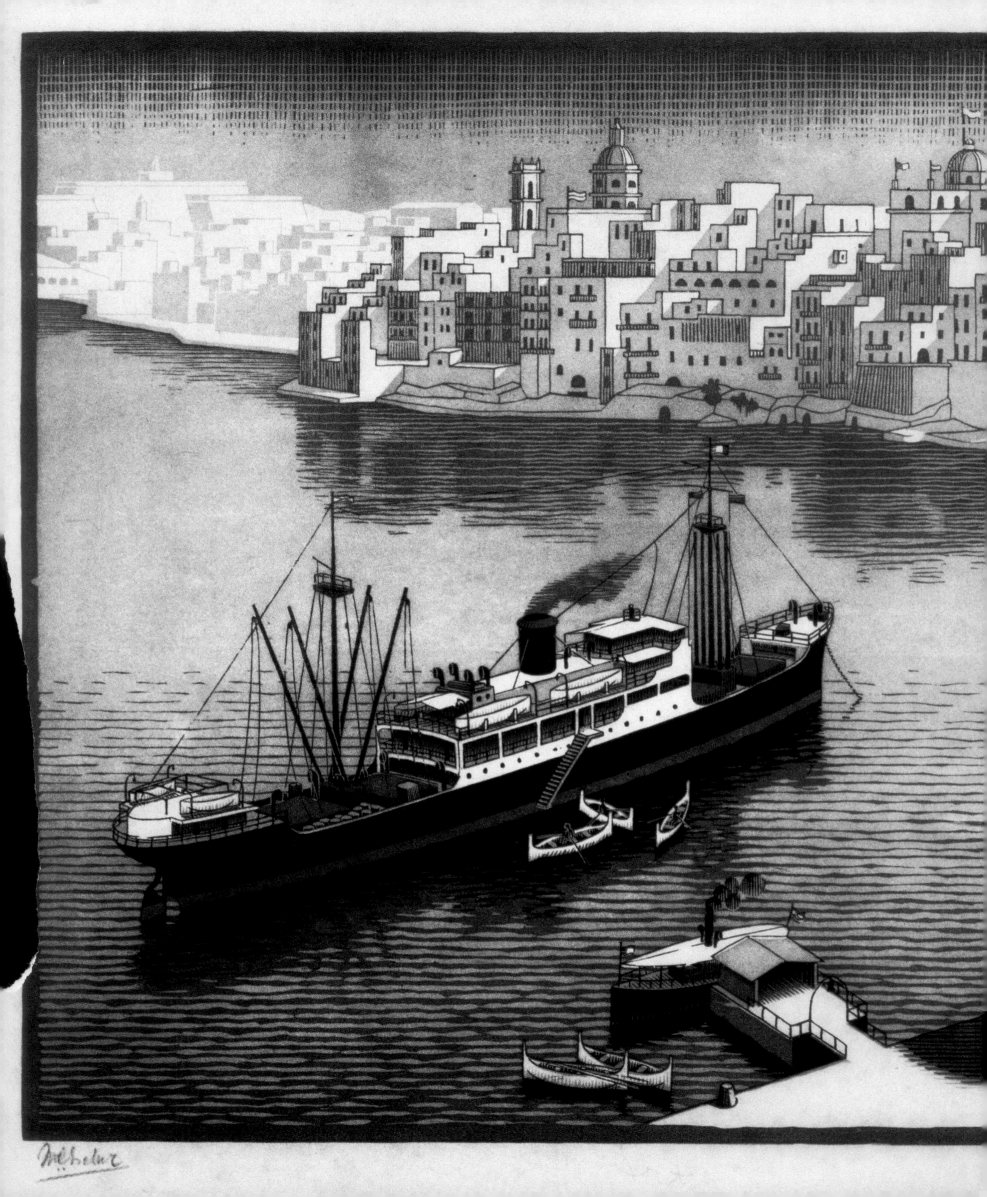

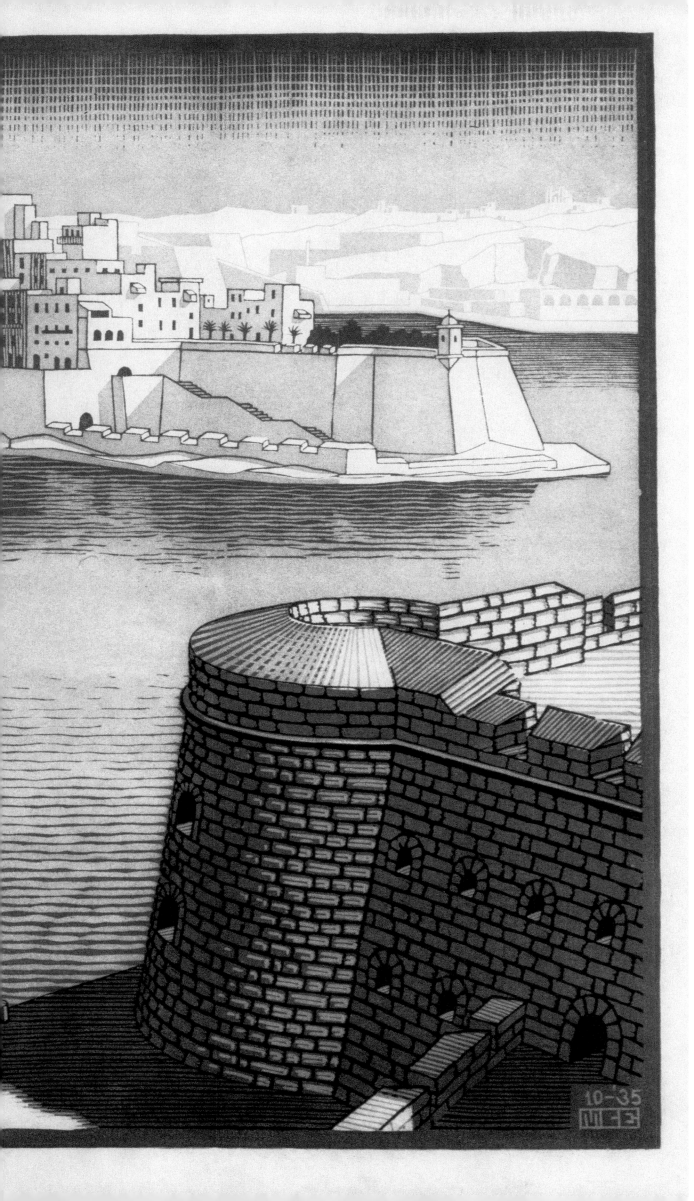

What a fantastic experience it is on a freighter like this, when waking up at night in your own cabin you are suddenly able to account for that contrast with your immovable bed on land, in which you're used to lying still and horizontally, while your bed at sea is continuously rolling around that horizontality.

Letter to his son Arthur, 28 May 1955

216 **Senglea, Malta**
1935. Woodcut,
12 ¼ x 18 ⅛" (310 x 460 mm)

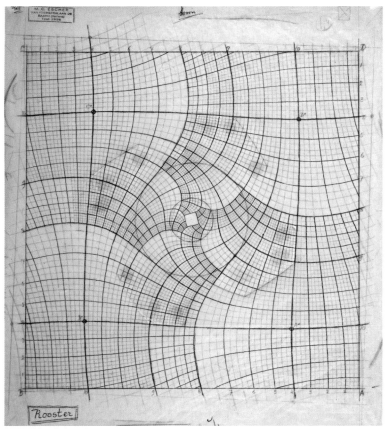

Yesterday and the day before there was such springtime
in the air that it gave me a lump in the throat, oh well,
I "had to work" (I didn't have to at all, but self-discipline,
a ghastly invention, commanded me).

Letter to his son George and daughter-in-law Corrie,
24 January 1960

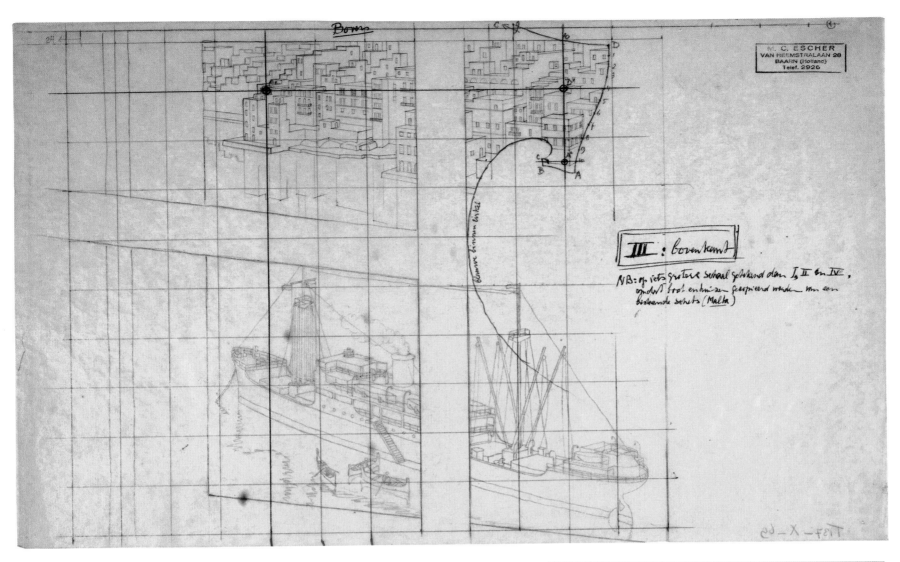

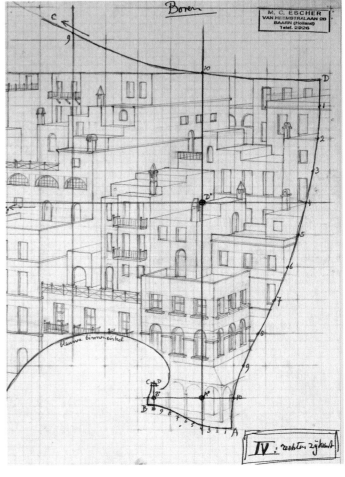

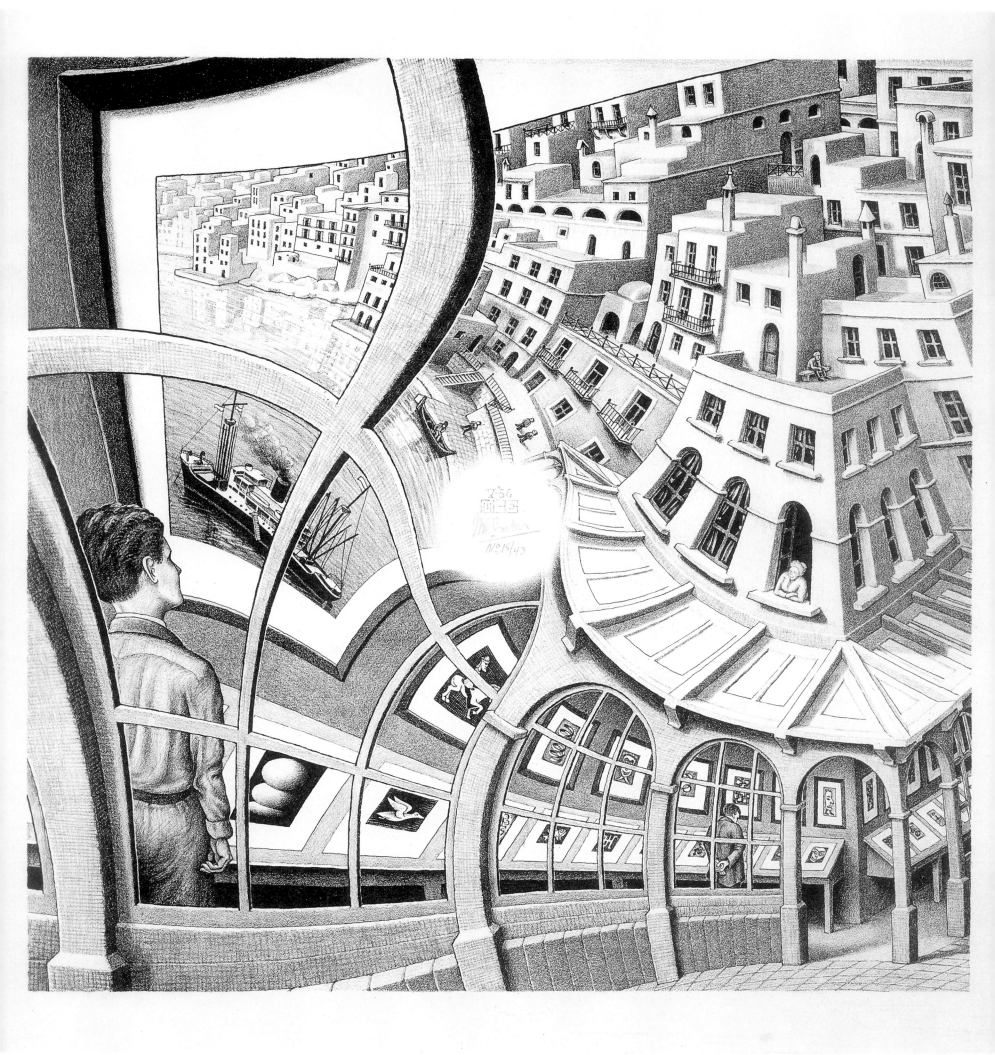

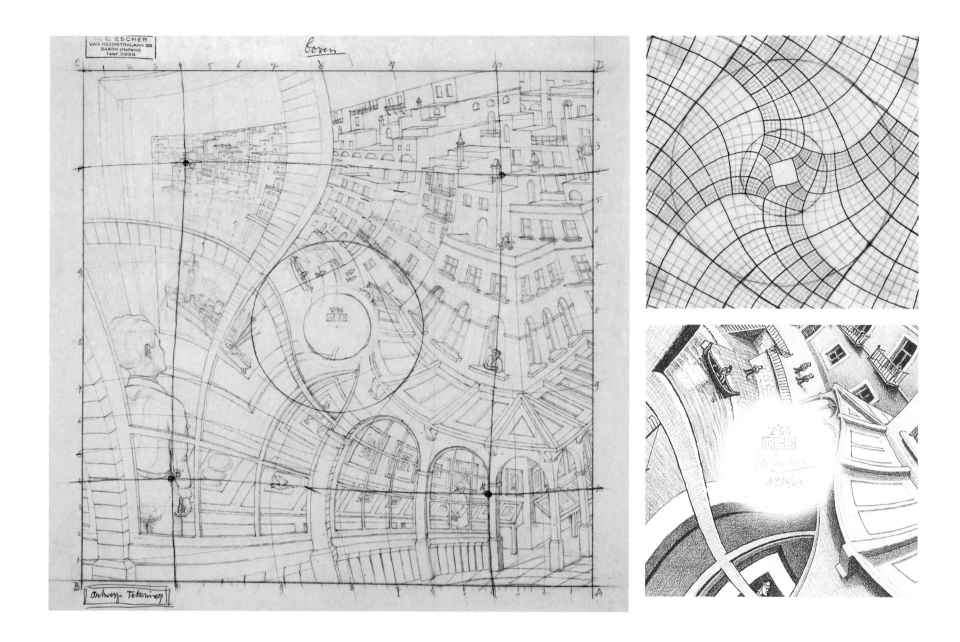

We are all just bits of the Evolution (to quote Teilhard) and if he is right then that evolution will end in millions of years in the mysterious "Omega point." And yes, why not?

Letter to his son George and daughter-in-law Corrie, 4 February 1962

Escher considered this to be one of his best pictures. With inexorable logic a ring-shaped swelling has been implemented, whereby an overlap is created of the depicted picture gallery and the world of one of the pictures therein exhibited. Only in an imagined world is such a thing possible.
J.L.L.

221 | 222 223
224

221 **Print Gallery**
1956. Lithograph, 12 ½ x 12 ½" (319 x 317 mm)
222 Study for **Print Gallery**
Pencil and ink, 14 ⅜ x 17 ⅜" (365 x 440 mm)
223 Detail of study for **Print Gallery** (see 218)
224 Detail of **Print Gallery**

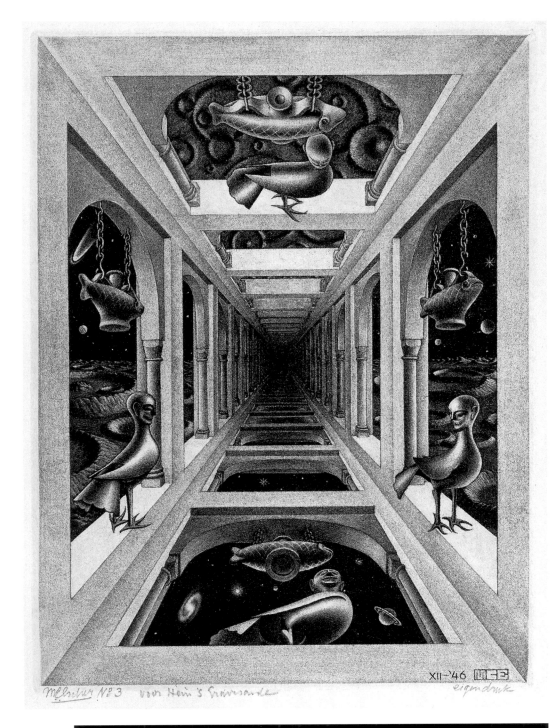

The illusion an artist wants to suggest
to his fellow men is much more subjective
and more important than the objective
material means by which he attempts
to attain it.
 Letter to B. Merema, 10 May 1952

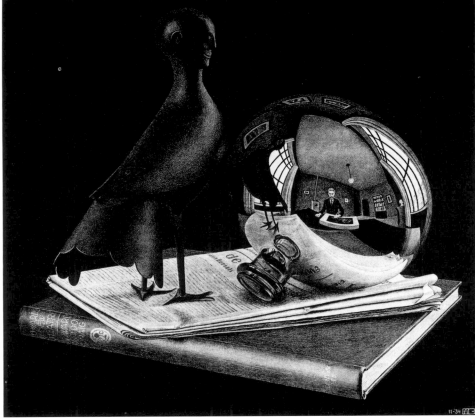

225 | 227
226

225 **Another World Mezzotint (Other World, Gallery)**
 1946. Mezzotint, 8 3/8 x 6 1/4" (213 x 159 mm)
226 **Still Life with Spherical Mirror**
 1934. Lithograph, 11 1/4 x 12 7/8" (286 x 326 mm)
227 **Another World (Other World)**
 1947. Wood engraving and woodcut,
 12 1/2 x 10 1/4" (318 x 261 mm)

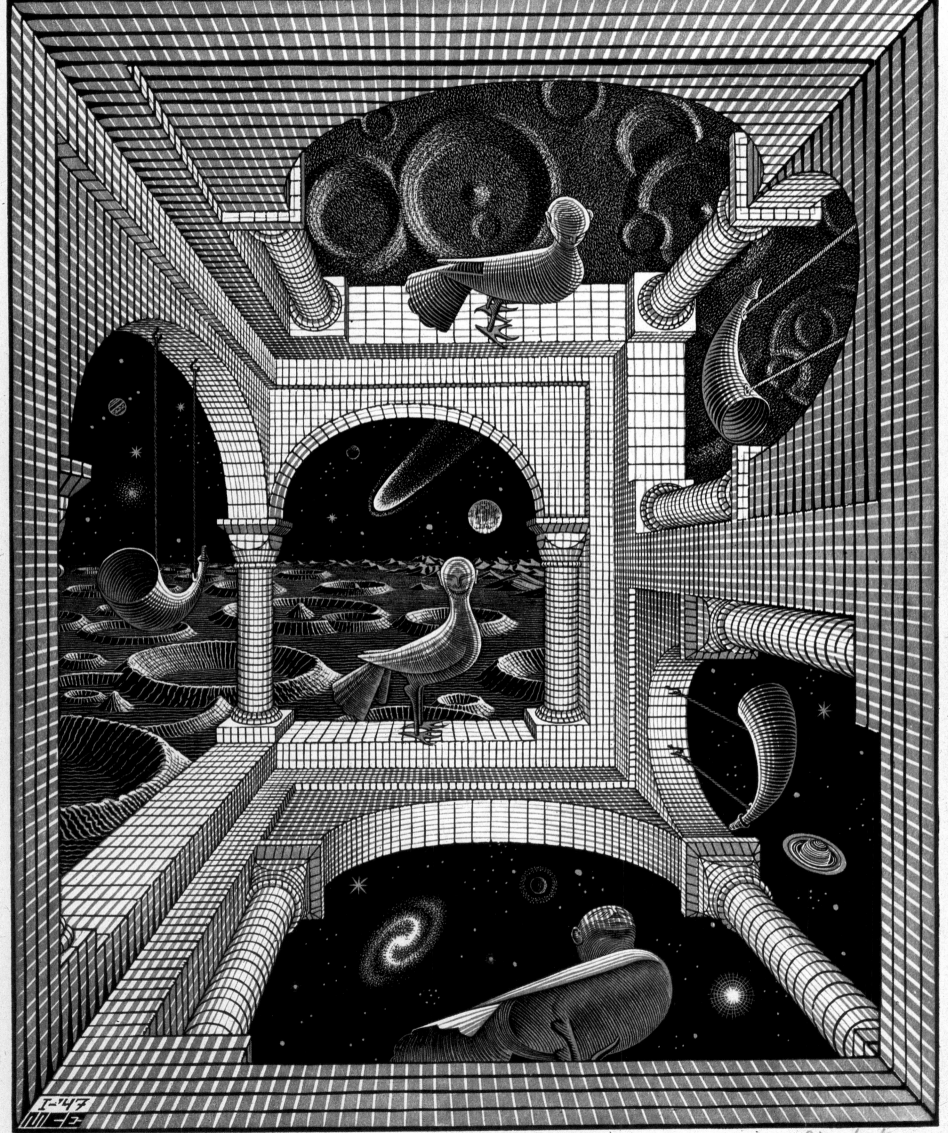

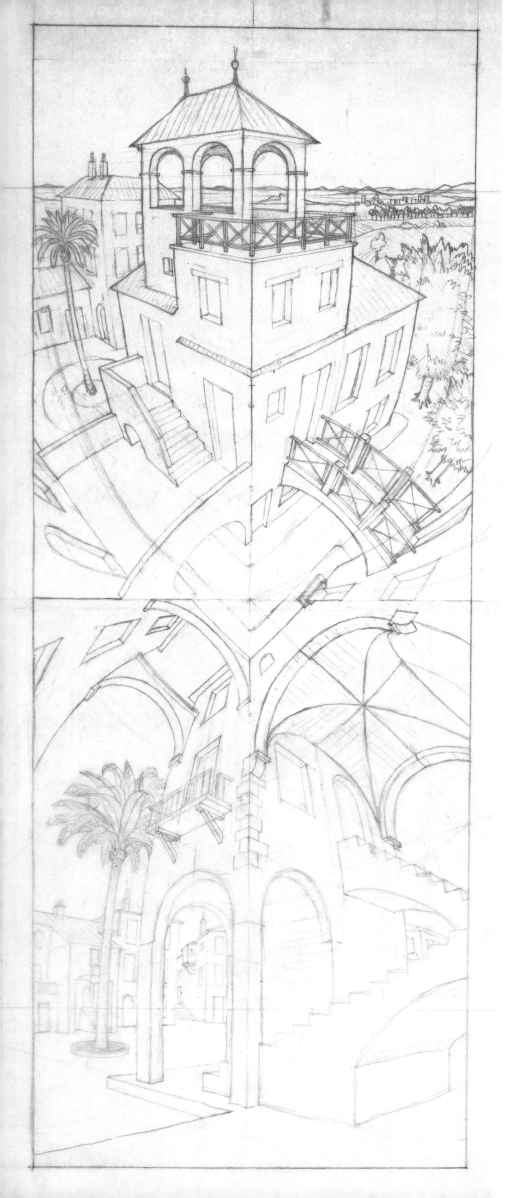

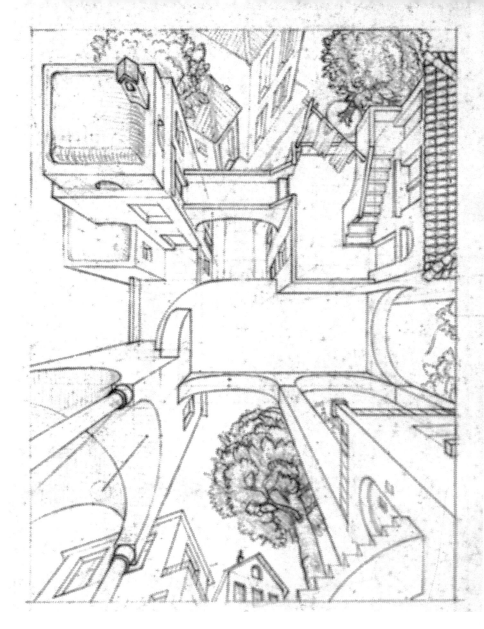

Not one of us needs to doubt the existence of an unreal, subjective space. But personally I am not sure of the existence of a real, objective space. All our senses reveal only a subjective world to us; all we can do is think and possibly mean that therefore we can conclude the existence of an objective world.
Letter to J. W. Wagenaar

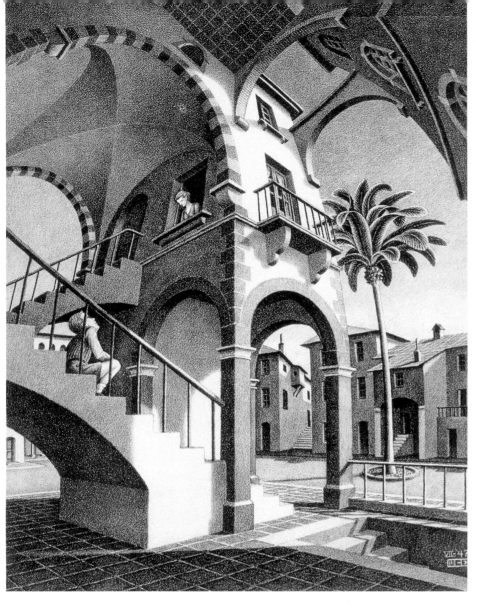

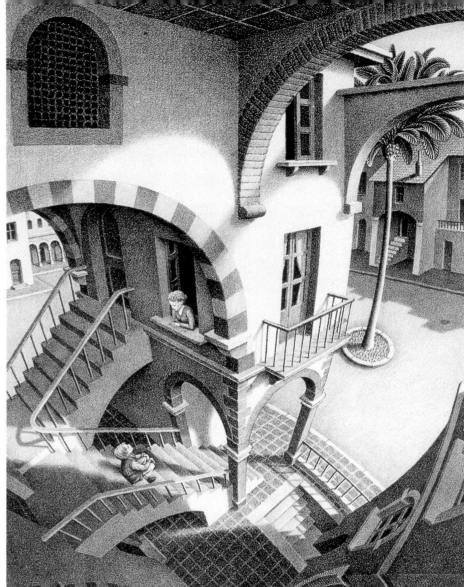

This (for a layman like myself) marvelous game in which my
thoughts penetrate into the farthest distances of so-called real
space, farther and farther, with now and then a star or a nebula
or a spiral galaxy as support and landmark, this game sometimes
suddenly turns into the contrary because of the question: what
is that so-called reality; what is this theory other than a beautiful
but primordially human illusion? Even if one corroborates
the correctness of the theory with observations, hence through
the senses, which seem to lead to the same conclusion, does that
mean the proof has been given? Why do we have such rigid faith
in our senses? And why should we not be content with the
subjective, for that matter?

Letter to J. W. Wagenaar, 16 January 1953

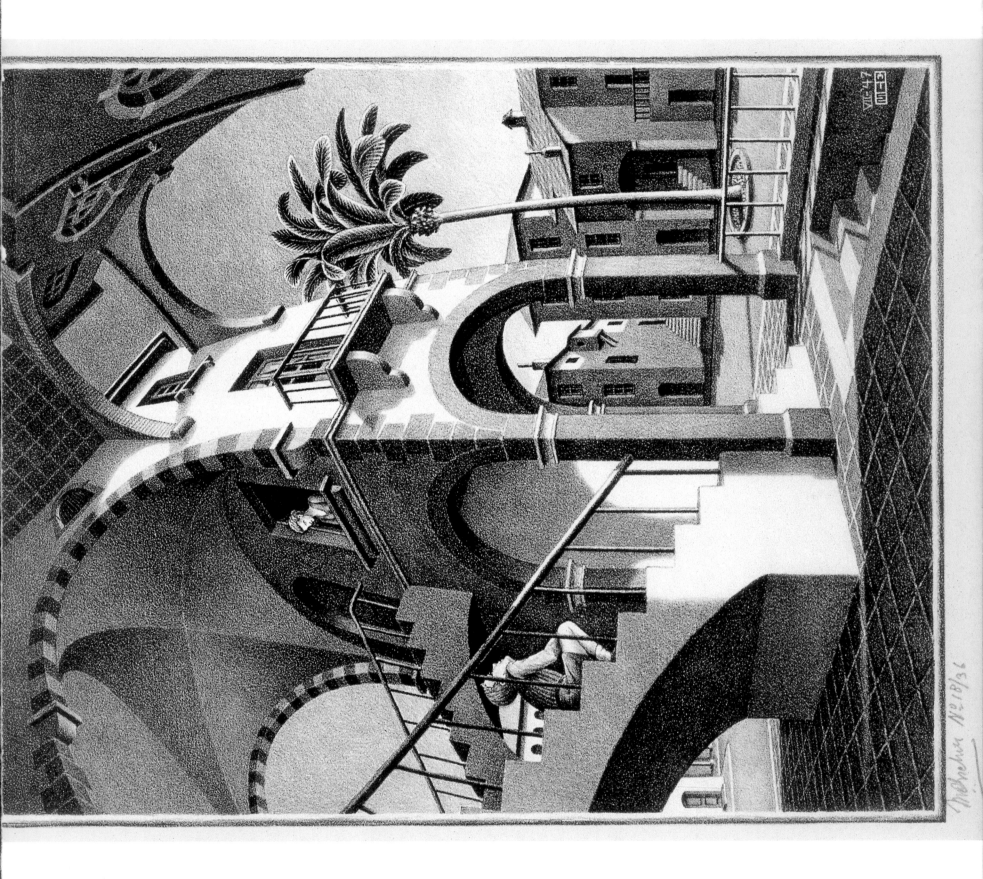

233 | 234 233 **Up and Down**

1947. Lithograph, 19 ¾ x 8 ⅛" (503 x 205 mm)

234 Detail of **Up and Down**

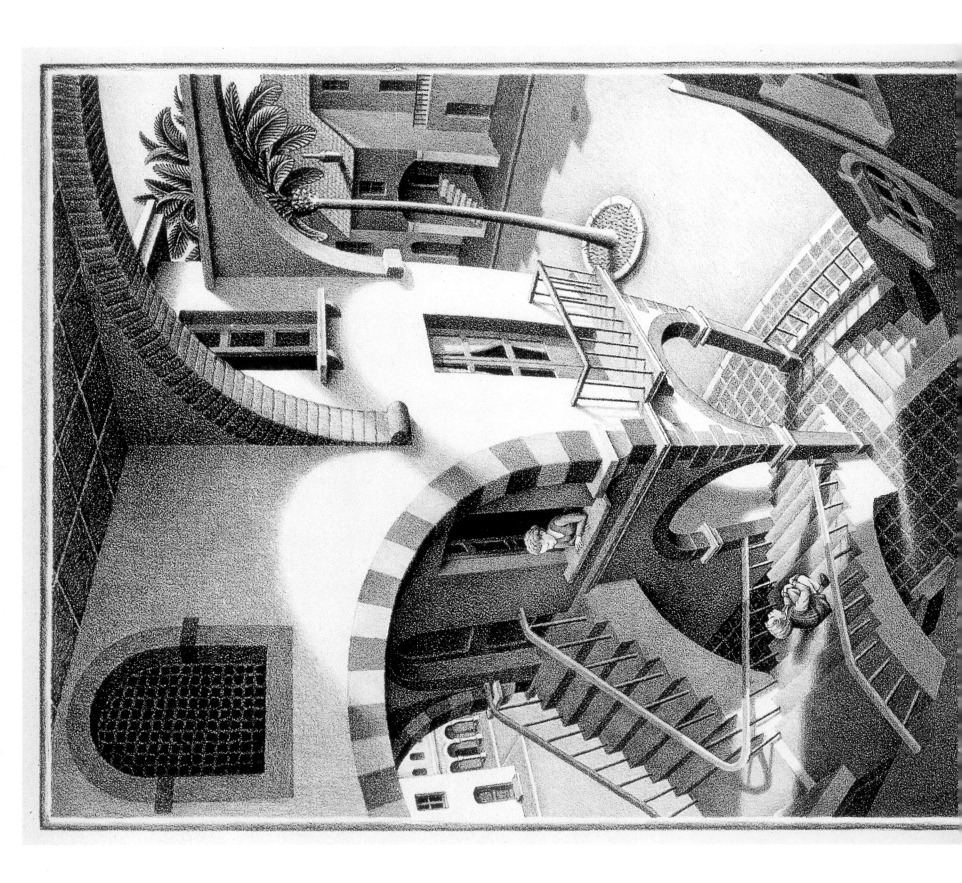

When, after secondary school, I became a student at the Haarlem School for Civil Engineering
and Decorative Arts, I only missed the chance of becoming a useful member of society by a hair.
Speech upon receiving the Culture Prize of the City of Hilversum, 5 March 1965

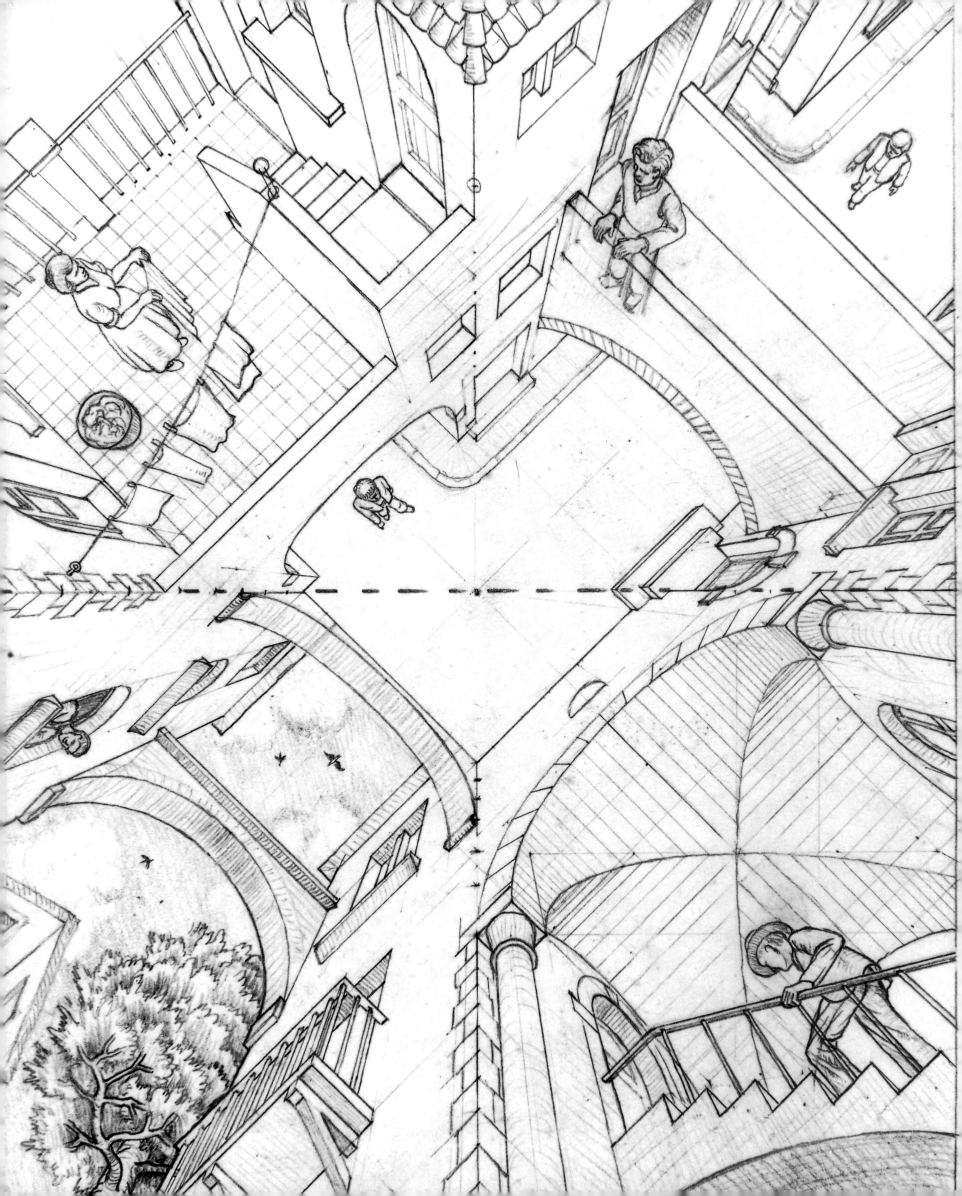

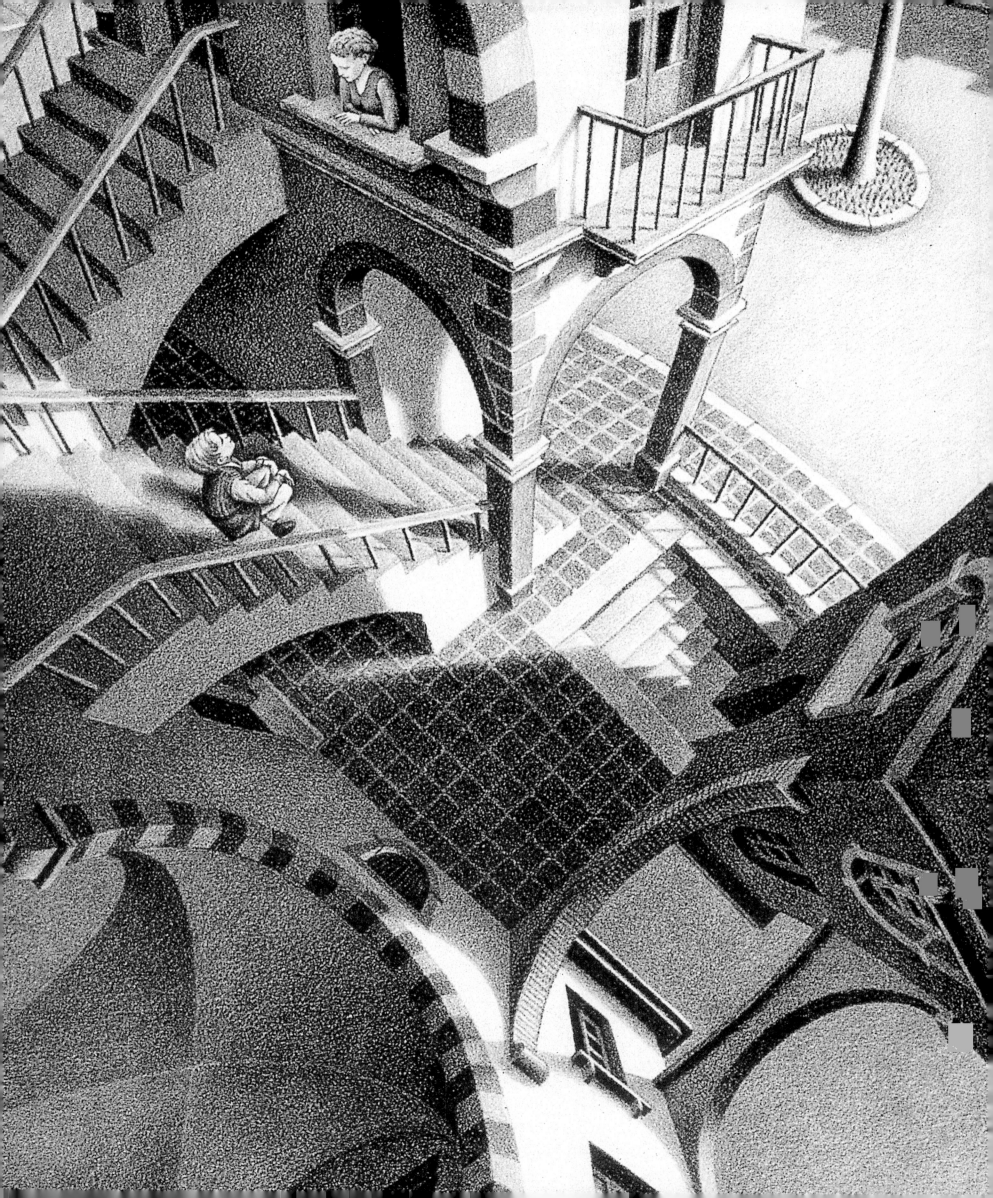

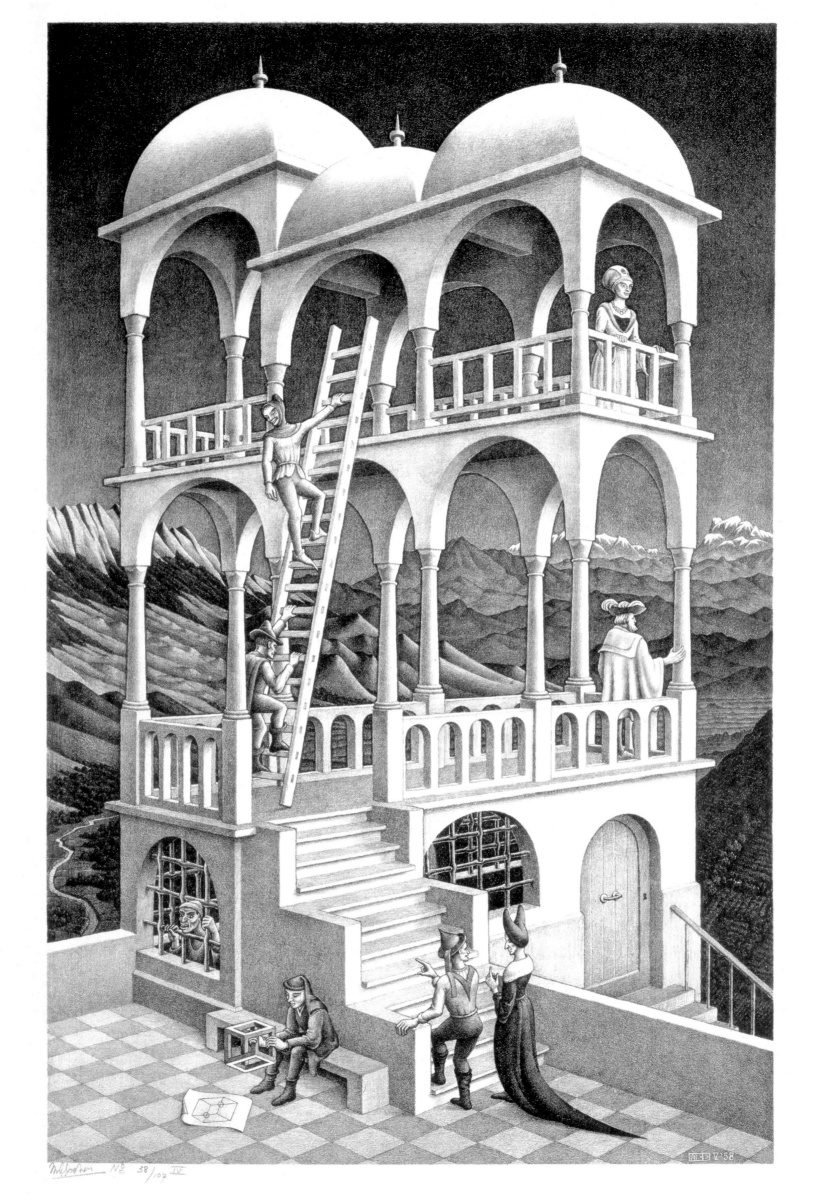

If you want to focus the attention on something nonexistent, then you have to try to fool first yourself and then your audience, by presenting your story in such a way that the element of impossibility is veiled, so that a superficial listener doesn't even notice it. There has to be a certain enigma in it, which does not immediately catch the eye.

Lecture, Amsterdam, 29 October 1963

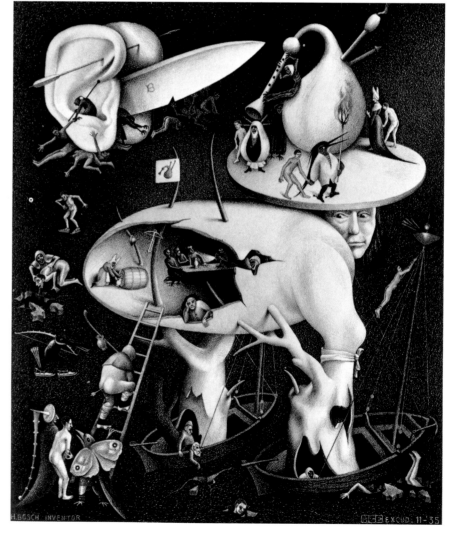

235 | 236 237
238

235 **Belvedere**
 1958. Lithograph, 18 ¼ x 11 ⅝" (462 x 295 mm)
236 **Man with Cuboid**
 1958. Wood engraving, 2 ½ x 2 ½' (64 x 64 mm)
237 Detail of 'Hell'
238 'Hell,' copy after Hieronymus Bosch
 1935. Lithograph, 9 ⅞ x 8 ⅜" (25: x 214 mm)

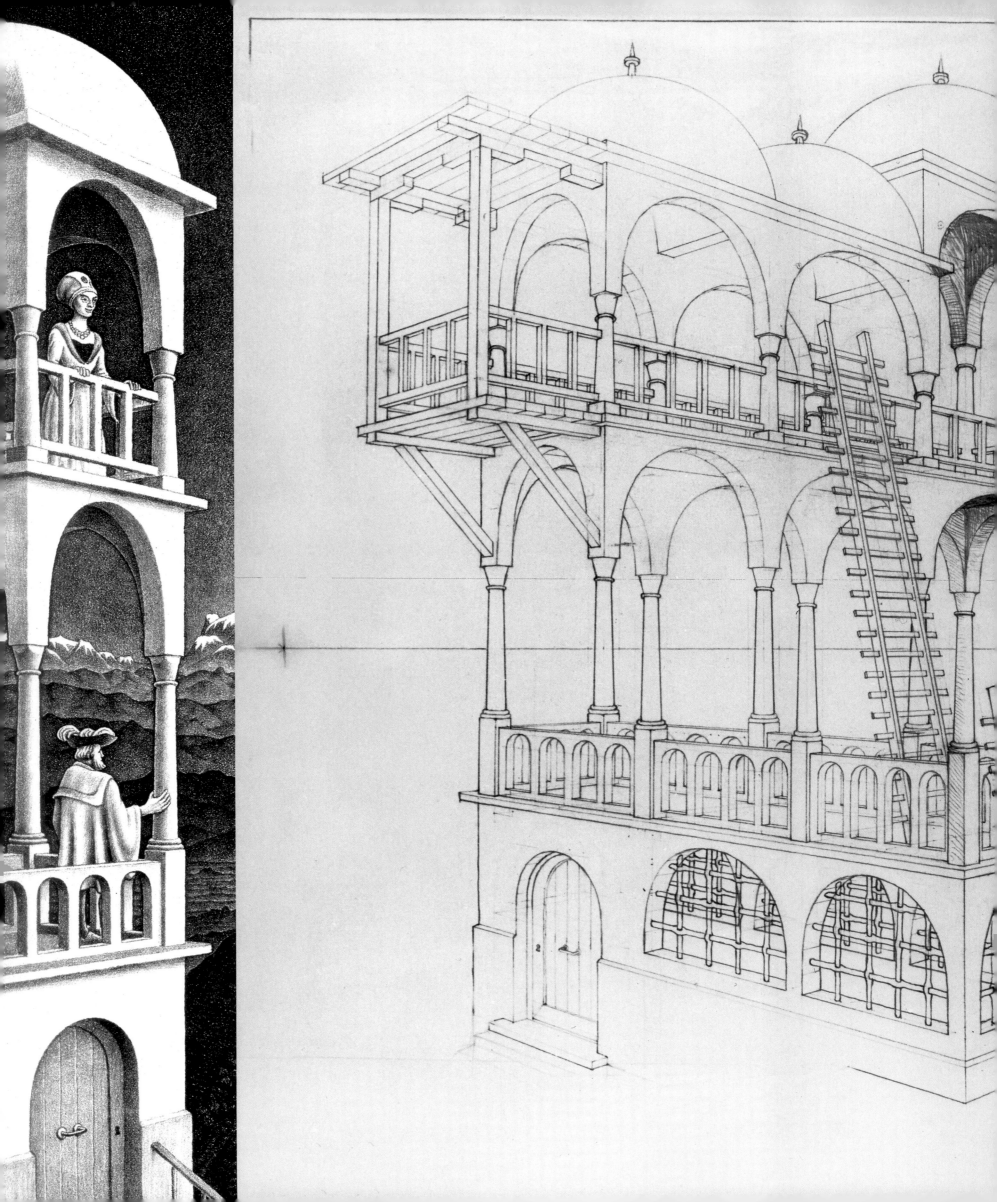

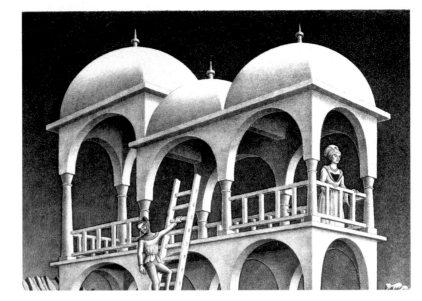

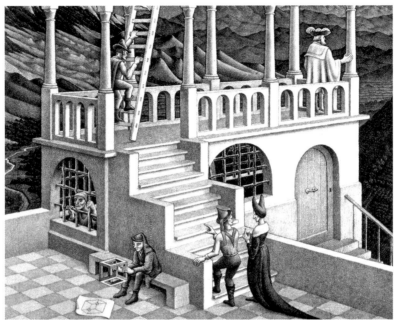

My picture [**Belvedere**] is no higher math. That I cannot state this more precisely is caused by my lack in mathematical training, I suppose. That is actually what is absorbing about my position as regards mathematics: our realms touch each other but do not overlap. I regret that!
Letter to Bruno Ernst, 1958

239 Detail of **Belvedere** (see 235)
240 Study for **Belvedere**
 Pencil, 21 ⅛ x 21 ¾" (535 x 552 mm)
241 **Belvedere** divided at the point
 where the perspective changes

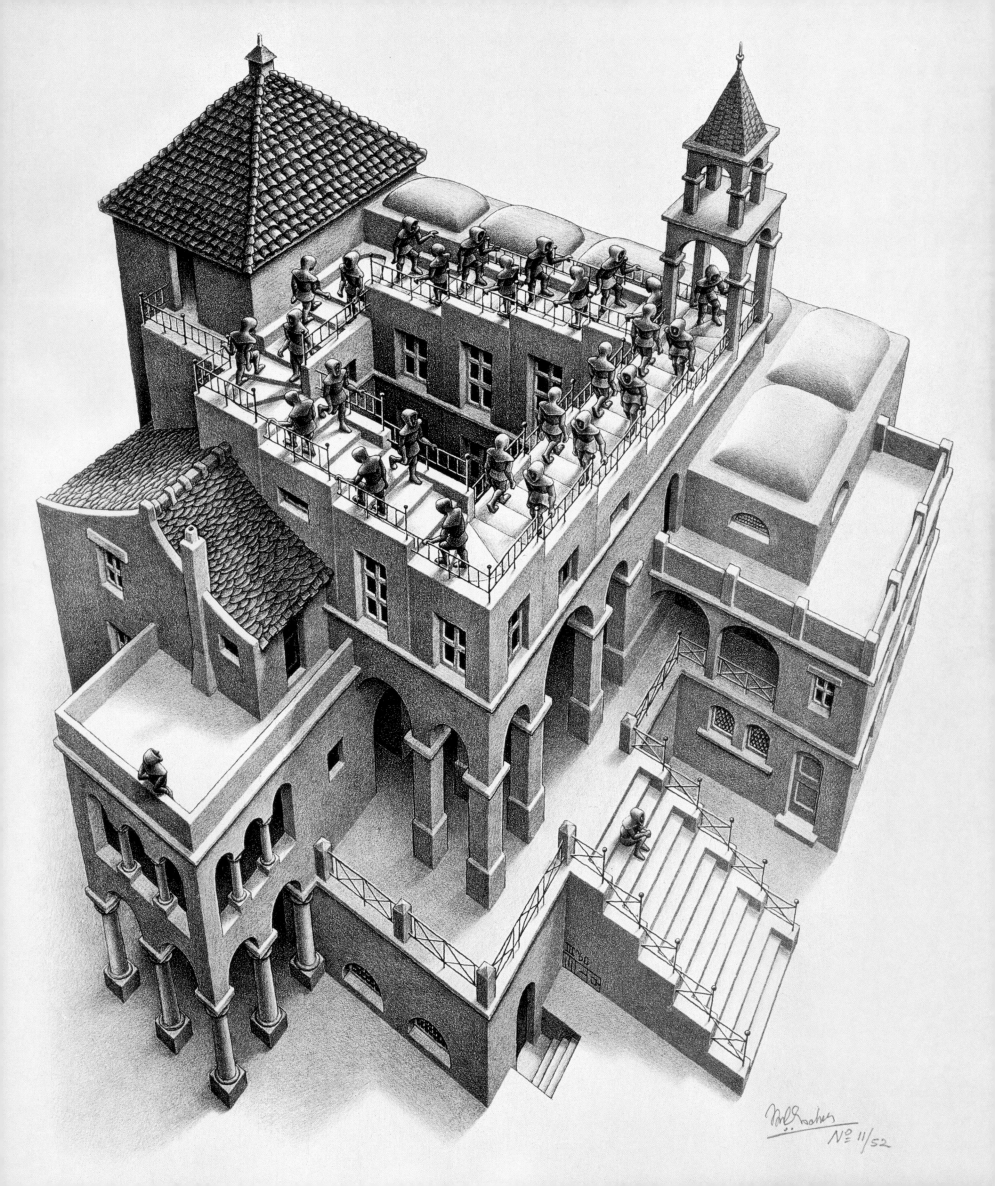

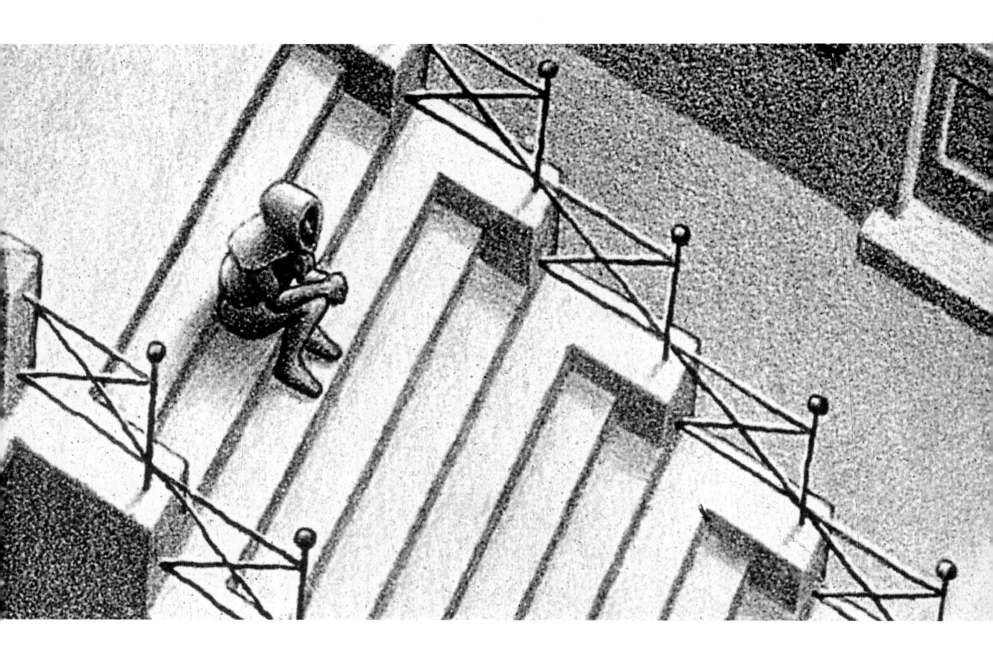

We imagine we are climbing; every step is about 20 cm high, terribly exhausting and where does it get us? Nowhere; we don't get one step farther or higher. Descending, rolling downwards deliciously, doesn't work for us either.
 On Ascending and Descending, 1960

242 | 243

242 **Ascending and Descending**
 1960. Lithograph, 14 x 11 ¼" (355 x 285 mm)
243 Detail of **Ascending and Descending**

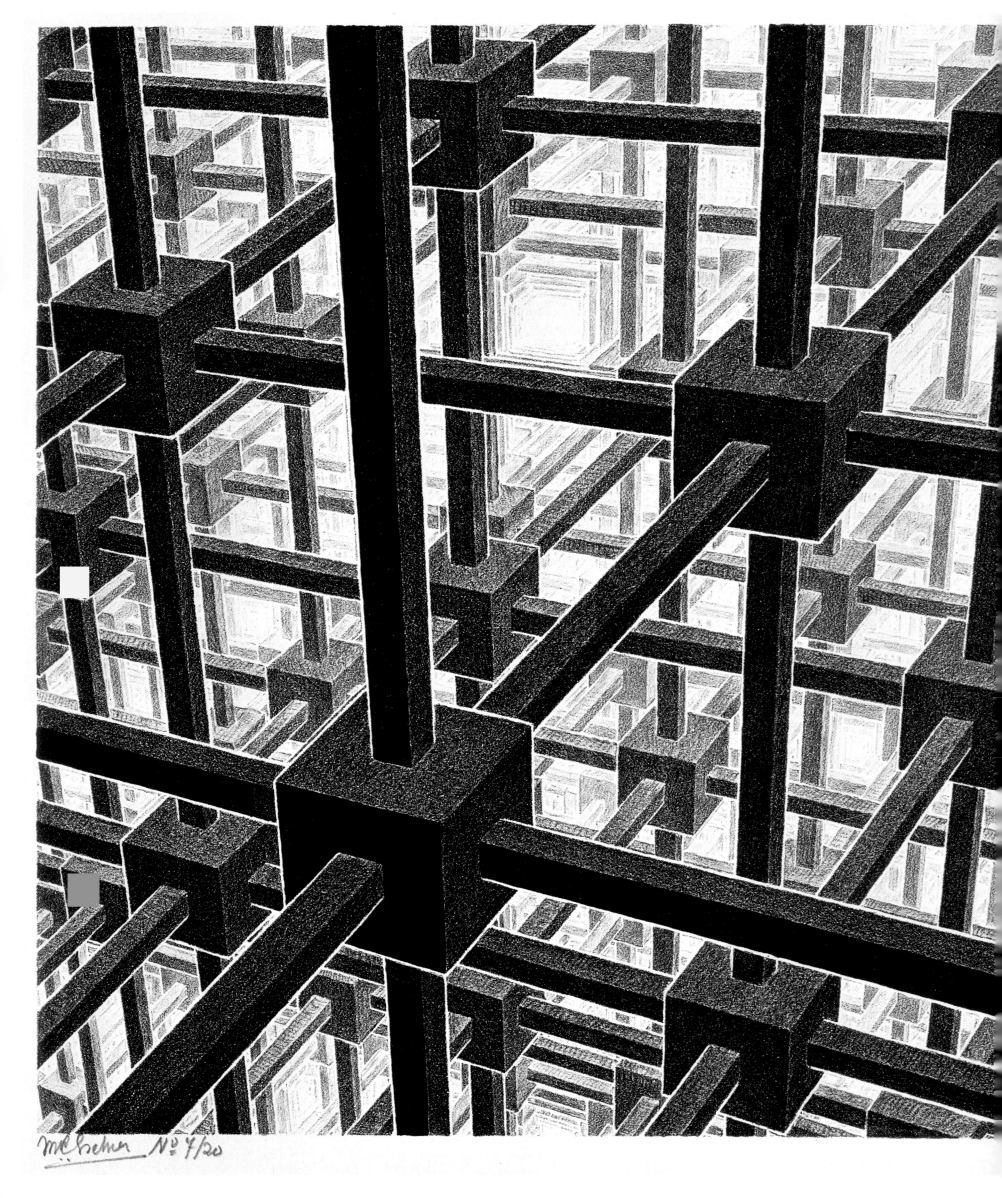

M.C.Escher Nº 7/20

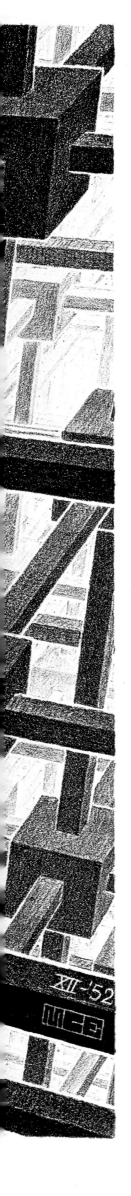

Every now and then I am able, also, to be enormously amazed at the state of lucidity in which I think I find myself.
Letter to his son Arthur, 26 May 1956

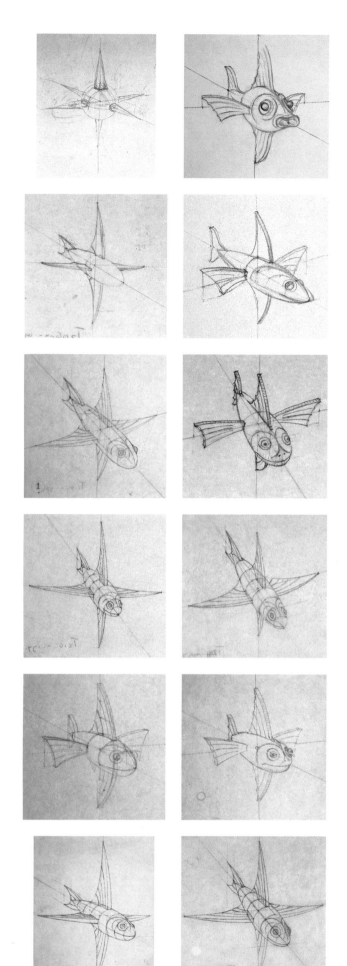

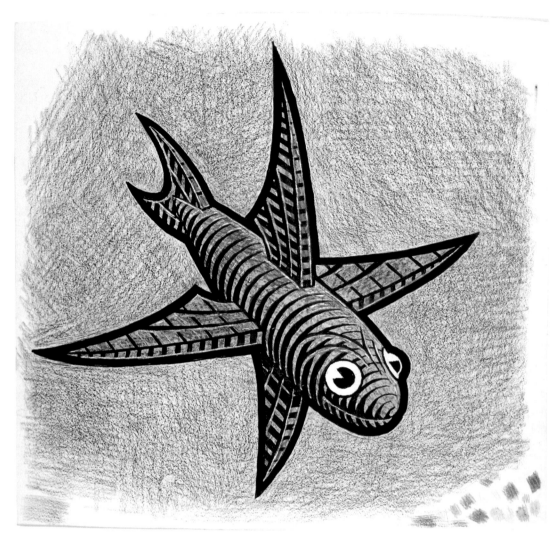

I'm playing a tiring game.

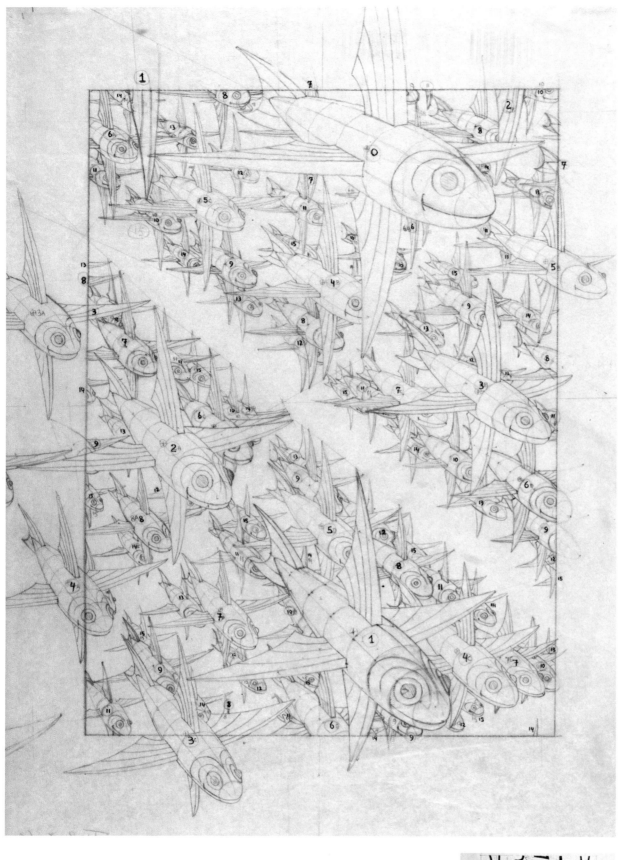

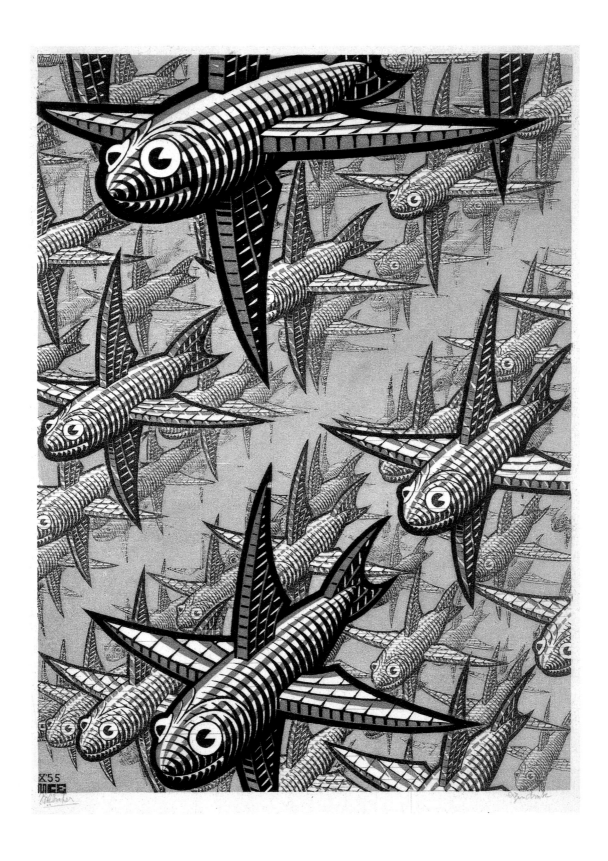

That which one person calls "art" often is not "art" at all for the next one. "Beautiful" and "ugly" are old-fashioned concepts, and today there rarely is anything to them any longer; maybe rightly so, who can say? Something revolting, something that causes you a moral hangover, something that hurts your eyes or your ears, could very well be art!

Speech upon receiving the Culture Prize of the City of Hilversum, 5 March 1965

269 | 270 269 **Depth**
 1955. Wood engraving and woodcut, 12 ⅝ x 9" (320 x 230 mm)
 270 Detail of **Depth**

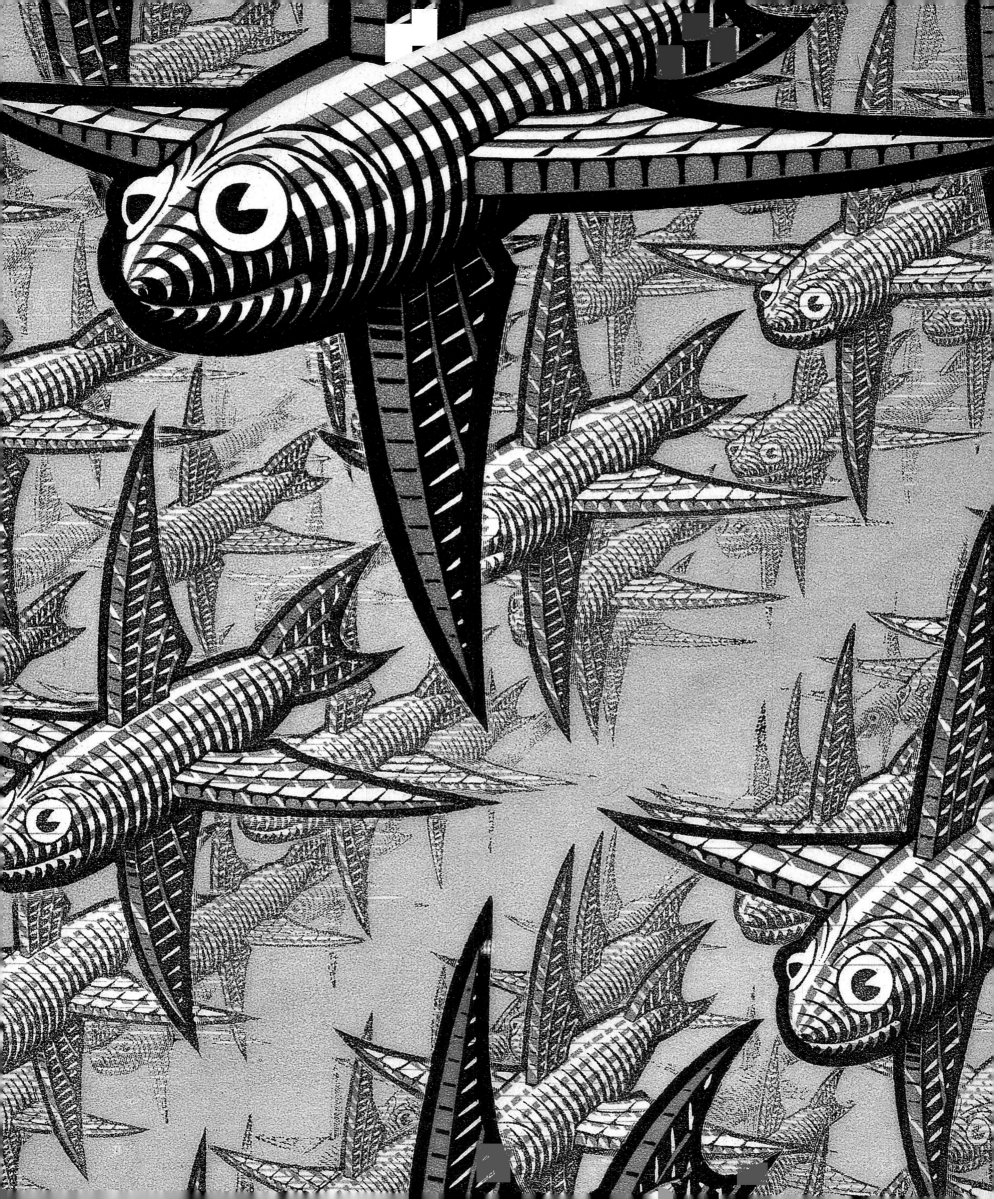

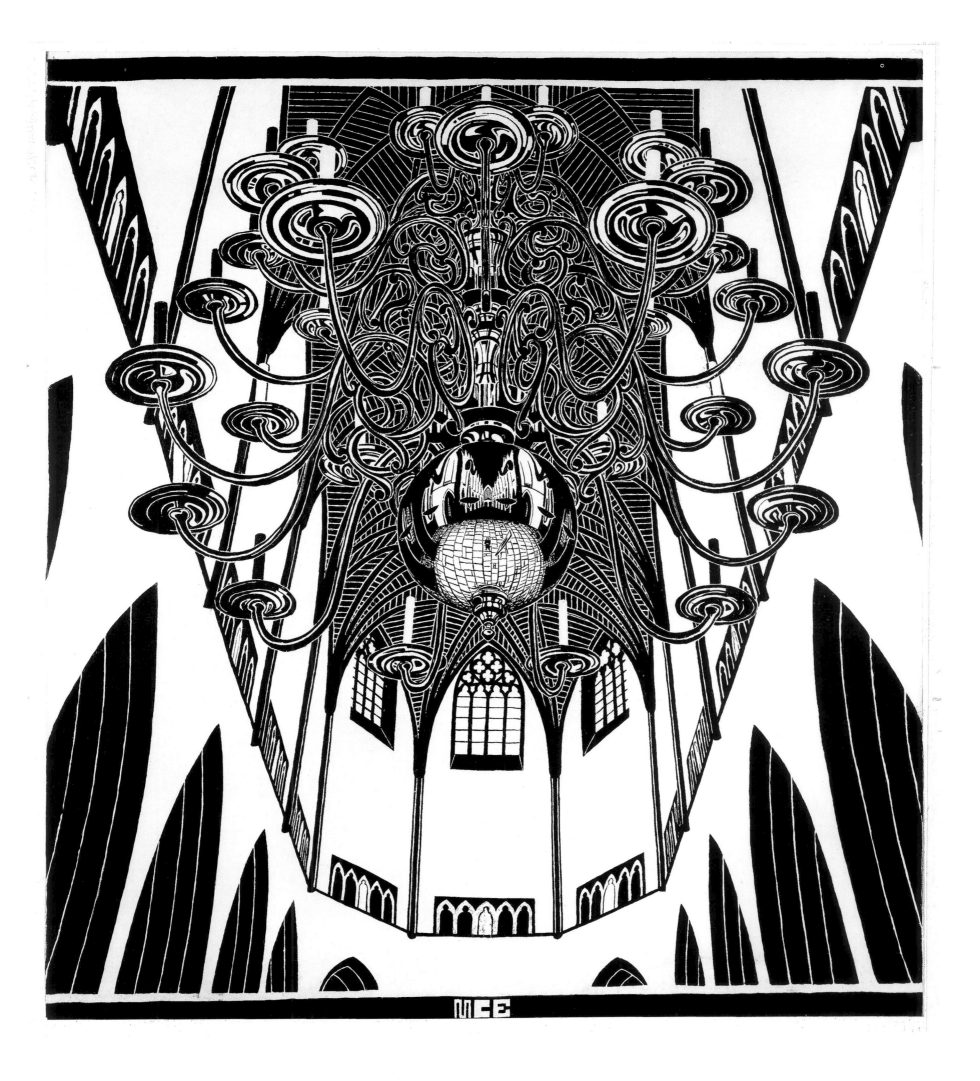

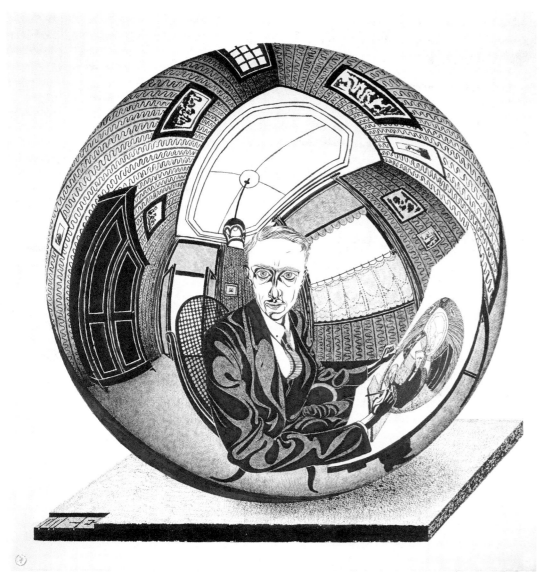

Ah! to write a novel — and then to die…!
If only I were a poet — I'd be immortal.
All I am is but a miserable fanatic….
Letter to Jan van der Does de Willebois,
October 1922

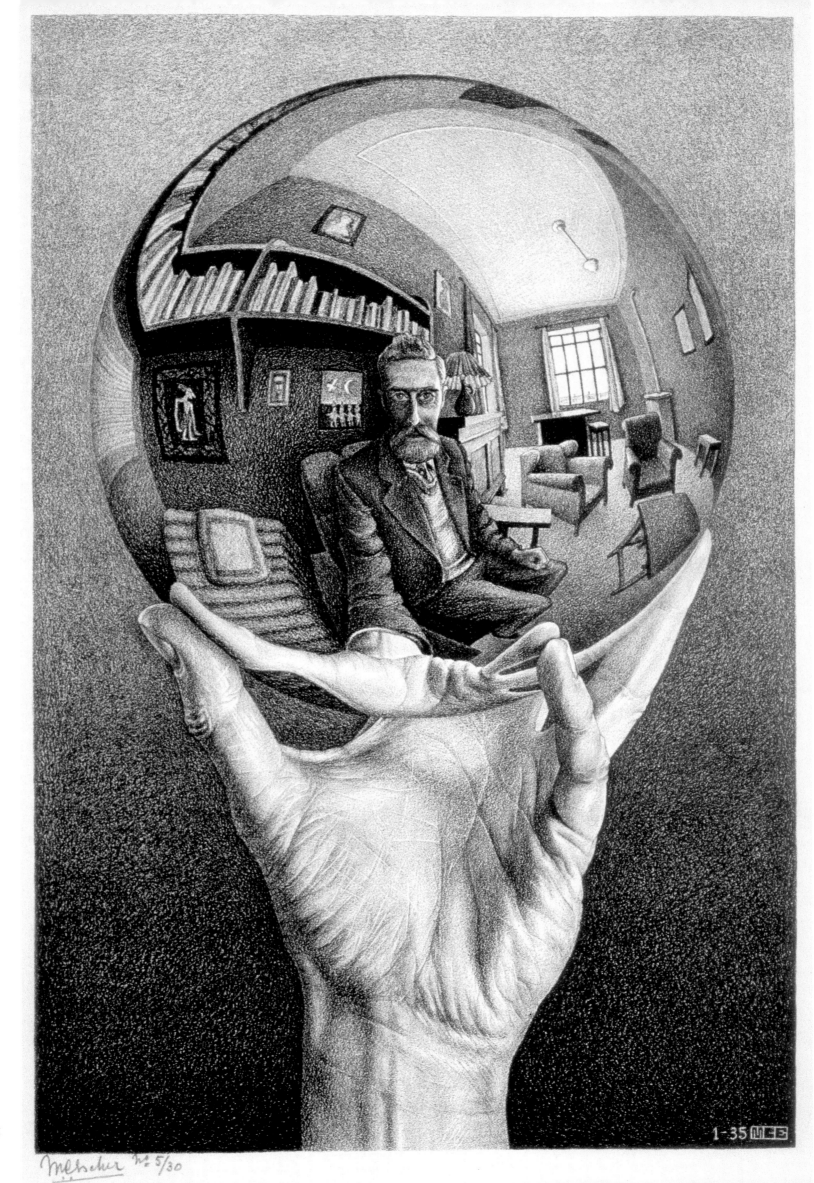

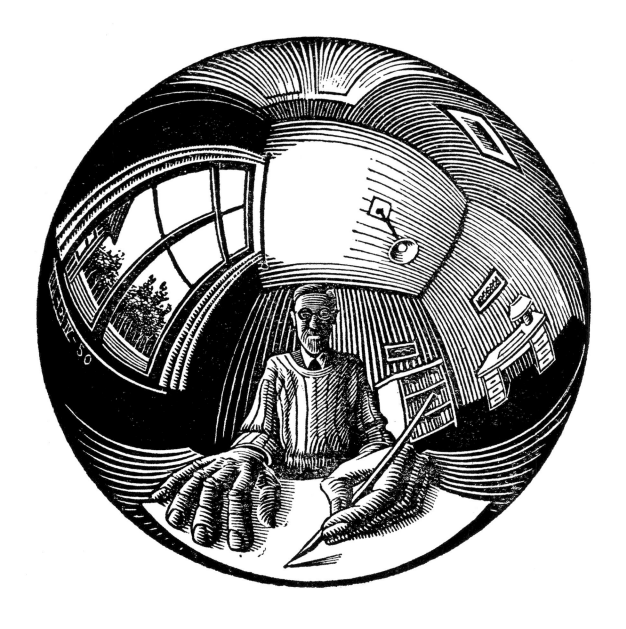

I won't grow up. In me is the little child of yore.

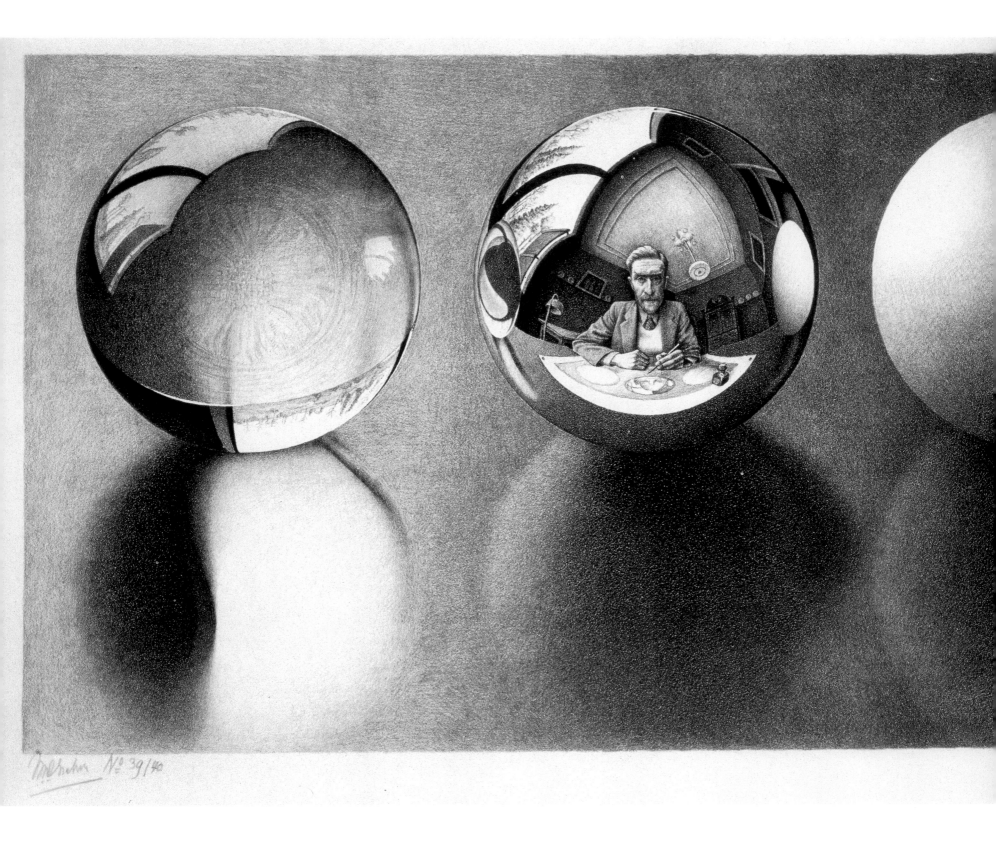

283 | 284

283 **Three Spheres II**
 1946. Lithograph, 10 5/8 x 18 1/4" (269 x 463 mm)
284 **Dewdrop**
 1948. Mezzotint, 7 x 9 5/8" (179 x 245 mm)

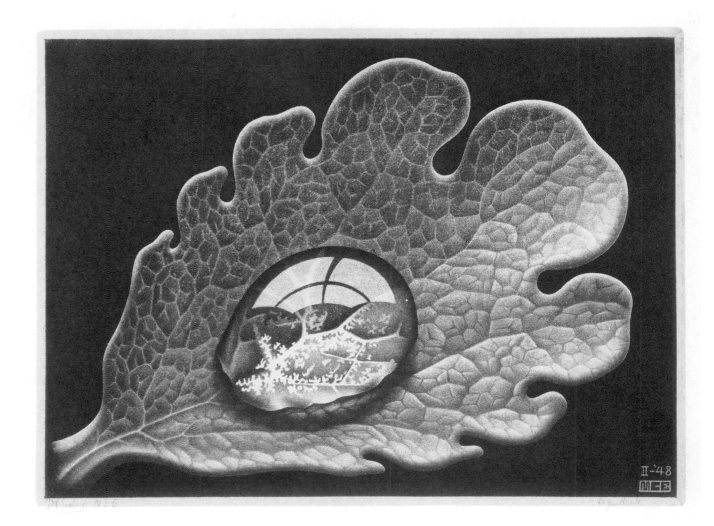

Talent and all that for the most part is nothing but hogwash. Any schoolboy with a little aptitude might very well draw better than I perhaps; but what he most often lacks is the tough yearning for realization, the teeth-grinding obstinacy and saying: even though I know I'm not capable of it, I'm still going to do it.

Letter to his son Arthur, 12 February 1955

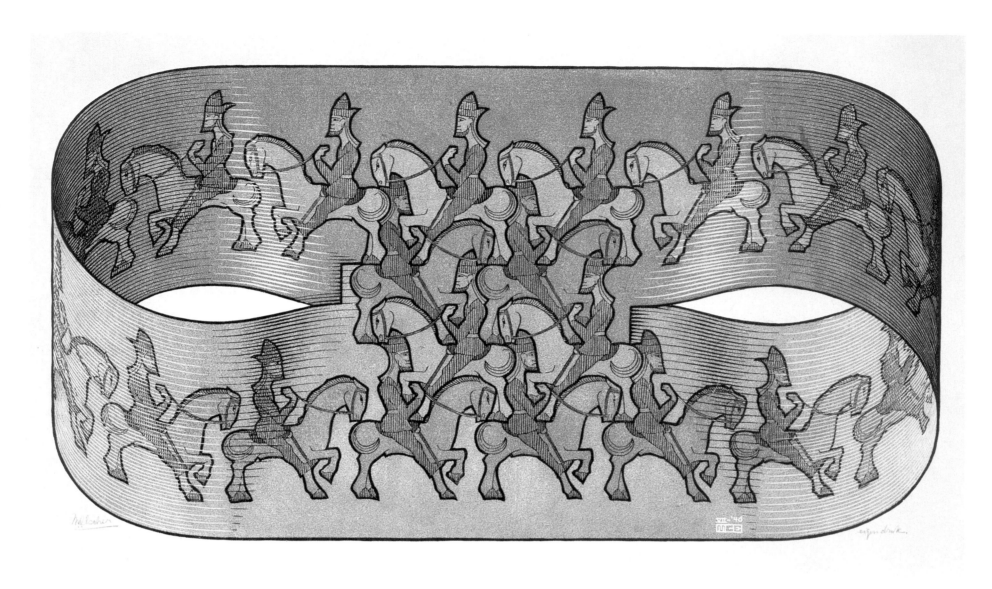

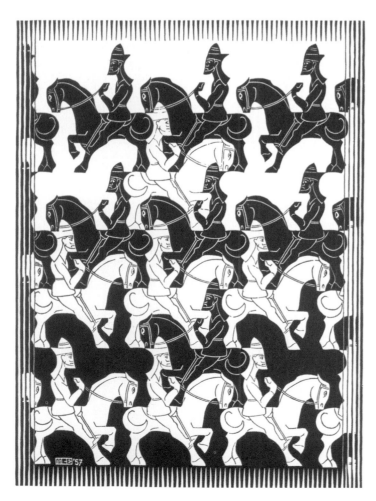

Fishes never eat birds, like they do in **Predestination**, but birds like fish.
Give your canary Our Wonderful Vacuum-Dried Fish Food and you will
hear how it sings like a nightingale!
Letter to Charles Alldredge, 24 January 1955

*A reversal with exceptional humor, particularly because Escher presents the
incident of the depicted fish as an inescapable fate, although he could have easily
turned the situation around, of course.*
J.L.L.

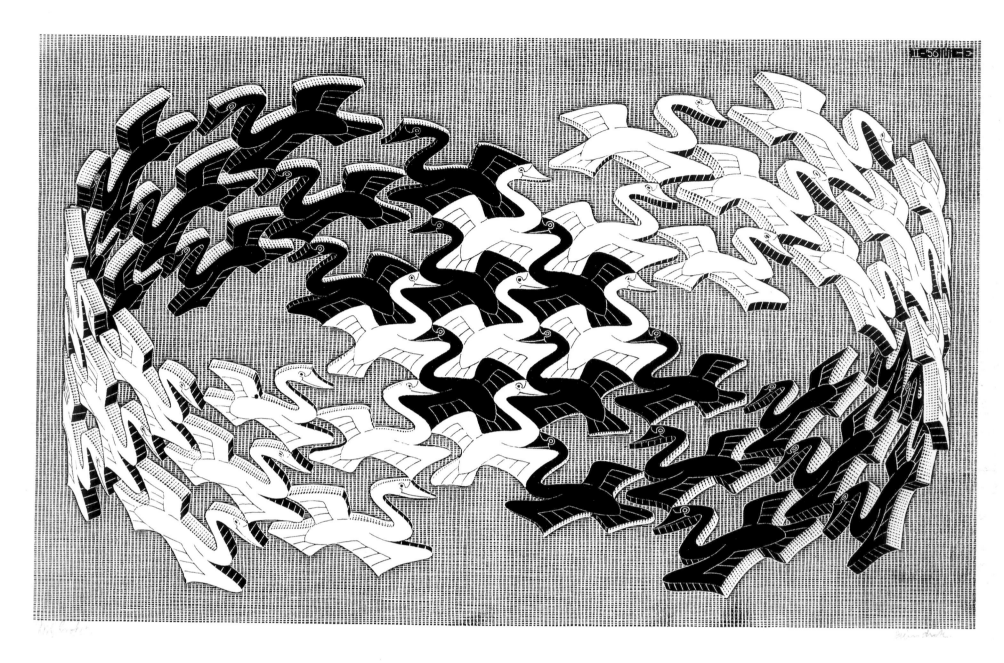

A human being is not capable of imagining that the flow of time could ever come to a standstill. Even if the earth were to stop turning around its axis and around the sun, even if there wouldn't be any more days and nights, any more summers and winters, time will continue to flow onward into eternity, that's how we imagine it.

Letter to his son George and daughter-in-law Corrie, 24 January 1960

289 | 290

289 **Swans**
1956. Wood engraving, 7 7/8 x 12 1/2" (199 x 319 mm)

290 **Study for Swans**
Pencil and ink, 8 5/8 x 7" (220 x 177 mm)
The handwritten note at the top reads:
"I'm alive! A trembling soul goes lost inside me."

BOVEN

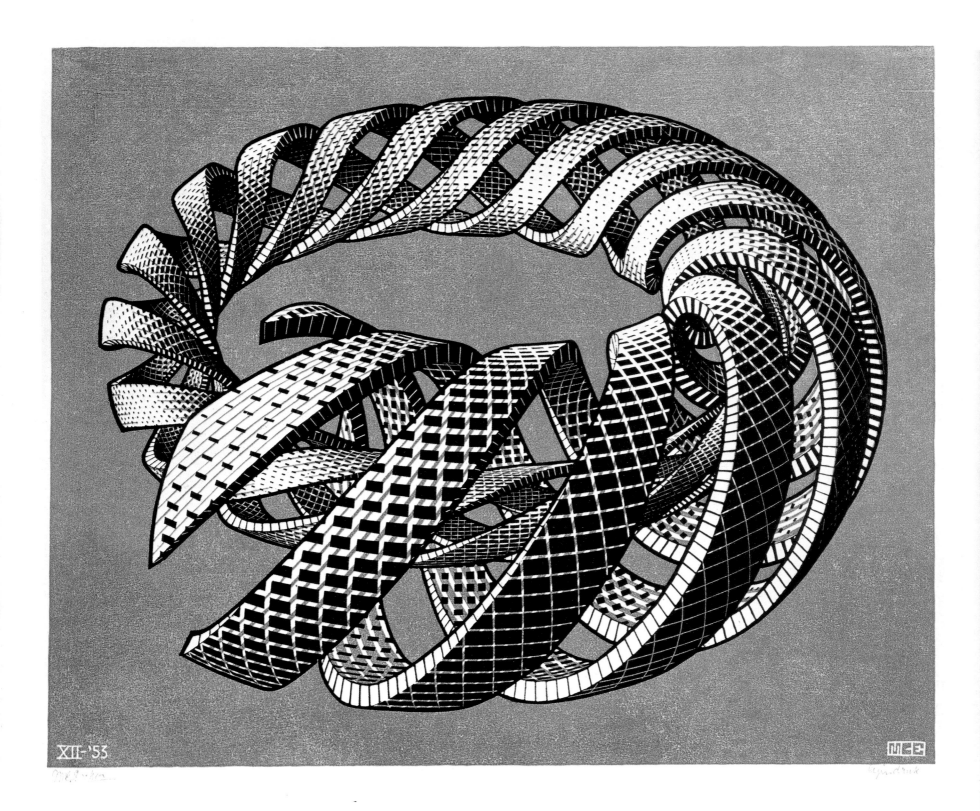

The Pope is dead. He is lying in a little glass container, just like Snow White, he's wearing little red mules with an embroidered cross on them and the Americans have fired off a projectile that may never come back to earth. Nice for a change that it isn't the Russians for once, even if that thing is zooming past the moon and even if that guy on the Hawaiian Islands is sitting there for nothing with the button he is supposed to push.

So we all play our own little game and not one of us knows why, the starlings don't, the comedians with their dress-up party of a dead man in Rome don't, the conquerors of gravity in America don't, you in the big city of Montreal don't, and I with my convex spirals least of all. It's a sad business, but it is and for the time being will continue to be fascinating.

Letter to his son George and daughter-in-law Corrie,
12 October 1958

291 | 292

291 **Spirals**
1953. Wood engraving, 10 ⅝ x 13 ⅛" (270 x 333 mm)
292 **Concentric Rinds (Concentric Space Filling)**
1953. Wood engraving, 9 ½ x 9 ½" (241 x 241 mm)

I-'53

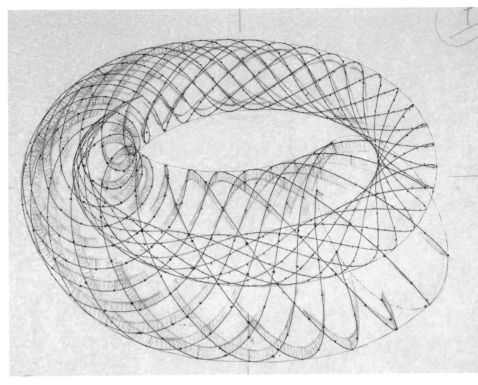
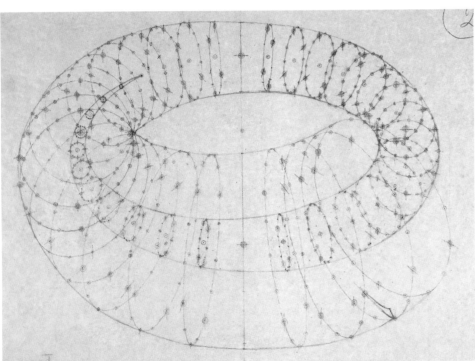
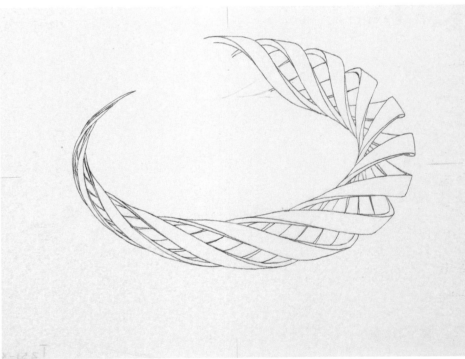

The graphic artist's goal is to produce graphic art. When he needs preliminary sketches in order to reach that goal, he will draw them, generally with a pencil on paper. Consequently his work consists of two distinctly separate stages, first preliminary sketches and second development into graphic prints. (It has become apparent to me from conversations and remarks of my colleagues who are graphic artists that certainly not everyone works in this manner but I cannot help being subjective.) Illustrations are consequently for the graphic artist (mostly) an indispensable link in the chain of his activities, but never his goal. That is probably the reason why a graphic artist cannot suppress a feeling of dissatisfaction when presented with an illustration as end result. You see, I don't give reasons, only statements. This feeling of

uneasiness on the part of the graphic artist with respect to illustrations had nothing to do with esthetic appreciation. It is obvious that a sketch, for example, a preliminary sketch for an etching, can be more "beautiful" (more spontaneous, more on target, freer, you name it) than the etching itself, and that we therefore sometimes prefer to see the preliminary stage rather than the end result at an exhibition. But aren't we talking strictly about the goal the artist sets for himself?

How could we possibly ever blame an illustrator for not getting "beyond" an illustration? Let him continue what he does. He has my blessing. However, it is another matter that I find it hard to imagine he is satisfied with it.

Letter to Oey Tjeng Sit, 26 May 1950

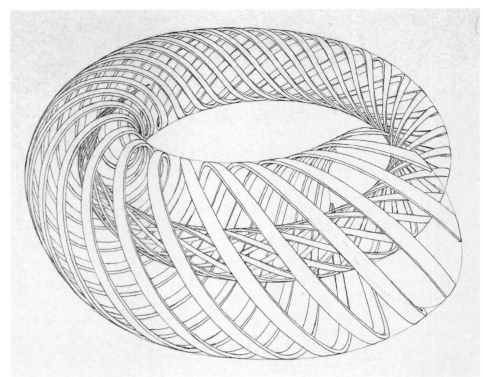

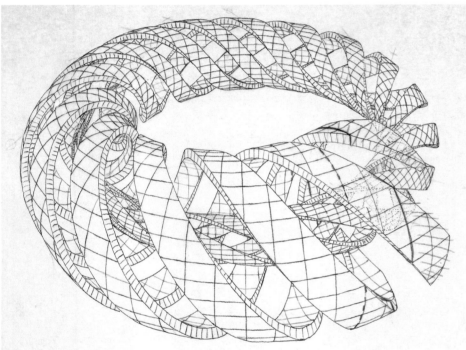

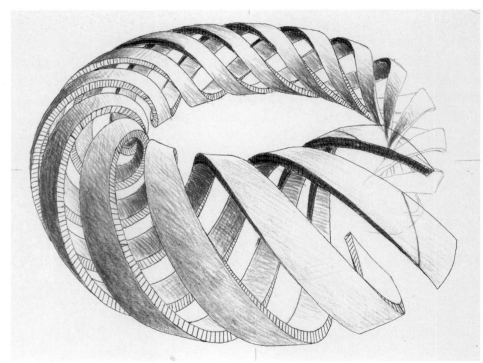

293 294 | 297 298
295 296 | 299 300

… I was asked, among other things, why does the black one have such a big nose. Well that's pretty obvious. That's because he's inside the belly of the white one, I can't help that.
Lecture, Rosa Spierhuis, 1971

I believe that I've never done any work with the purpose of symbolizing something specific, but the fact that people sometimes encounter or notice a symbol is of value to me, for then I more readily accept the inexplicability of my hobbies, which will not leave me in peace.
Letter to Dr. A.W.M. Pompen, 3 September 1951

296 **Encounter**
 1944. Lithograph, 13 ½ x 18 ¼" (342 x 464 mm)
297 **Magic Mirror**
 1946. Lithograph, 11 x 17 ½" (280 x 445 mm)

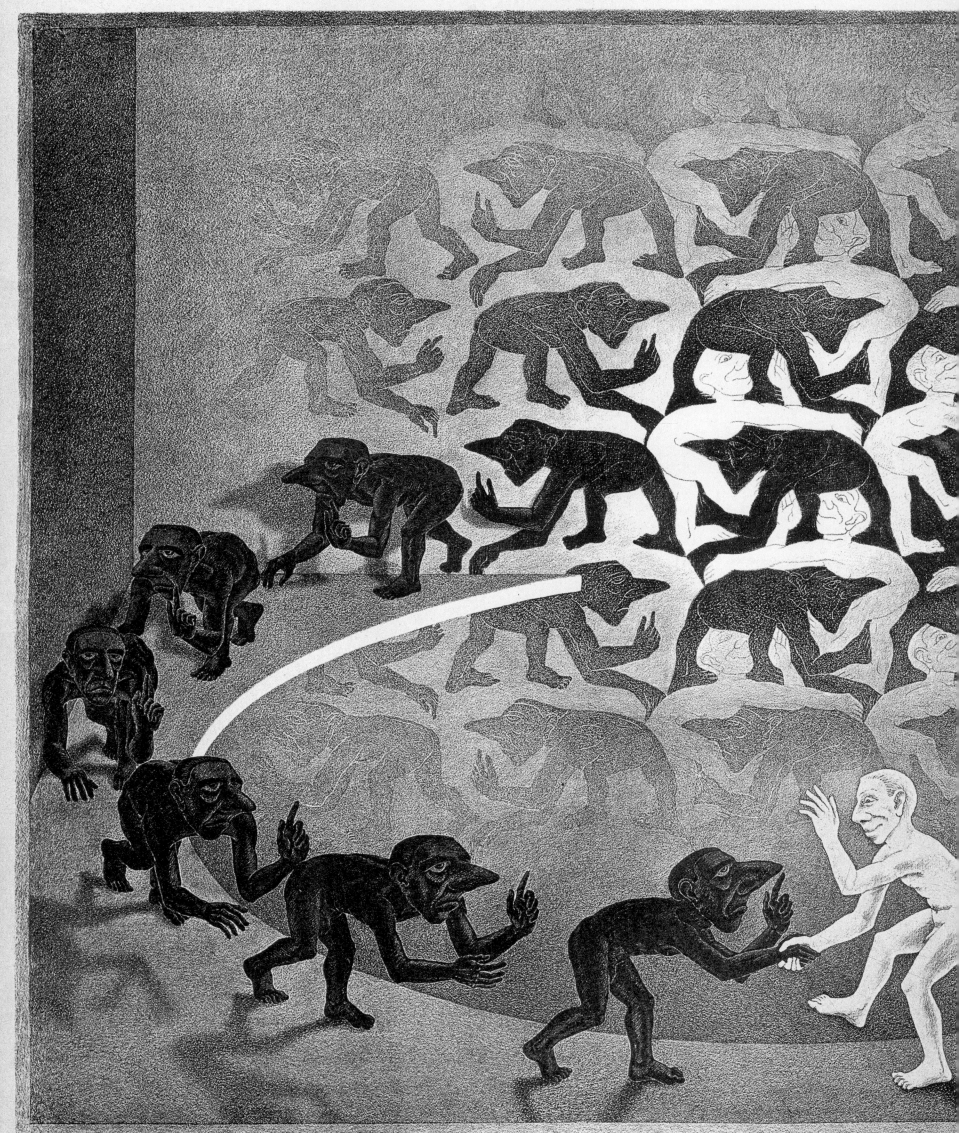

MCEscher No 44/50 IV

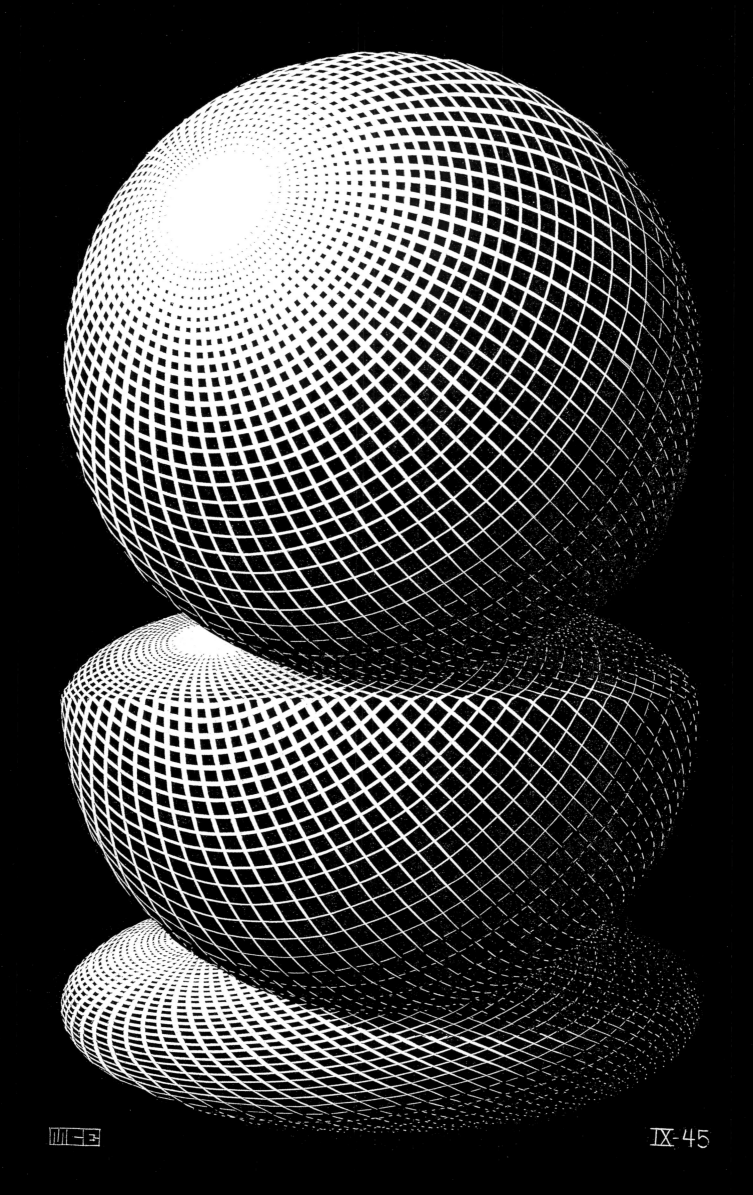

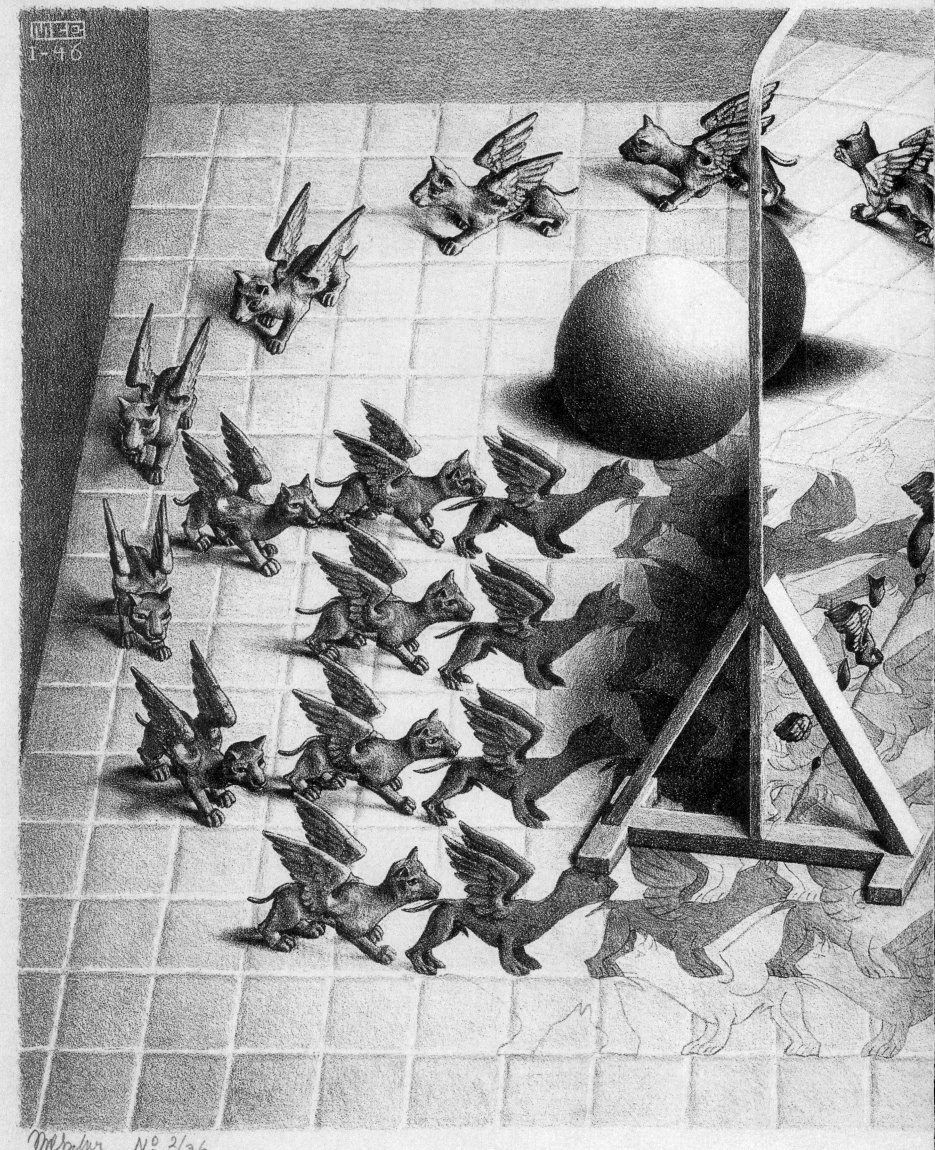

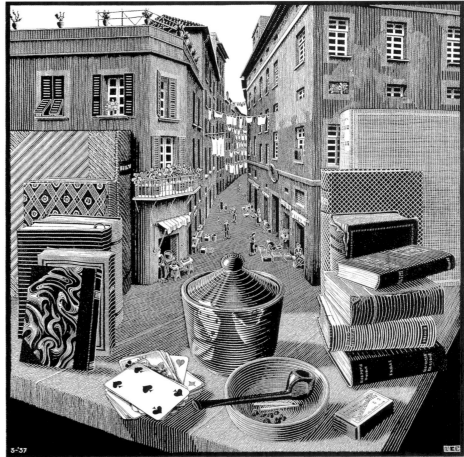

In a room something of the world outside the house can be present by means of a mirror, and this can be depicted. But in a picture, the surface of a worktable can also be connected to a street in an almost self-evident manner. Instead of a depiction of an observation there now exists the realization of a personal picture-thought, which, moreover, is not without humor.
 J.L.L.

That which an artist makes is a mirror image of what he sees around him.
Lecture to Friends of the Stedelijk Museum, Alkmaar, 16 November 1953

305 306 | 307

305 **Still Life with Mirror**
 1934. Lithograph, 15 ½ x 11 ¼" (394 x 287 mm)
306 **Still Life and Street**
 1937. Woodcut, 19 ⅛ x 19 ¼" (487 x 490 mm)
307 **Reptiles**
 1943. Lithograph, 13 ⅛ x 15 ⅛" (334 x 385 mm)

174

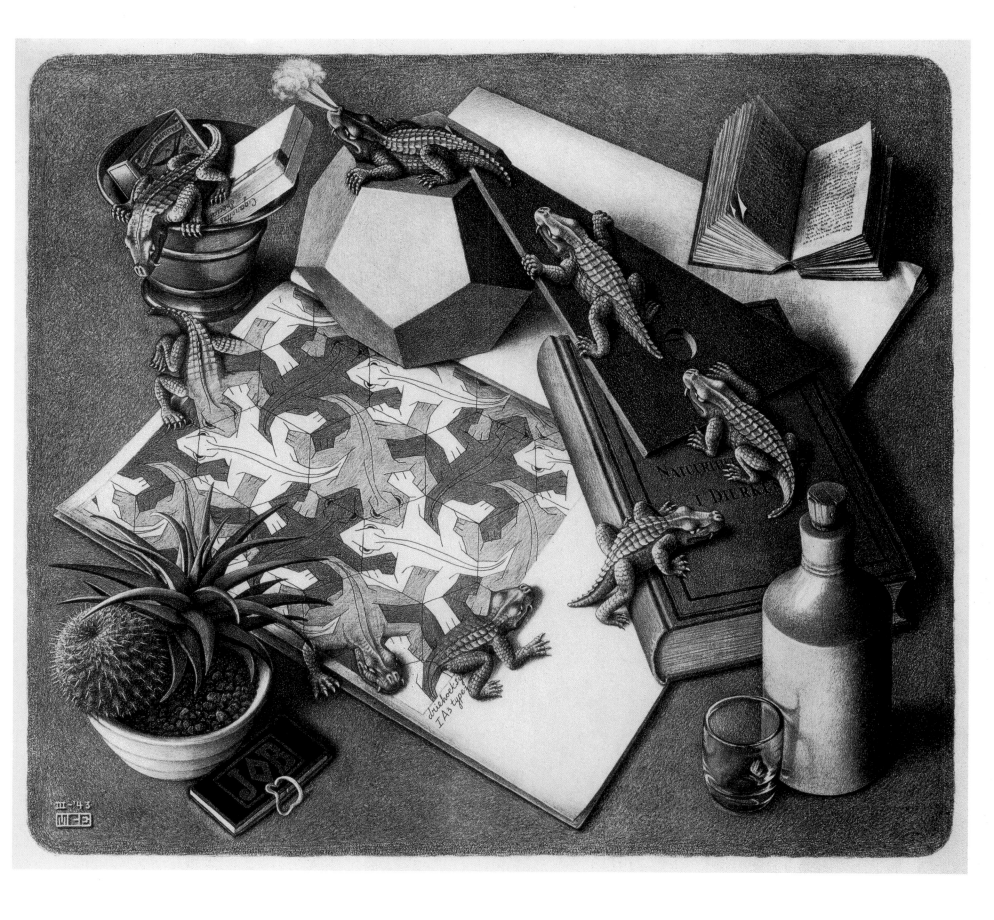

One of Escher's most humorous pictures is this orbit
of an alligator. Escher was very amused when the
little book JOB was interpreted in Biblical fashion.
It was in fact a little book of Belgian cigarette paper.
 J.L.L.

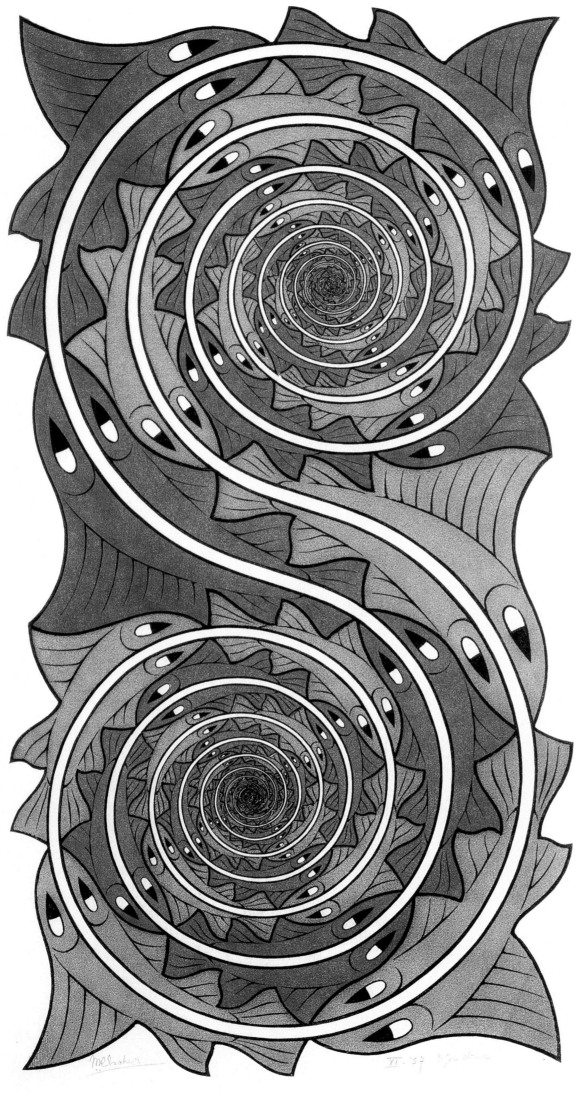

I doubt that "the public" will ever
understand, much less appreciate,
how many gymnastics of the brain,
fascinating to me, have preceded
the construction of such a picture.
*On **Whirlpools**, 1958*

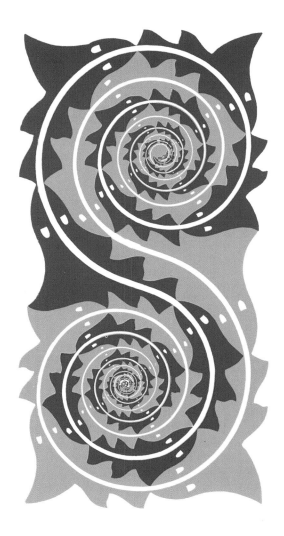
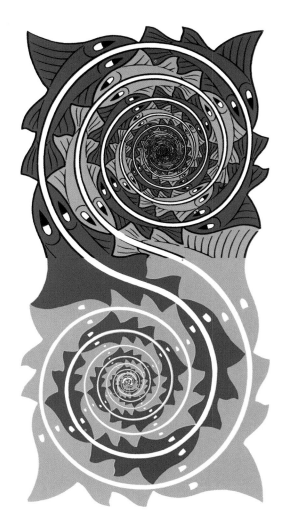

308 309 | 310 311 312
313 314

308 **Whirlpools**
1957. Wood engraving and woodcut,
17 ¼ x 9 ¼" (438 x 235 mm)

309-312 Progressive proofs from cancelled woodblocks

313 Woodblock for **Whirlpools**
Block for black

314 Woodblock for **Whirlpools**
Block for red and grey

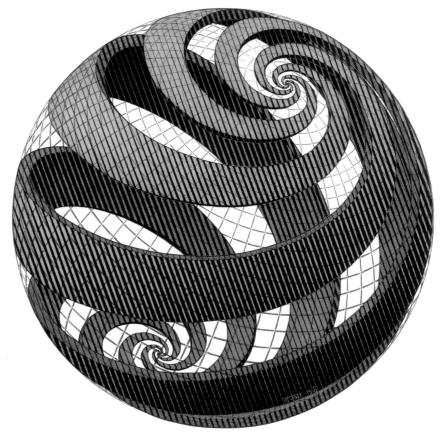
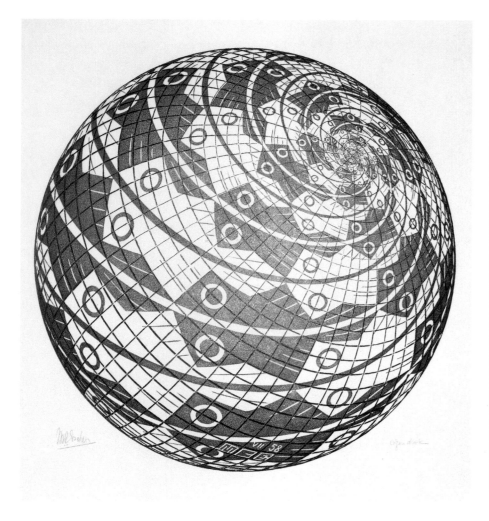
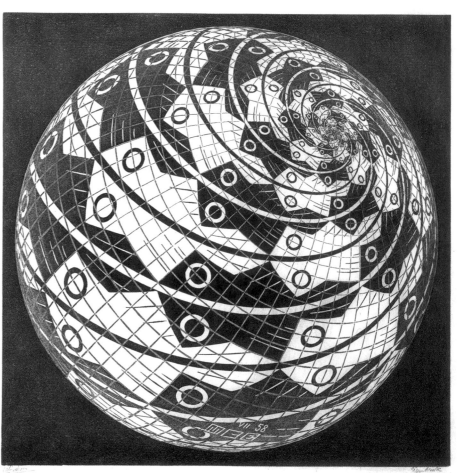

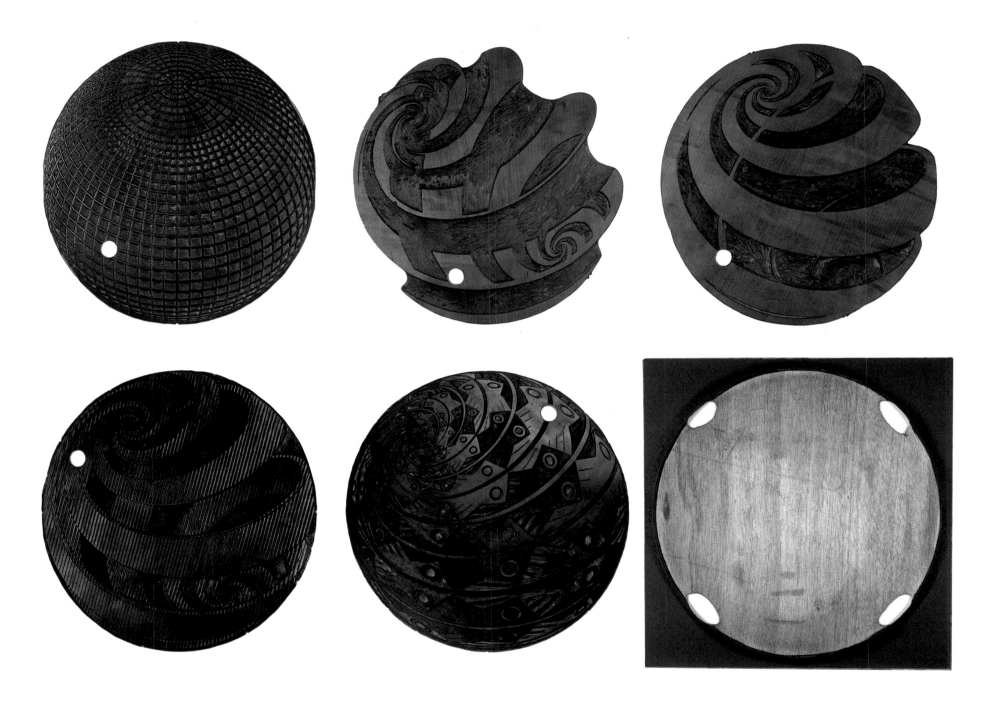

315 Proof for **Sphere Spirals** and **Sphere Surface with Fish**

316 **Sphere Spirals**
 1958. Woodcut, diameter 12 ⅝" (320 mm)
 Sphere Spirals was printed using woodblocks 319, 320, 321 and 322

317 **Sphere Surface with Fish**, variation without linoleum cut
 1958. Woodcut, diameter 12 ⅝" (320 mm)

318 **Sphere Surface with Fish**
 1958. Woodcut and linoleum cut, 13 ⅜ x 13 ⅜" (340 x 340 mm)
 Sphere Surface with Fish was printed using woodblocks 319, 323 and 324

319 Woodblock for **Sphere Spirals** and **Sphere Surface with Fish**
 Block for grey (**Sphere Spirals**)
 Block for gold (**Sphere Surface with Fish**)

320 Woodblock for **Sphere Spirals**
 Block for pink

321 Woodblock for **Sphere Spirals**
 Block for yellow

322 Woodblock for **Sphere Spirals**
 Block for black

323 Woodblock for **Sphere Surface with Fish**
 Block for grey
 Woodblocks 322 and 323 were cut on opposite sides of one piece of wood

324 Linoleumblock for **Sphere Surface with Fish**
 Block for brown

As far as the craft is concerned, I know of course that for the creation of any image whatsoever the hand is the miraculously refined tool, the intermediary between spirit and matter. But the illustrator doesn't know anything about what we graphic artists call "the craft" — the struggle with the unmanageable material, the process of conquering a hostile material resistance, which the wood-carver and the engraver do know (more or less in the way the carpenter knows it), and I feel sorry for the illustrator because he is thus deprived of a great joy.
 Letter to Oey Tjeng Sit, 26 May 1950

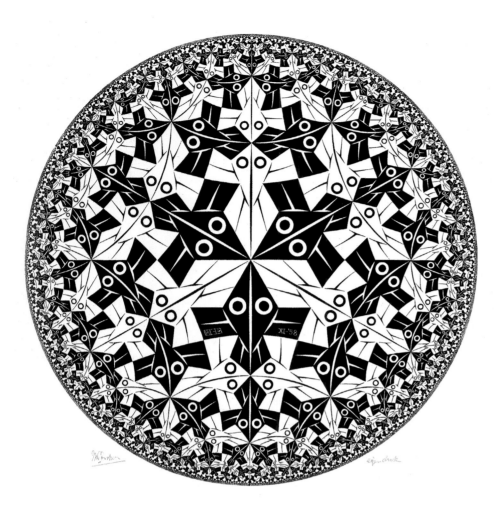

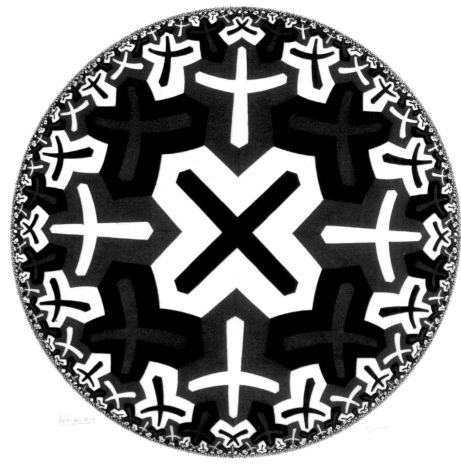

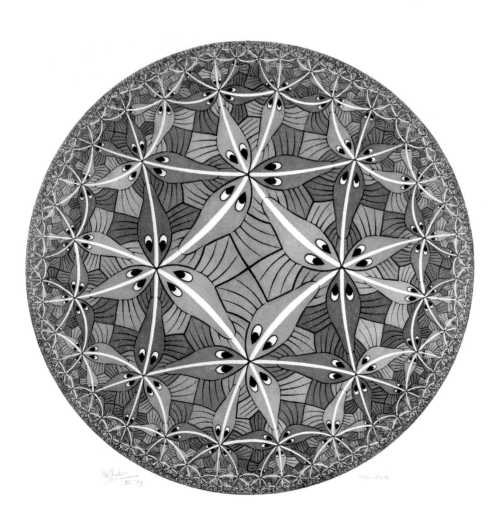

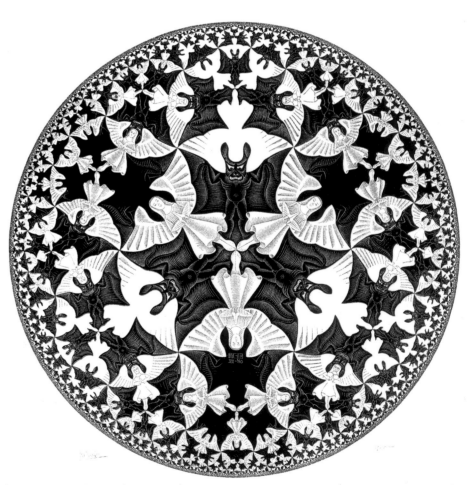

I've been killing myself, first to finally finish that litho and then,
for four days with clenched teeth, to make another nine good prints
of that highly painstaking circle-boundary-in-color. Each print
requires twenty impressions: five blocks, each block printing four
times. All of this with the odd feeling that this piece of work means
a "milestone" in my development and that, besides myself, there will
never be anyone else who'll realize that.

Letter to his son Arthur, 20 March 1960

325 326 | 329 325 **Circle Limit I**
327 328 330 1958. Woodcut, diameter 16½" (418 mm)
 331 326 **Circle Limit II**
 1959. Woodcut, diameter 16⅜" (417 mm)
 327 **Circle Limit III**
 1959. Woodcut, diameter 16⅜" (417 mm)
 328 **Circle Limit IV (Heaven and Hell)**
 1960. Woodcut, diameter 16⅜" (416 mm)
 329 Woodblock for **Circle Limit I**
 (Escher made the print by rotating the block around a pin.
 Three impressions were sufficient for the finished print.)
 330 Study for **Circle Limit I**
 Pencil and ink, 6½ x 8¼" (163 x 210 mm)
 331 Study for **Circle Limit I**
 Pencil and ink, 10⅜ x 9⅝" (265 x 245 mm)

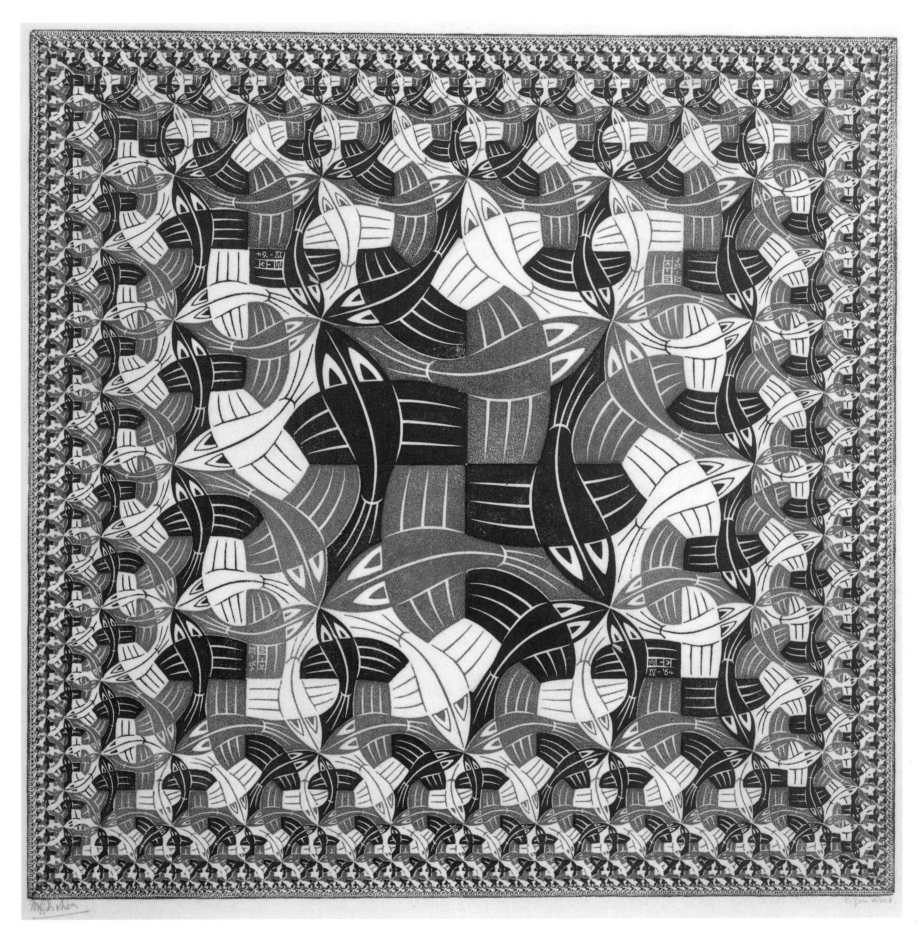

A whole lot of tinkering and ruminating, but the aesthetic result
is not particularly gorgeous. Still, to me it means another little step
forward on the road I have taken.
Letter to Gerd Arntz, 14 April 1964

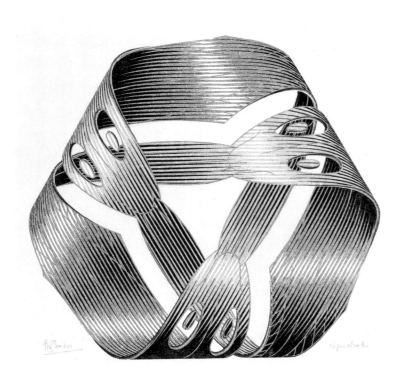

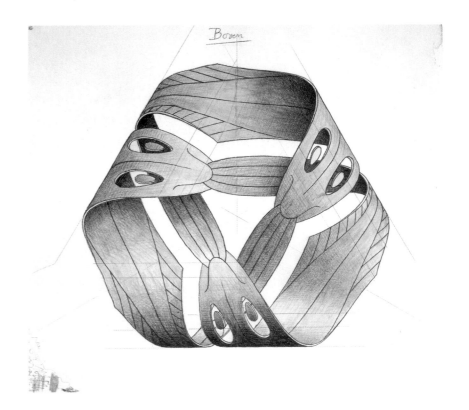

If you were to ask, why do you do such silly things, such absolute objective things that have nothing personal any more? Then all I can answer is: I cannot stop it. This particular case has never been satisfactorily resolved, as far as I know, by that group of folks, around 1500 and 1600, Dürer, Pacioli, Barbaro, and even Leonardo. Undoubtedly they were originally interested in pure form in the same way as I am: the beauty and the order of regular bodies are overwhelming. There's nothing you can do, for they're there. If you then insist on speaking about god: they have something divine, at least nothing human. But we cannot do anything about the idiosyncrasy of wanting to bear witness to what touches us either. We cannot stop it. My personal result, of course, is a wash-out, a proof of my impotence; I may say that, just as long as nobody else says it. But I have given it my best effort and more than that I cannot do. Who knows, perhaps I'll do it better some time later on.

On Möbius Strip, 1961

335 **Möbius Strip I**
 1961. Wood engraving and woodcut,
 9 3/8 x 10 1/4" (238 x 259 mm)

336 Study for **Möbius Strip I**
 1961. Aquarelle and pencil, 12 3/8 x 14 1/4" (315 x 362 mm)

337 **Knot**
 Pencil and crayon, 14 5/8 x 13 1/2" (371 x 341 mm)

338 **Knots**
 1965. Woodcut, 16 7/8 x 12 5/8" (430 x 320 mm)

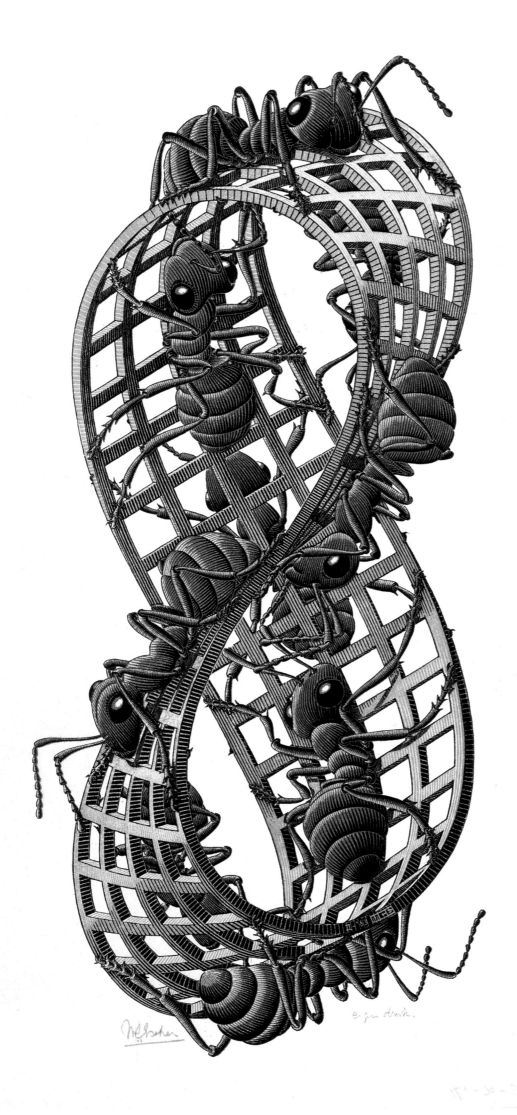

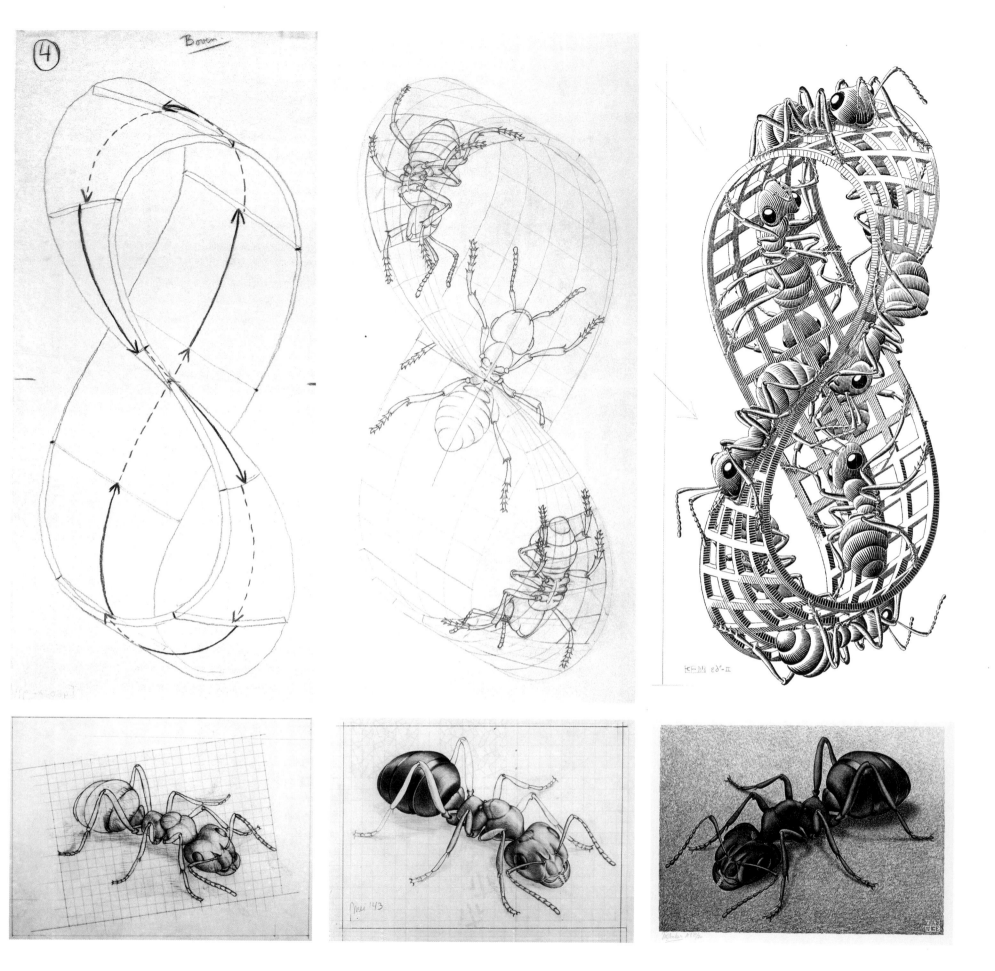

And so I can keep on going on and on never to make a new picture again…
But that I flatly refuse to do, because there's a Möbius strip waiting in my soul.
Every now and then I hear it scream: I want out! I want out!
 Letter to his son George and daughter-in-law Corrie, 29 January 1961

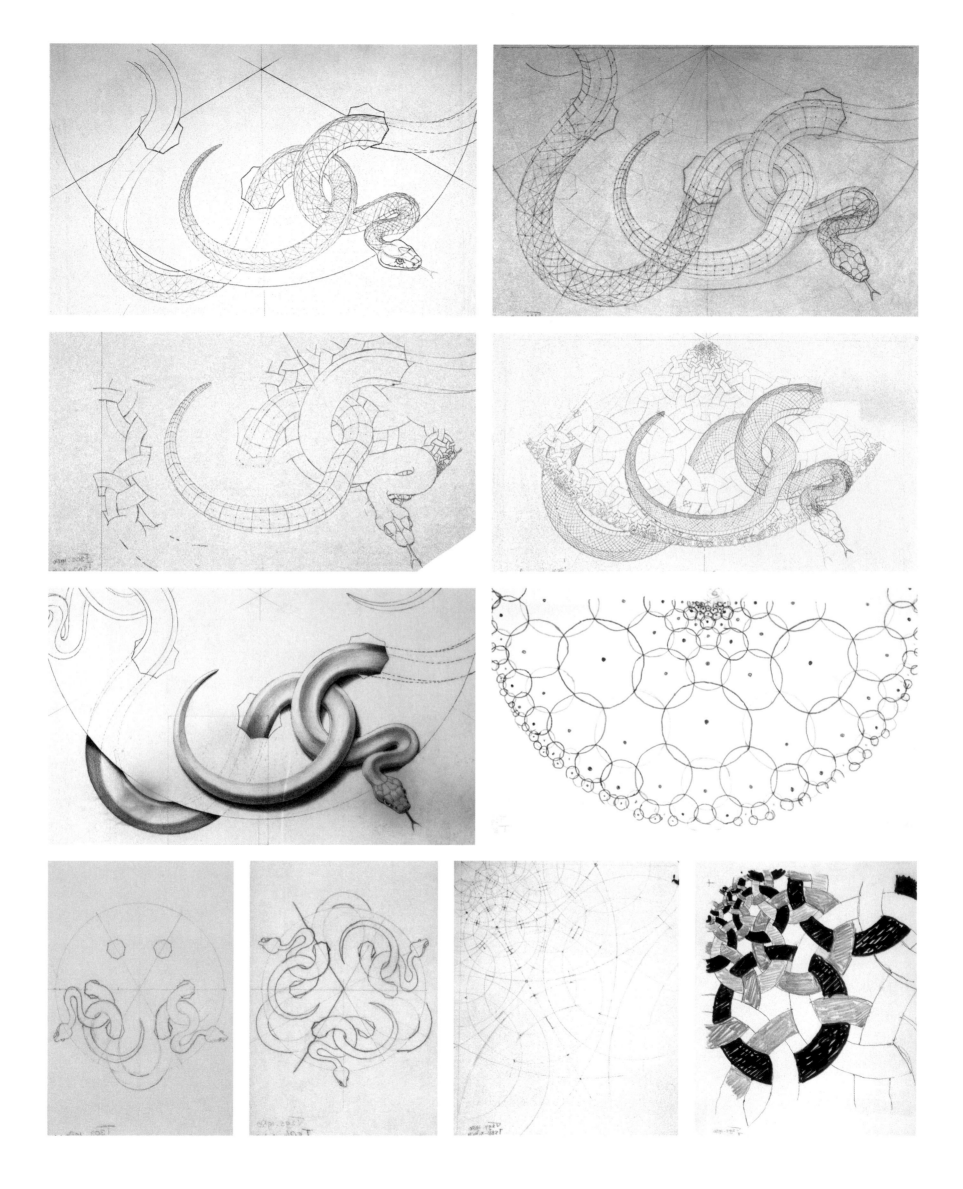

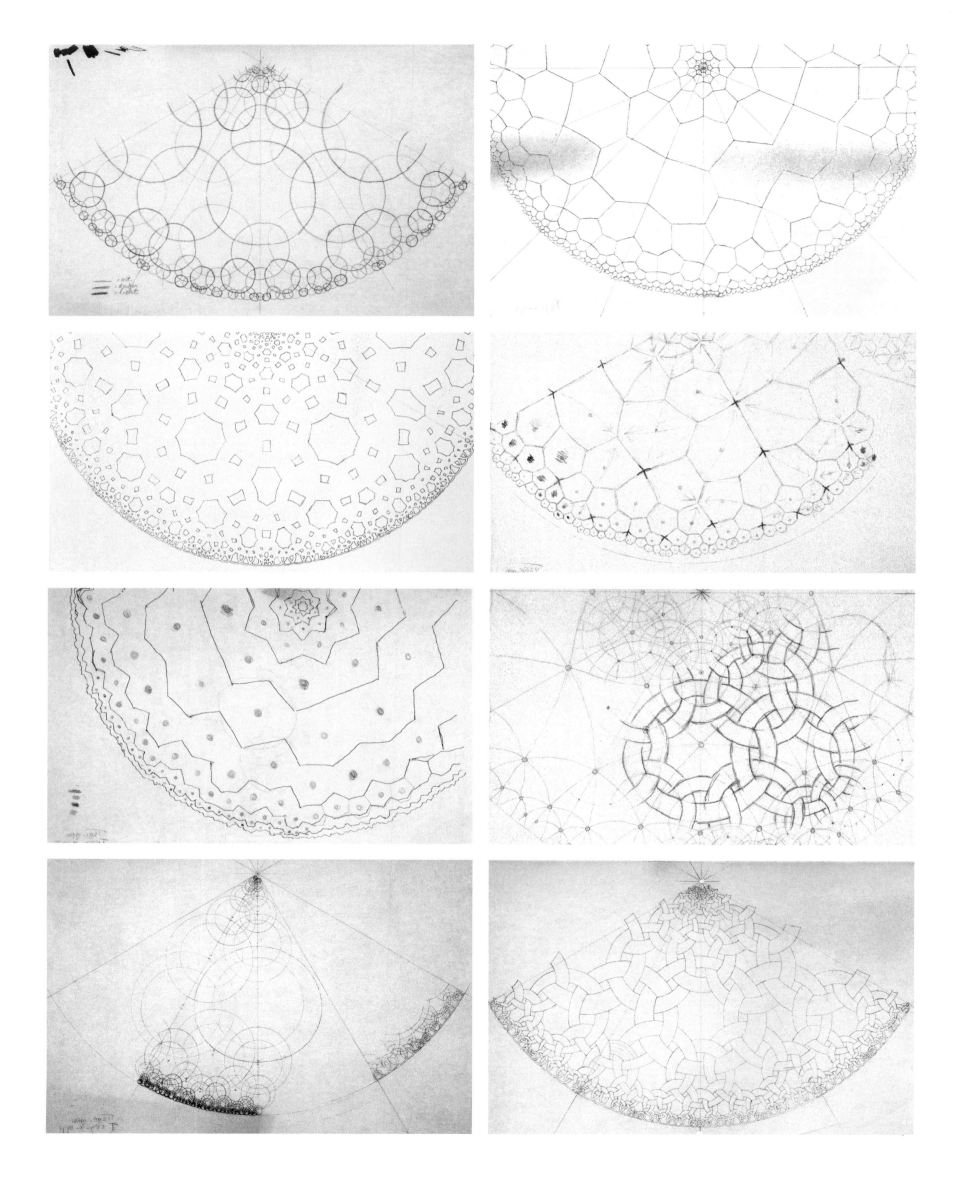

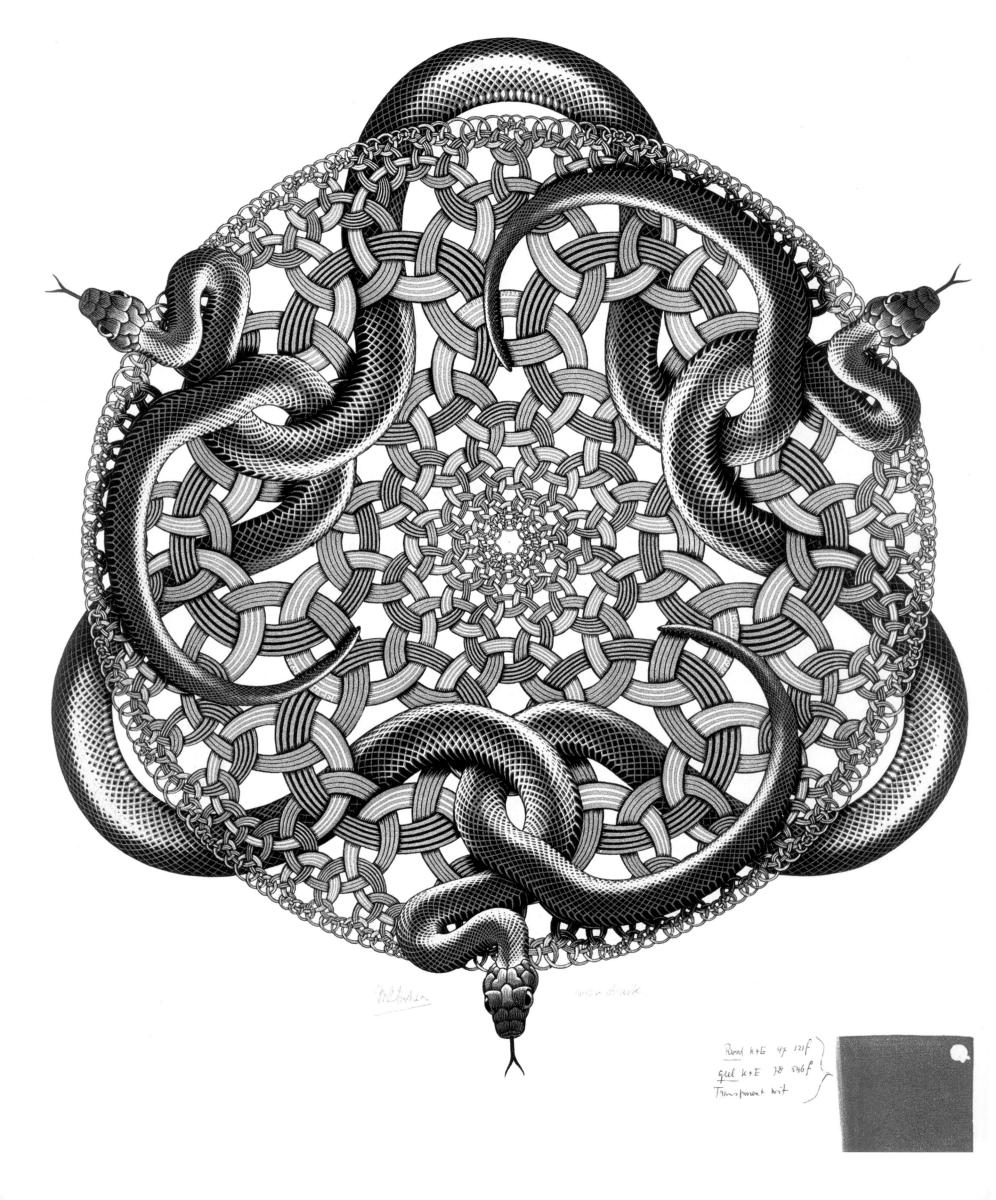

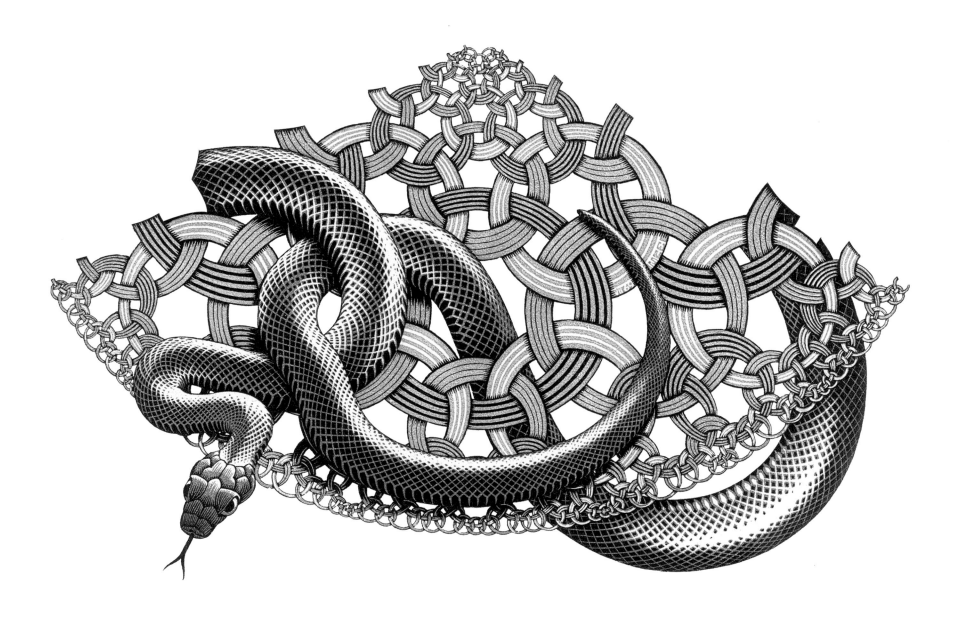

... and the next day I continue again, as if my
life depends on it and I am terrified, for example,
that I might die before I've finished this last,
so-called masterpiece.

Letter to his son Arthur, 24 March 1956

347 | 348

347 **Snakes**
 1969. Woodcut, proof, 19 ⅝ x 17 ⅝" (498 x 447 mm)

348 This is the repeat pattern that, when printed three
 times in a circle, resulted in **Snakes**

(Pages 188-189)

349 Study for **Snakes**
 Pencil and pen, 13 x 17 ⅜" (332 x 441 mm)

350 Study for **Snakes**
 Pencil, 9 ⅞ x 14 ¾" (250 x 373 mm)

351 Study for **Snakes**
 Pencil, 9 ⅞ x 14 ¾" (250 x 374 mm)

352 Study for **Snakes**
 Pencil, 11 ¾ x 18 ⅞" (300 x 480 mm)

353 Study for **Snakes**
 Pencil and chalk, 12 ¾ x 15 ⅞" (325 x 405 mm)

354 Study for **Snakes**
 Pencil, 9 ⅜ x 19 ⅜" (237 x 493 mm)

355 Study for **Snakes**
 Pencil, 7 ¼ x 4 ⅞" (183 x 124 mm)

356 Study for **Snakes**
 Pencil, 7 ⅜ x 4 ⅞" (189 x 124 mm)

357 Study for **Snakes**
 Pencil, 11 ⅞ x 9 ½" (303 x 242 mm)

358 Study for **Snakes**
 Pencil, pen and ink, 11 ⅞ x 9 ½" (302 x 241 mm)

359 Study for **Snakes**
 Pencil, 9 ⅞ x 14 ⅝" (250 x 371 mm)

360 Study for **Snakes**
 Pencil, 9 ⅞ x 18 ¼" (250 x 465 mm)

361 Study for **Snakes**
 Pencil, 9 ⅞ x 14 ¾" (250 x 373 mm)

362 Study for **Snakes**
 Pencil and pen, 9 ⅞ x 14 ¾" (250 x 375 mm)

363 Study for **Snakes**
 Pencil and pen, 9 ⅞ x 14 ¾" (250 x 375 mm)

364 Study for **Snakes**
 Pencil, 9 ⅞ x 14 ¼" (251 x 375 mm)

365 Study for **Snakes**
 Pencil, 9 ⅞ x 14 ¾" (250 x 373 mm)

366 Study for **Snakes**
 Pencil, 9 ½ x 12" (242 x 306 mm)

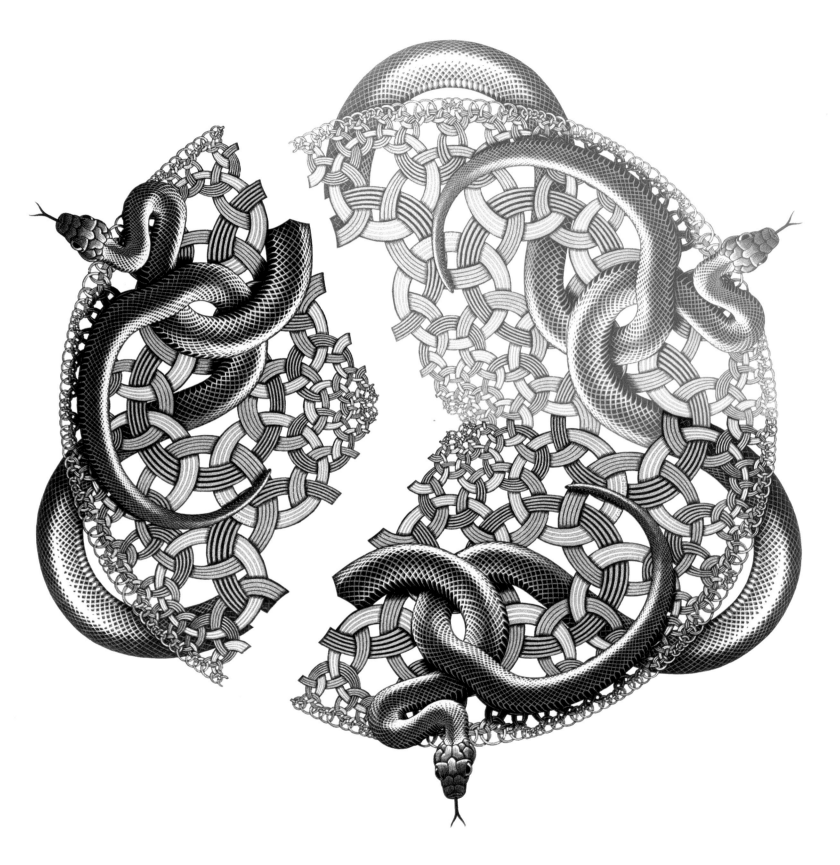

367 The three equal sections of **Snakes** make a whole
circle. Because **Snakes** was printed in three colors,
the finished print was made from three woodblocks,
each requiring three impressions.

Chronology

1898	Maurits Cornelis Escher born to George Arnold Escher and Sarah Gleichman in Leeuwarden, Holland, on 17 June. Youngest of five brothers
1903	Escher family moves to Arnhem
1912-18	Attends secondary school in Arnhem
1916	First graphic work (linoleum cut)
1917	Escher family moves to Oosterbeek. First etching
1919-22	Attends the School for Architecture and Decorative Arts in Haarlem
1919	First woodcut
1921	Travels to French Riviera and Italy. *Flor de Pascua (Easter Flower)* (Aad van Stolk, with woodcuts by Escher) published in November
1922	Travels in Italy and Spain. First visit to the Alhambra. First Italian landscape woodcut completed in July. Moves to Siena in November
1923	In Ravello from March to June. Meets Jetta Umiker. First one-man exhibition in Siena in August. Moves to Rome in November
1924	First exhibition in Holland (at the gallery De Zonnebloem, The Hague) in February. Marries Jetta on 12 June. They buy an apartment in Rome
1926	Exhibition in Rome in May. Son George Escher born on 23 July. Growing fame in Holland leads to numerous exhibitions there in the following years
1927-35	Annual travels in Italy
1928	Son Arthur Escher born on 8 December
1929	Exploring lithography
1932	*XXIV Emblemata (XXIV Epigrams)* (G. J. Hoogewerff, with woodcuts by Escher) published
1933	*De vreeselijke avonturen van Scholastica (The Terrible Adventures of Scholastica)* (Jan Walch, with woodcuts by Escher) published
1934	Wins third prize at the Exhibition of Contemporary Prints, Art Institute of Chicago, for the lithograph *Nonza*. This was the first Escher work to enter an American collection
1935	Moves his family to Switzerland in July. Rents house in Château-d'Oex in September
1936	Travels along the Mediterranean coast. Second visit to the Alhambra. End of landscape work; begins to portray his inner visions
1937	Moves his family to Brussels
1938	Son Jan Escher is born on 6 March
1939	His father dies on 14 June
1940	German invasion of Holland on 10 May. His mother dies on 27 May
1941	Moves his family to Baarn, Holland, in February
1946	First mezzotints
1951	Articles published in *The Studio* (February), *Time* (April), and *Life* (May) spark international interest in his work
1954-61	Annual travels in Italy
1954	Exhibition at the Stedelijk Museum, Amsterdam, in conjunction with the International Mathematical Conference in September. Exhibition at the Whyte Gallery, Washington, D.C., in October. Beginning of a strong collectors' market for Escher prints in America
1955	Family moves into a new house in Baarn in February. Decorated by the Dutch government (Knighthood of the Order of Oranje Nassau) in April
1958	Publishes *Regelmatige vlakverdeling (The Regular Division of the Plane)*
1959	*Grafiek en tekeningen M.C. Escher* (P. Terpstra) published in November (English-language edition published as *The Graphic Work of M.C. Escher* in 1961)
1960	Exhibition and lecture at a conference of the International Union of Crystallography at Cambridge University, England, in August. Voyage to Canada to visit George. Lecture at the Massachusetts Institute of Technology, Boston, in October
1962	The first of several serious operations requires extended hospitalization in April. In the following years his health is uncertain
1965	Receives the culture prize of the city of Hilversum in March. *Symmetry Aspects of M.C. Escher's Periodic Drawings* (Caroline H. MacGillavry) published in August
1967	Second decoration from the Dutch government
1968	Exhibition at the Gemeentemuseum, The Hague, in June. Escher Foundation established. Makes last graphic work in July. Jetta moves to Switzerland to live with Jan at the end of the year
1970	Moves to the Rosa Spierhuis in Laren, Holland, in August
1971	*De werelden van M.C. Escher* (J.L. Locher) published in December (English-language edition published as *The World of M.C. Escher* in 1972)
1972	Dies in the hospital in Hilversum, 27 March

List of Illustrations

All numbers refer to illustrations

Selected Bibliography

Writings by Escher

Grafiek en Tekeningen M.C. Escher. Introduction by P. Terpstra. Zwolle, 1959

The Graphic Work of M.C. Escher. London and New York, 1961. Enlarged ed. New York, 1967

"Hoe ik er toe kwam, als graficus ontwerpen voor wandversiering te maken." *De Delver*, vol. 14, no. 6 (1941), p. 81

"Introduction." *Catalogus M.C. Escher.* No. 118, Stedelijk Museum, Amsterdam, 1954

Mededelingenblad van de Nederlandse Kring van Grafici en Tekenaars. No. 3 (June 1950), pp. 5-7 and 19-20; no. 5 (December 1950), pp. 4-7

"Nederlandse grafici vertellen van hun werk II." *Phoenix*, vol. 2, no. 4 (1947), p. 90

"Oneindigheidsbenaderingen." *De Wereld van het Zwart en Wit.* Edited by J. Hulsker. Amsterdam (1959), p. 41

Regelmatige vlakverdeling. Utrecht, 1958 (limited ed., De Roos Foundation)

"Samuel Jessurun de Mesquita." *Catalogus Tentoonstelling S.J. de Mesquita en Mendes da Costa.* Stedelijk Museum, Amsterdam, 1946

"Timbre-poste pour l'avion." *Les Timbres-poste des Pays-Bas de 1929 à 1939.* The Hague (1939), p. 59

Wit-grijs-zwart. Mededelingen van "De Grafische". No. 13 (September 1951). pp. 8-10; no. 20 (November 1953), pp. 7-10; no. 24 (February 1956), pp. 14-15 and 15-17

The Writings and Lectures of Escher, and His Collection of Clippings. The original texts, in addition to the complete, authentic collection of all 2,100 drawings, held up to 1980 at the Gemeentemuseum, The Hague (4 vols.). Microfiche publication. Zug, Switzerland, 1981

Books illustrated by Escher

Drijfhout, E.E. [G.J. Hoogewerff] *XXIV Emblemata dat zijn zinne-beelden.* Bussum, 1932

Stolk, A.P. van. *Flor de Pascua.* Baarn, 1921

Walch, J. *De vreeselijke avonturen van Scholastica.* Bussum, 1933

Books and Articles on Escher after 1950

Albright, T. "Visuals–Escher." *Rolling Stone*, no. 52 (1970)

Bibeb. "Interview met M.C. Escher", *Vrij Nederland*, April 20th, 1968

Bool, E.H., Kist. J.R., Wierda, E. *"Escher, His Life and Complete Graphic Work"*, New York, London, 1982

Chapelot, P. "Une découverte: le visionnaire Escher." *Planète*, no. 8 (1963), p. 60

Ebbinge Wubben, J.C. "M.C. Escher: Noodlot." *Openbaar Kunstbezit*, vol. 1, no. 6 (1957)

Ernst, Bruno. *De Toverspiegel van M.C. Escher*, Amsterdam, 1976

"M.C. Escher lithographies." *Caractère Noël* (1963)

"Escher's Eerie Games." *Horizon*, vol.8, no.4 (1966), p. 110

Escher, Rudolf and Escher M.C. *Beweging en metamorfosen. Een briefwisseling*, Amsterdam, 1985

Books and Articles on Escher after 1950 (continued)

Flocon, Albert. "A la frontière de l'art graphique et des mathématiques: Maurits Cornelis Escher." *Jardin des Arts*, no. 131 (1965), p. 9

"The Gamesman." *Time*, vol. 65, no. 17 (1954), p. 68

Gardner, Martin. "The Eerie Mathematical Art of Maurits C. Escher." *Scientific American*, vol. 214, no. 4 (1966), p. 110

Gombrich, E.H. "How to Read a Painting." *The Saturday Evening Post*, vol. 234, no. 30 (1961), p. 20

's-Gravesande, G.H. *M.C. Escher en zijn experimenten*

Hazeu, Wim. *M.C. Escher. Een biografie,* Amsterdam, 1998

Hofmeijer, D.H. "The Wondrous World of M.C. Escher." *Circuit*, no. 26 (1969).

Hofstadter, R. *Gödel, Escher, Bach: An Eternal Golden Braid.* New York, 1979

Hoorn, W.J. van, Wierda, J.F. *Het oneindige. M.C. Escher over eigen werk*, Amsterdam, 1986

IDC, *The authentic collection of all Escher drawings from the Gemeentemuseum The Hague*, Zug, Switzerland, 1980

Kohga, Masaharu. *Escher Collection*, catalogue in 4 vol., Tokyo, 1986

Locher, J.L. *Catalogus Overzichtstentoonstelling M.C. Escher* (with contributions by C.H.A. Broos, G.W. Locher, M.C. Escher, H.S.M. Coxeter, Bruno Ernst), Gemeentemuseum, The Hague, 1968

Locher, J.L., C.H.A. Broos, M.C. Escher, G.W. Locher, H.S.M. Coxeter. *The World of M.C. Escher*, New York, 1972

Locher, J.L. *M.C. Escher: His Life and Complete Graphic Work,* London and New York, 1982

Loveland, R.J. *Graphic Imagery of M.C. Escher.* Master's thesis. University of Wyoming, 1967

Maas, J. "The Stately Mansions of the Imagination." *Horizon*, vol. 5. no. 7 (1963), p. 10

MacGillavry, Caroline H. *Fantasy & Symmetry. The Periodic Drawings of M.C. Escher*, New York, 1976

Nemerov, H. "The Miraculous Transformations of Maurits Cornelis Escher." *Artist's Proof*, vol. 3, no. 2 (1963-64), p. 32

Platt, C. "Expressing the Abstract." *New Worlds*, vol. 51, no. 173 (1967), p. 44

"Prying Dutchman." *Time*, vol. 57, no. 14 (1951), p. 50

Schattschneider, Doris. *Visions of Symmetry, Notebooks, Periodic Drawings and related Work of M.C. Escher*, New York, 1990

Severin, M.F. "The Dimensional Experiments of M.C. Escher." *The Studio*, vol. 141, no. 695 (1951), p. 50

Sheldon-Williams, P.M.T. "Graphic Work of M.C. Escher." *Apollo*, vol. 76, no. 82 (1962)

"Speaking of Pictures." *Life*, vol. 5, no. 18 (1961), p. 18

"Tricks Played on Hand and Eye." *The UNESCO Courier*, vol. 19, no. 5 (1964), p. 14

Vermeulen, J.W. *M.C. Escher, een eigenzinnig talent*, Kampen, 1995

Wennberg, G. "Tillvaron som synvilla." *Ord och Bild*, no. 1 (1962), p. 52

Wilkie, Kenneth. "The Weird World of Escher." *Holland Herald*, vol. 9 (1974)

Credits

Project Director: Andreas Landshoff

Art Director: Erik Thé

Editorial Board: Joost Elffers, Eric Himmel,
Andreas Landshoff, Hans Locher,
Michael Sachs, Erik Thé, Mark Veldhuysen,
Wim Veldhuysen

Translations: Marjolijn de Jager

Project Coordinator: Radha Pancham

Lithographer: Litho Köcher GmbH, Cologne

Printer: Druckerei Uhl, Radolfzell am Bodensee

Binder: Fikentscher, Darmstadt

An Andreas Landshoff Production for

Joost Elffers Books

Photograph Credits

All numbers refer to illustrations

M.C. Escher Foundation, Baarn: binding case, front endsheet, back endsheet,
1, 2, 3, 4, 7, 8, 11, 14, 15, 18, 20, 21, 22, 23, 24, 25, 26, 28, 29, 30, 31, 32, 33, 34, 35,
36, 37, 38, 39, 40, 41, 42, 43, 44, 47, 51, 52, 53, 54, 55, 56, 57, 60, 62, 63A+B, 66,
67, 68, 69, 70, 73, 74, 75, 76, 77, 78, 79, 80, 84, 85, 86, 87, 88, 93, 94, 95, 100,
101, 103, 104, 105, 106, 108, 110, 111, 112, 113, 114, 115, 117, 118, 119, 121, 122, 123,
124, 125, 128, 134, 135, 136, 137, 143, 145, 146, 147, 148, 149, 150, 152, 153, 154, 155,
161, 163, 164, 165, 166, 167, 168, 169, 170, 171, 172, 173, 174, 181, 183, 184, 185, 186,
187, 195, 196, 197, 198, 199, 200, 201, 211, 212, 214, 215, 216, 221, 224, 225, 226,
227, 229, 230, 231, 232, 233, 234, 235, 236, 237, 238, 239, 240, 241, 242, 243, 244,
245, 247, 263, 264, 266, 267, 268, 269, 270, 271, 273, 275, 276, 277, 279, 280,
281, 282, 283, 284, 285, 286, 288, 289, 291, 292, 301, 302, 303, 304, 305, 306, 307,
308, 316, 318, 325, 326, 327, 328, 332, 333, 334, 335, 337, 338, 339, 344, 345, 346,
347, 348, 349, 350, 351, 352, 353, 354, 355, 356, 357, 358, 359, 360, 361, 362, 363,
364, 365, 366, 367

Collection Paul A. Firos, Athens: 127

Masaharu Kohga, Tokyo: 188, 189, 190, 191, 192, 193, 194

Portland Art Museum, Portland, Oregon, Anonymous loan: 175, 176, 177, 178,
179, 180, 182

Collection Michael S. Sachs, Inc., Westport, CT (photography by Iwan Baan):
5, 6, 9, 10, 13, 15, 16, 17, 19, 27, 45, 46, 48, 49, 50, 58, 59, 64, 65, 71, 72, 81, 82, 83,
89, 90, 91, 92, 96, 97, 98, 99, 102, 107, 109, 116, 120, 129, 131, 132, 133, 139, 140,
141, 142, 144, 151, 162, 202, 203, 204, 205, 206, 207, 208, 209, 210, 217, 218, 219,
220, 222, 223, 228, 246, 248, 249, 250, 251, 252, 253, 254, 255, 256, 257, 258, 259,
260, 261, 262, 265, 274, 278, 287, 290, 293, 294, 295, 296, 297, 298, 299, 300,
309, 310, 313, 314, 315, 317, 319, 320, 321, 322, 323, 324, 329, 330, 331, 336, 340, 341,
342, 343

Collection Dr. Stephen R. Turner, Winston-Salem, NC: 126, 130, 158, 159, 160

Mark Veldhuysen, Baarn: 12, 61